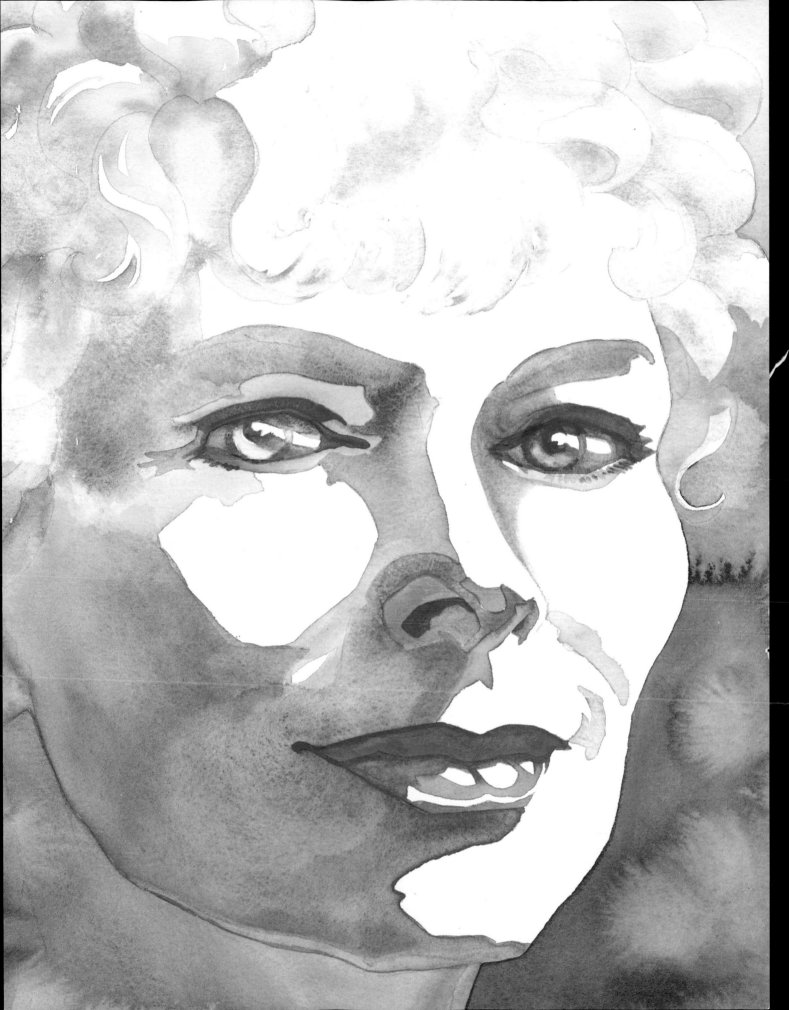

Frontispiece: Self-Portrait.
(Watercolor on Arches paper.)

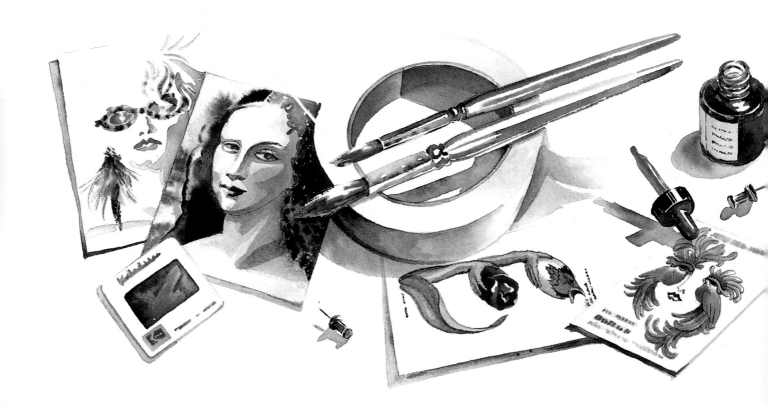

Watercolor for Illustration
Jacqui Morgan

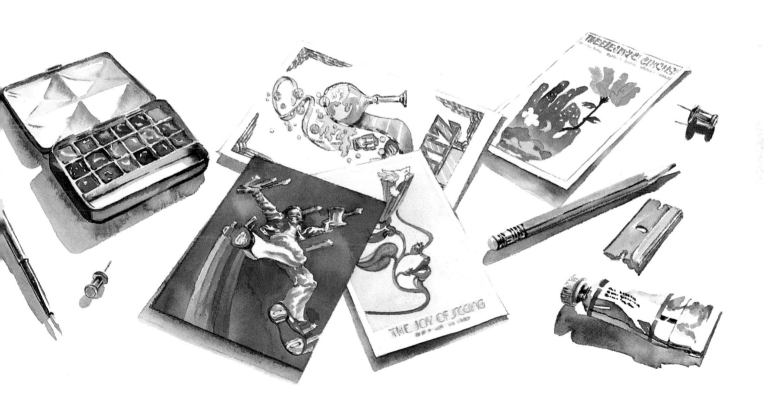

WATSON-GUPTILL PUBLICATIONS/NEW YORK

For Esther
and for Henry and Emily

Acknowledgments

My deepest gratitude to Tomas Gonda for his ongoing belief, patience, and advice. Many thanks for the contributions of some of the finest watercolor illustrators in the world as well as the talented participants in my workshops who encouraged experimentation with learning approaches. Very special acknowledgment is due Glorya Hale, editorial director, for her intelligent questions, clarity, experienced guidance, and, finally, friendship. Thanks also to book designer Bob Fillie, whose thoughtfulness and taste made a difference. My appreciation to Sylvie Eyral, not only for her poem but also for her inspiring support that turned some of the most difficult miles into a fulfilling pleasure.

Pigments explode in clear water beads
Traveling from light to shadow
To reveal form

Words of poetry grow into images
Abstract forms, sharp edges
Listening to the freely watery dialogue

Liquidly shapes delight in
Dancing transparency

Joyfully discovering the illusive
A magical world emerges
In watercolors.

SYLVIE EYRAL

All the artwork in this book, unless otherwise noted, is by Jacqui Morgan and has been previously copyrighted by Jacqui Morgan.

First published in 1986 in New York by Watson-Guptill Publications, a division of Billboard Publications, Inc., 1515 Broadway, New York, N.Y. 10036

Library of Congress Cataloging-in-Publication Data

Morgan, Jacqui.
 Watercolor for illustration.

 Includes index.
 1. Watercolor painting—Technique. 2. Watercolor painting—Themes, motives. I. Title.
 ND2420.M6 1986 751.42′2 86-15885
 ISBN 0-8230-5658-9

Distributed in the United Kingdom by Phaidon Press Ltd., Littlegate House, St. Ebbe's St., Oxford

Manufactured in Japan

First printing, 1986
2 3 4 5 6 7 8 9 10/91 90 89

Contents

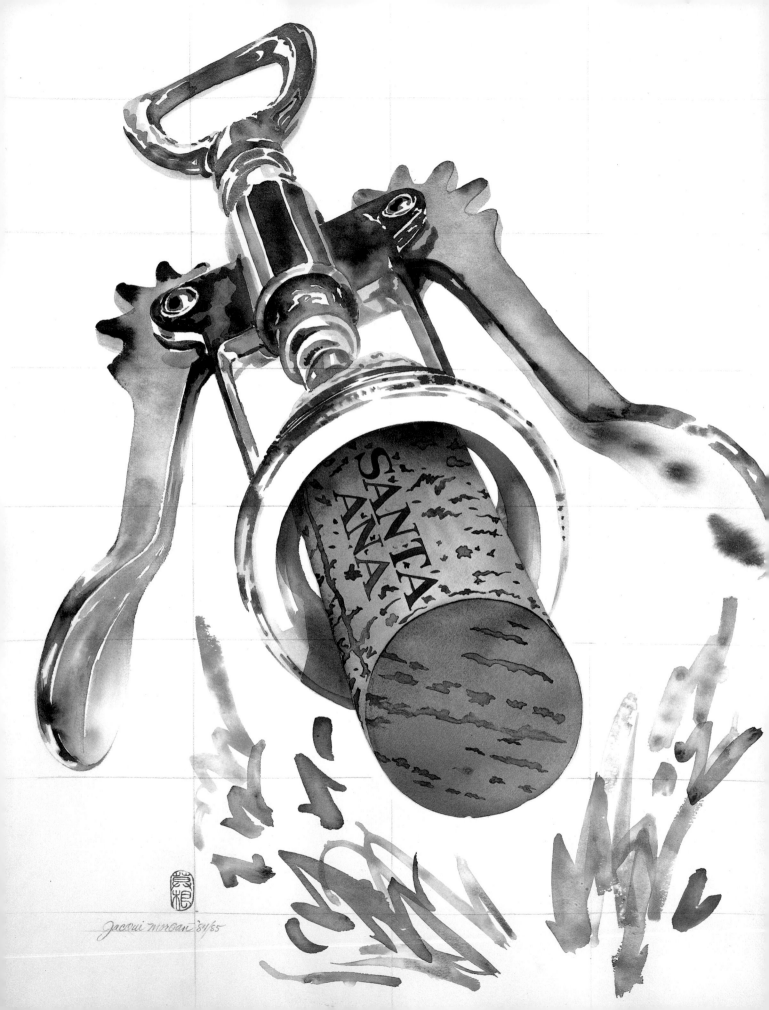

Introduction

Welcome to the magical world of watercolor and its use in illustration.

Watercolor is about water. Flowing, liquidy, wet, vehicle of transparent color, conveyer of light and luminosity, water fills the streams, lakes, and oceans of our planet and is a major component of our bodies; it is ever changing, full of fresh surprises and tactile pleasures. These qualities of water blend with the illustrator's objectives—communication of mood, professional execution, formalistic excellence, and problem solving—a challenging set of goals to be achieved within a limited time frame. Indeed, for the illustrator, the speed of execution required by watercolor, combined with the unique vitality that communicates energy, joy, playfulness, and the spontaneity of the captured moment, is the advantage of this medium over others. Most artists consider its disadvantage—the element of risk or unpredictability—the same quality that accounts for its popularity. Watercolor is a challenging medium because the process of painting is visible, and alterations are difficult to make.

This book is organized as a workshop; once skimmed, it is most effectively read according to chapter sequence. It takes the serious student and the professional, step by step, from perception on to a variety of subjects, each progressively more complex than the previous one. These include the figure nude and clothed, the portrait, and reflective and transparent forms. Photography and projectors and copiers are examined as studio tools. Classical and new painting techniques are explored, as are unusual painting surfaces, the mixing of other media with watercolor, as well as portfolio preparation and marketing possibilities.

Geared to the criteria of illustration—convincing rendition of objects and narrative—this book also reaches for the surface beauty and unique painterly qualities that can be achieved only with watercolor. In addition, painting methods and repair procedures that bring unusual control of the medium are discussed and demonstrated.

To you, the reader, best wishes for success, unsurpassed hours of pleasure, and lasting satisfaction.

Happy New Year, *originally done as a self-promotional New Year's card, was bought by Santa Ana, an Argentine winery, for use as their New Year's card. Only the cork was repainted and patched over the original. (Watercolor on Arches paper, 22" × 30", 56 × 76 cm.)*

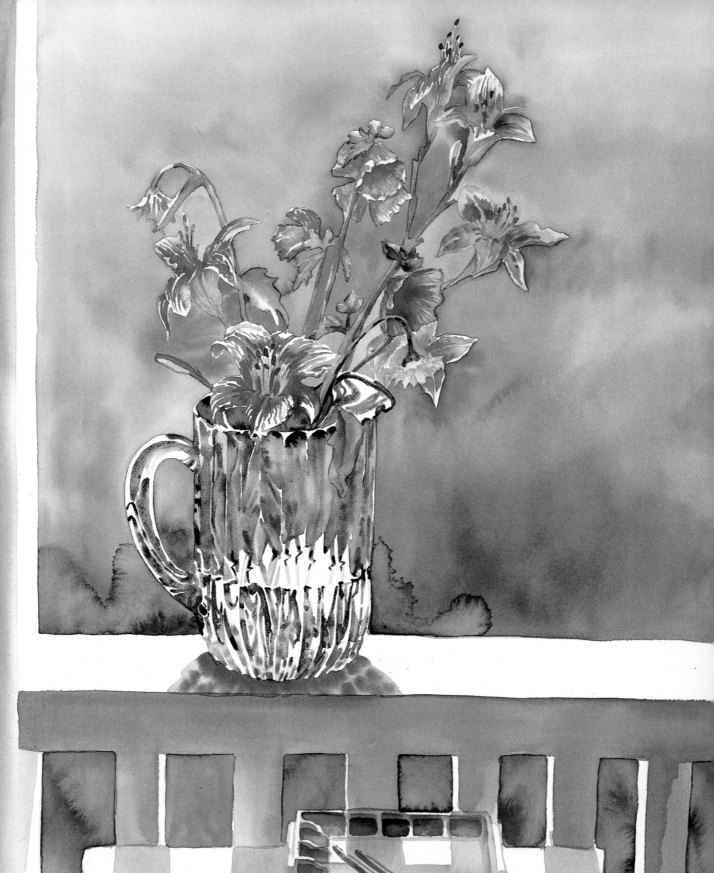

1

Tools and Equipment

The choice of the tools and equipment you use should be based not only on excellence of results but also on the comfort and pleasure they afford you. They are not only reliable good friends but a source of inspiration and a motivation to begin to paint. What follows, therefore, are recommendations. Personal criteria, trial, and testing must be factors in your ultimate choices.

Papers

More so than with any other medium, the most important tool for watercolor is the surface, or paper. The color and texture of the paper remain visible in the final product and are also visible in a reproduction that is close to the original size. Paper is one area where economizing is not economical. Only the best handmade papers are durable, do not yellow or crack. Since they are made of 100 percent cotton rag, with no wood pulp, they are acid-free and do not easily fatigue. (In this context, "fatigue" means that the surface texture alters or pills, causing some areas to accept color differently than the rest.) On less expensive papers, a few coats of water or pigment or slight amounts of scrubbing will unpleasantly mar the surface. No less a reason for choosing good-quality paper is that beautiful paper is a tactile pleasure and an inspiration. Among such papers the variety of whiteness, surface texture, and weight are matters of personal preference.

Some of the best papers are d'Arches from France; Whatman, Saunders, and Wookey Hole from England; and Fabriano and Capri from Italy. Several of these manufacturers, however, produce fine papers for both printmaking and watercolor. Be sure to purchase the watercolor paper; printmaking paper responds like a blotter to watercolor.

During a workshop in New Hampshire, my favorite palette interested me more as a subject to paint than did the porch, pitcher, and flowers . . . and it shows.

Brushstrokes on wet and dry Arches 140-lb. coldpress watercolor paper.

Watercolor papers are available in three surface textures: rough, cold-pressed (semirough), and hot-pressed (smooth). Cold-pressed is best for most purposes. It has adequate tooth to prevent running and does not cause the pigment to leave hard edges as hot-pressed paper tends to do. It is not so rough that dots of white remain in the deep valleys, requiring a second coat or very wet, slow working. Surfaces vary, however, from manufacturer to manufacturer. The cold-pressed paper of one manufacturer may more nearly resemble the rough or the hot-pressed paper of another.

During manufacture, sizing, a gelatinlike substance, or animal hide glue, is applied to the surface of the paper to control its absorbency. Without sizing, the paper would immediately absorb the paint, like a blotter, leaving the painter no time for manipulation. Printmaking papers have no sizing. Too much sizing repels watercolor, but the paper can be washed down with a sponge or soaked to make it more receptive.

Another question of preference is the choice of weight, or thickness, of paper. The available possibilities are 70 lb., 90 lb., 140 lb., 200 lb., 300 lb., and 400 lb. Most watercolorists prefer the thicker 300-lb. paper because it does not necessitate prestretching and takes greater abuse. Heavier-weight paper can take more applications of water and paint and more scrubbing and scraping before it fatigues or ripples.

For some jobs, however, the lighter 70-lb., 90-lb., and 140-lb. weights have advantages. Usually, the design and drawing of a job are planned on tracing or layout paper and are often accompanied by color comps (comprehensive sketches). Since such planning would preclude many changes at a later stage, thinner, lighter paper facilitates the transfer by light box of the design from the tracing to the final surface. In addition, you can buy, for example, two sheets of 140-lb. paper, my favorite, for the price of a single 300-lb. sheet. As with texture and tooth, the thickness of each weight varies with the manufacturer.

While there are a variety of sheet sizes available, the most common, the Imperial, is 22 inches by 30 inches (55.8 cm by 76.2 cm). As a full sheet, it has good proportions and also divides well into half and quarter sheets. Through experimentation, you will arrive at your personal preferences.

Recommended here, for the first exercises, are quarter sheets of 90-lb. or 140-lb. Arches cold-pressed paper. After you have achieved some mastery on a watercolor surface of this quality, it is easy to modify your working method for other surfaces.

Brushes

You will probably need no more than four brushes to do any painting—a large round brush, a medium-size round brush, a flat brush for large washes and backgrounds, and a brush

for lightening or scrubbing. Brushes, like paper, should afford pleasure to the user, but they need not be the most expensive available.

Round brushes (rounds) are full-bodied brushes that come to a fine point. Their fullness holds a lot of juice, requiring less dipping in water or paint. They should, without manipulation, come to a fine point when dipped in water and shaken out by a single, sharp movement to get rid of the excess. Red sable is considered the best because of its softness, the tapering of each hair, and its flexibility; it is also the most expensive. However, many manufacturers and large art supply stores produce imitation sable brushes of good quality. In sizes over number 10 the imitation sable brush, made of synthetic materials, has the advantage of having more bounce and maintains its shape much longer. Art material suppliers understand the necessity for the brush-dip test prior to purchase. You should avoid camel hair and any student-quality brushes.

The scale you work in dictates your choice of brush size. Recommended is one round that is comfortable to use to render an eye in your scale of work. Usually this falls within the range of numbers 3 to 7. The second, larger round, used for most of a painting, usually ranges from number 10 through number 14.

Flat brushes (flats) are necessary for large washes and backgrounds. Sometimes referred to as "sky" brushes, they are used on the flat surface rather than on one edge. Lettering brushes are used by many artists for the same purpose. They are used both full flat and on the thin edge for greater precision. Because these brushes contain more hair, in genuine sable they cost a fortune. While red sable is excellent in these large sizes, good synthetics can be preferable for their bounce and control. Again, scale of work dictates choice of size, which usually ranges between ¾ inch and 1½ inches (1.9 cm and 3.8 cm). As you gain experience and confidence, you may want to add flat brushes of different sizes and another round brush.

The fourth brush is used for lightening or softening areas. For pigment watercolor, a stiff, abrasive bristle brush, such as the kind made for acrylics and oils, provides the friction to loosen the pigment. Any small, short-haired bristle does the job, if the hairs are short enough to stay rigid and provide adequate friction. To get into the smallest areas without disturbing an adjacent area, the smallest size range, numbers 1 through 4, are recommended. The stiff brush end of a typewriter eraser is also effective for this purpose. The hairs can be clipped shorter for better control.

For concentrated watercolor, which dyes the paper, scrubbing is useless because there is no pigment to remove. The color can be lightened by bleaching,

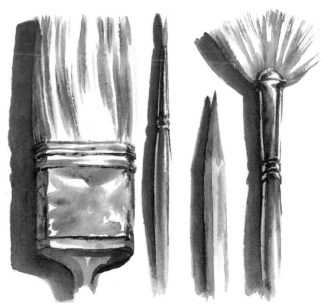

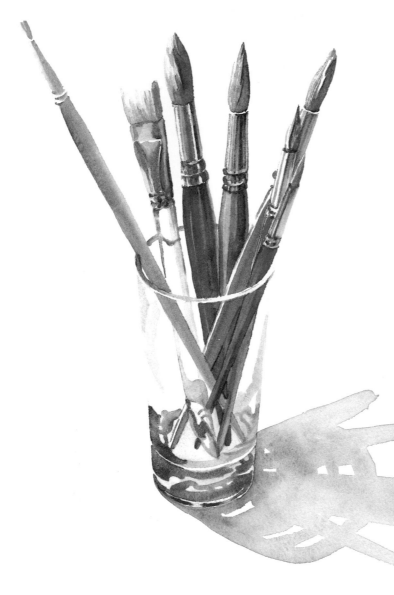

however, even to the white of the paper. Since household liquid laundry bleach will destroy a good sable brush in a single dip, use a synthetic round, preferably white-haired, which is durable and can easily be distinguished from the other, less hardy brushes. Bleaching should be done little by little to avoid having to paint over the bleached area because the process changes the paper texture, and the newly applied color can also bleach out or turn yellow. A smaller brush is therefore recommended. Try a white synthetic round, numbers 1 or 2.

Brushes wear well and last for a long time when they are properly cared for. When a brush is not in use, always keep it heel (handle) down in an empty can or jar. Do not leave a brush sitting in water; it may never return to its original straight shape and natural point. While you're working, always rinse each brush in a jar of water and return it to heel down position. Especially when you're using concentrated watercolor, rinse your brush with mild detergent every once in a while to promote longevity.

For travel there are straw mats, identical to those used to make sushi, that roll up and protect the brush. These are expensive when purchased from an art supply store, but can be obtained economically from a Japanese food store. You can improve the mat by weaving elastic in and out of the slats to provide firm slots for the brushes you carry. I store my studio brushes in this handy device, which keeps the brush tips clean and straight.

Paint

There are four aspects to consider when choosing paint: the type, the form, the quality, and the color.

Watercolor comes in two types: the pigments of classical transparent watercolor and the concentrates, commonly referred to as dyes. Transparent watercolor, historically used by fine artists, is also popular with illustrators and architects. Concentrated watercolor is almost exclusively used by illustrators and textile designers.

Watercolor pigments give a more painterly appearance than dyes, with crisper edges and subtler coloration. Although some of the pigments have staining properties, they stain far less than concentrated colors. Scrubbing can lighten the pigment, and additions of water can move or effect slightly moist areas, achieving watery, feathery effects. Pigment color is

Rest brushes on their heels to maintain the points and to promote longevity.

more manipulable and changeable and requires less advance planning.

Since concentrated watercolors, or dyes, have no sediment or opacity, they are like stained glass, even more transparent than pigment. The colors are far brighter and cleaner and actually stain the paper. Once laid down, they cannot be manipulated except, while moist, by blotting and, when dry, by bleaching. Multiple layers of this exceptionally transparent brilliance do not easily become opaque or muddy. The colors are so intense that they require premixing, and a mixture can be rewet and used again and again.

Each type of watercolor has its advantages and should be tried, but I recommend pigments for the initial exercises in this book because they are easier to control. Pigments also provide an excellent background for the later use of dyes. At this time, my personal preference is for pigments, but on occasion I combine them with concentrate when I need an exceptionally vibrant color.

Another aspect of paint you must consider is form, that is, whether you prefer watercolors in pans or tubes. Pans, containing solid, dry squares or rectangles of color set in a self-closing box, are the best choice for traveling or reportage. Some portable sets include a cap that protects the brush and that, like a pen, may be added to the heel of the brush to extend its length when it is being used. The cover of the box is used as a mixing palette. Also available is a miniature canteen, the size of a pack of cigarettes, which has a tight screw-on top plus a large cover. The cover may be filled with water and hooked onto the paint box. My favorite portable water holder is a clear, plastic, lightweight collapsible cup that resembles a Japanese lantern. It has a wire handle for easy carrying when full.

Tubes, which contain pigment that is already soft and moist, are studio favorites because they are easier on brushes, eliminating the need for scrubbing to soften the pigment. In addition, tubes are also sold individually, and each color can be selected for permanency, transparency, and cost. Fewer shops sell pans individually. Since almost identical colors can be found with varying degrees of transparency and permanency, you should choose carefully. Tubes also allow you to control the placement of each color on your palette. When the water evaporates from tube colors, you simply add more water before use to soften them. Additional tube color can always be added.

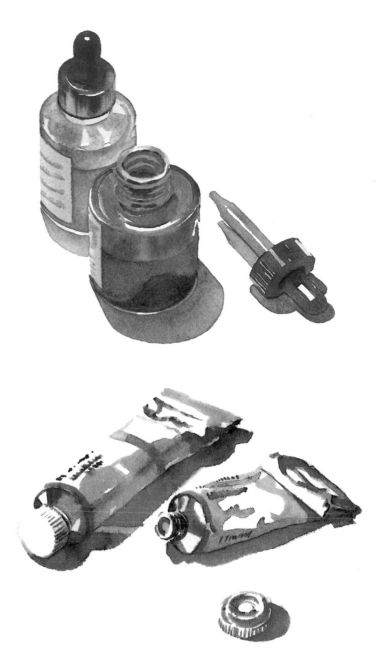

The colors of concentrated watercolor, or dyes, top, are far more intense and transparent than pigment watercolor and require more practice to manipulate. Watercolor pigment in tubes is easier to use and available individually in a wider range of colors. While dyes and pigments can be used effectively in the same painting, premixing them is not recommended because each reacts differently to the water and paper.

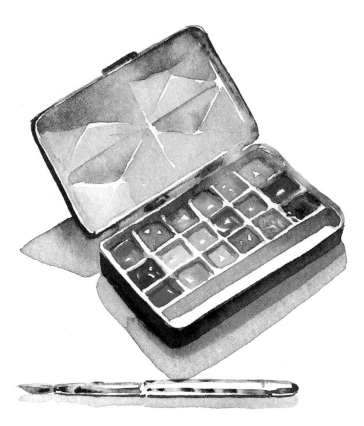

A travel case of watercolor pigment in cake or pan form is convenient for small on-the-spot studies. The stainless steel water container has a screw-on cap and is the size of a cigarette pack. The cover hooks onto the watercolor case to hold painting water.

Careful closing of tube caps ensures durability. You can also empty the entire tube into the palette compartment.

Whether you choose pigment or concentrate, tubes or pans, quality begets quality. When buying pigment colors, avoid any that are labeled student quality because they contain less pigment and more carrier. Paint is less costly than paper or brushes and lasts longer. Winsor Newton and Holbein pigments are excellent, but artist's-quality paint of almost any manufacturer is a good investment.

As for concentrated watercolor, the best-quality brands are Luma, Flax, and Ecoline, not all of which will be available at every shop. Be sure to purchase colors that mix with one another. A single manufacturer may produce three different categories of concentrate and each category will have a different chemical base. Each category has a tremendous range of colors, so there is no need to experiment with colors that do not mix.

Palettes

The best palette for tube colors is a large one of white plastic or porcelain about 10 inches by 13 inches (25.4 cm by 33 cm). It has fourteen to seventeen separate compartments, about 1½ inches (3.8 cm) square, for pigment. They surround a large, central mixing area. You should mix only in that area, keeping the color compartments unadulterated. You need wipe clean only that portion of the palette without disturbing the unused pigment. Thus the palette is always ready, to entice you to begin the next painting or for a rush job. Some palettes come with covers to keep out dust and maintain moisture, but you can easily rig one out of cardboard or plastic.

Palettes for concentrated colors, or dyes, are inexpensive and disposable. Also made of white plastic, they are approximately 8 inches by 9 inches (20.3 cm by 22.8 cm) with thirty small but deep, round cups. The cups provide space for mixing, instead of a dry, flat mixing area, because dyes are liquid. As the water evaporates from them, simply add more. They can be used indefinitely. Often old, mixed evaporated colors are preferable because of their greater depth and subtlety. Therefore, keep and accumulate used dye palettes rather than discarding them. Begin a new palette when pure intensity is required.

Whether you are using pigments or dyes, you should arrange them in a logical order and consistently maintain that order so that your palette stays

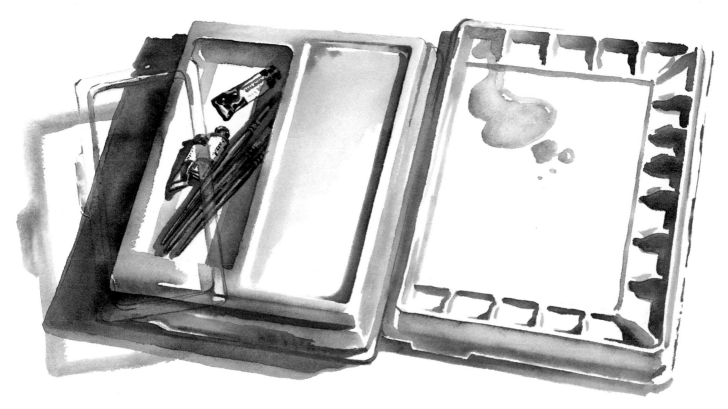

My favorite palette, which I use with tube pigment, has a large mixing area. It comes with a cover that has a recess that holds pencil, eraser, sharpener or brushes and has its own transparent cover.

neat and you do not have to search for a color and can find the one you need almost by reflex action. Any logical order, such as a progression from yellows to reds to violets to blues and greens to neutrals, works well. As you use a color, replace it in the same position. Allow some empty compartments to mix a large amount of color and to experiment with a new color that could replace an existing one.

Board and Table

You can paint anywhere, under almost any conditions, but a comfortable painting area, set aside for that purpose only, encourages productivity.

You do need a table and a rigid board that moves independently of it to provide a flat surface to which the paper can be taped or tacked to make it taut. A smooth, clean piece of plywood, Masonite, Formica, or heavy cardboard will serve. It should be just larger

than the sheet of paper on all sides to allow room for taping. Masking tape is popular, but artist's staples are preferred by some people.

The board has to be tilted at times to make it easier to work on and to control the flow of washes. You may frequently have to change the angle of the tilt from top to bottom or from side to side, which is the reason the board must be independent from the table. A tilt can be achieved by placing the board on any large household table, on which you have put a box or block of wood about 2 by 4 inches (5 by 10 cm). The block supports the top of the board, making it tilt toward you. A flat area should be left next to the board to hold palette, brushes, and water. Alternately, the board can be placed on a commercially available tilt-top drafting table with a raisable bottom edge to hold the board firm. Although the drafting table is adjustable, the board remains a necessity for painting upside-down, unless the table top can be spun around. A taboret or a flat table can be placed next to your painting hand to hold your other tools.

Whatever kind of table you use, it is helpful to work in white surroundings, like the watercolor paper, to facilitate color decisions. A white Formica table top, which does not become stained by either pigments or dyes, as well as a white palette, makes it easier to

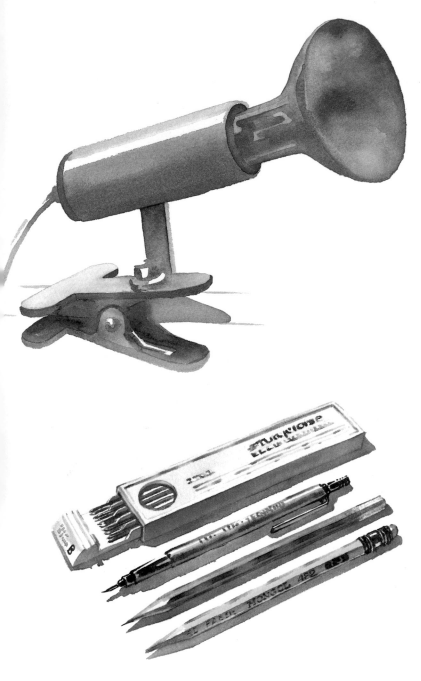

The versatile clamp-on lamp, top, has a color-balanced bulb that appears identical to daylight.

It is best to draw with Number 2 leads or pencils, which do not indent the paper's surface. Softer leads seem to smear too readily.

judge the appropriate palette colors and visualize them as they will appear on the white watercolor paper. A dark-colored palette would make the pigment appear relatively lighter, certainly different, than it would appear on white paper, necessitating more color guesswork.

Lighting

Your light source is important both to light the work surface evenly, without the hand or brush casting shadows, and to cause minimal distortion of color perception. The ideal light is from a northern skylight or window, which provides cool, indirect light for the whole day. In reality, any daylight source works, except for direct sunlight, which causes strong shadows to be cast across the working surface. Direct sunlight is also so brilliant that semiblindness and distortion of color commonly result.

Even with a perfect daylight source, supplementary artificial light is necessary for night and for overcast, rainy days. It should imitate, as nearly as possible, northern daylight. Seek a balanced light, which is neither too red, as is the household incandescent lamp, nor too blue, as is cool, white fluorescent light. Either extreme results in color choices that are too red or too blue when seen in daylight. One solution is a fluorescent light with half the bulbs warm white and the other half cool white. Another solution is a work lamp containing an incandescent bulb surrounded by a cool fluorescent tube. Or you could use a daylight, or balanced, light bulb. A little shopping may yield still other solutions.

You will need a second light source when painting from life. The criteria for choosing lighting for a subject are the opposite of those necessary for the working surface. First, the subject requires stronger light than the work surface. If the work light on the paper is more powerful than the light on the subject, semiblindness results, which makes the variations of color and light on the subject difficult to perceive. Second, a reddish light on the subject can be desirable because it causes bluish tones of shadow and a richer overall color. Third, strong cast shadows on the subject can be an asset because they increase the sense of form. For this purpose, direct or simulated sunlight can be desirable.

For the supplementary artificial light source, a single spotlight, floodlight, or incandescent work lamp are all good choices. Here, the important consideration is the light's adjustability, so that you can

control its effect on the subject. Whatever the temperature of the bulb, a clamp-on light is generally more flexible than a work lamp.

Blotter

To lighten and soften pigment while it's wet, you will need a blotter. Although the typical office blotter is useful to attain sharp edges, it can leave undesirable edges within large shapes and transfer previously blotted pigment to another section of the work. A crumpled facial tissue also leaves a distinguishable texture.

The best solution is smooth, untextured toilet paper. Unroll it in the direction that allows it to unwind freely. Used sheets are torn away so it always stays fresh, free of previously blotted, transferable pigment. In addition, because of its being rolled, it will not leave any unwanted edges and the edge of the roll can be used to straighten a wiggly edge. Be sure to select a brand free of waffling or texture so that it will not interfere with the texture of the watercolor paper, which is visible in reproduction. You can also dry the brush on the upper flat side of the toilet-paper roll without interfering with its function as a blotter. One good spin of the brush dries it sufficiently so that the brush can be used as a sponge to pick up a wet corner or the bottom bead of a wash.

Pencils and Erasers

A soft lead pencil can be used with a light touch without indenting the paper surface. A mechanical pencil with a 2B lead or an ordinary number 2 office pencil serves equally well. Unwanted lines are completely erasable. The eraser on an office pencil, however, can leave a rust-colored residue. A kneaded eraser lightens marks, but lacks the friction to remove lines completely. The Staedtler Mars-Plastic is recommended for complete erasure. It is white, has adequate abrasiveness, and does not mar the paper surface or leave a colored residue. After a painting is thoroughly dry, the plastic eraser can even erase unwanted pencil lines through the dyes though pigment may become lighter, sometimes desirable.

Knife and Blade

After the work is complete and absolutely dry, a mechanical knife or a single-edge razor blade can be a lifesaver for finishing touches. Either can be used to scratch in highlights or straighten an edge. A blade can also be used before applying

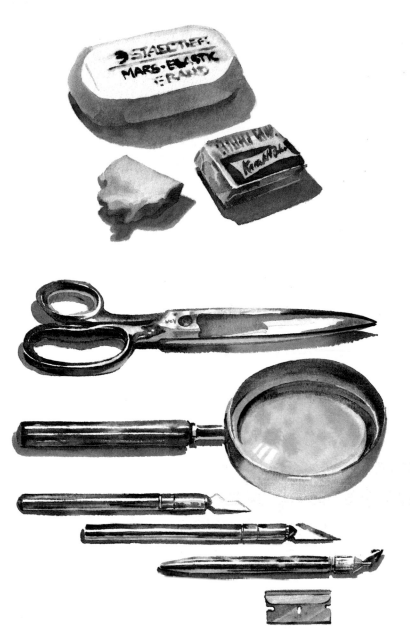

The white plastic Staedtler-Mars eraser, top, completely removes soft pencil line without leaving an undesirable color residue. A kneaded eraser is less abrasive and best for softening lines.

Retouch and repair aids include scissors for patching, a reducing glass to judge how the art will reproduce smaller, and blades and holders that are useful for touch-up scraping and patching.

Special Effects

A fine-textured sponge dipped and stamped on dry Whatman paper.

A fine-textured sponge stamped on a wet surface.

Salt used to crystallize pigment.

A rougher sponge used on a dry surface.

A rougher sponge used on a wet surface.

A liquid mask applied before charging in wet-in-wet.

A sanded wooden letter stamped on a dry and then on a wet surface.

A sanded wooden letter covered with a layer of facial tissue and stamped on a damp surface.

Toothbrush splatter on a dry surface.

A matchbook edge, wrapped in tissue, and used as a pick-up from a wet-in-wet surface.

Dry paper scraped with a blade before the application of pigment creates the darker weed effect and then scraped afterward for white weed effect.

Pigment applied directly to a dry surface, then clean water immediately dropped into it.

Salt used to crystallize pigment.

*A liquid mask applied before
a flat wash on dry paper.*

Toothbrush splatter on a wet surface.

*Pigment applied directly
to a dry surface, then clean
water immediately
dropped into it.*

pigment to achieve special effects. By breaking through the sizing, you make the paper more absorbent so that a single-color wash can affect reeds or grass, for example, by turning a deeper value where the paper is scratched.

Materials for Special Effects

Special effects should be used sparingly. The results can too easily look tricky, contrived, superficial, and amateurish. There are times, however, when their use is valid, even necessary.

You can, for example, apply coarse table salt or rock salt to portions of the wet paper and then charge in pigment, or you can apply salt on top of the wet pigment. Allow the paper to dry thoroughly before brushing off the salt. The salt crystals absorb the water along with the pigment, leaving a white, crystallized effect resembling snow or the breakers of waves. A toothbrush splatter results in a similar but less subtle effect.

You can also use cardboard edges, rubber stamps, cosmetic sponges, and found objects to produce interesting effects. The results depend upon the wetness or dryness of the paper.

Other special effects can be achieved with masks, available in liquid or paper, to cover areas to be left white. Applied to clean, dry paper, a mask repels water, pigment, or dyes applied over it. Its effectiveness depends upon the texture of the watercolor paper. Some experimentation is necessary to discover which kind of mask does the cleanest job. A mask should not be removed until the paint is thoroughly dry. A paper mask should be lifted with the help of a blade, without marring the paper surface. If you cannot do this successfully, try another brand. Liquid masks, applied with a brush, are removed with a rubber cement solvent. Remember, however, that any mask leaves hard edges.

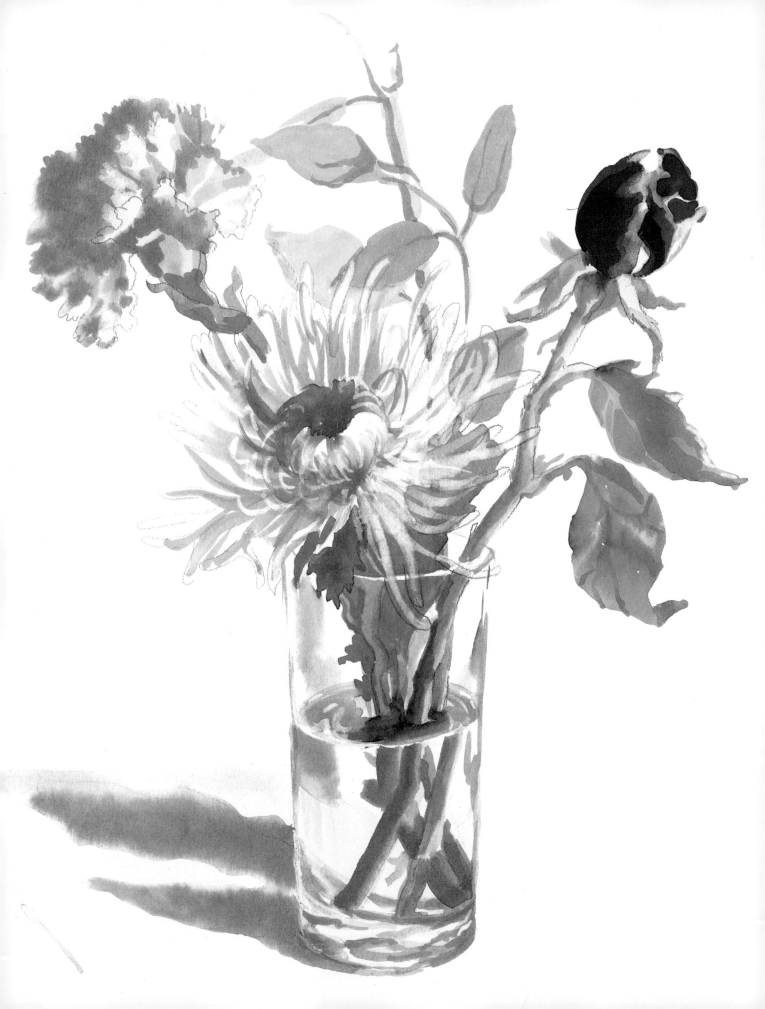

2

Working Methods

The magical little tricks achieved by water and pigment are unobtainable and unimaginable in any other medium. The flowing water that carries the pigment can be used in a great variety of ways, and it is this variety that makes the process of painting in watercolor so exciting to watch. Each experiment will seduce you into trying another one; as you work you will discover that watercolor is definitely not a dry brush technique but, on the contrary, one that thrives and radiates in its element—water.

The Drawing

After you have taped all sides of the watercolor paper to the rigid, free-moving board, take a 2B pencil and lightly draw the contour of the subject. Erase any line that can be misleading; too many lines and shapes confuse. Next, draw the shapes of the darks and shadows.

You have just completed your map, or painting guide. The purpose of this drawing is to make the painting process easier, clearer, more pleasurable, and more relaxing. A competent drawing frees you to enjoy the painting process; pleasure and concentration are always visible in the final product.

Wet-in-Wet Painting

Wet-in-wet is a classical watercolor technique. Many artists first dip the entire sheet of paper in a tub of water and allow it to soak before taping it down to the board. This process removes some of the sizing, stretches the paper taut, and allows the pigment to be worked into an entirely wet surface. As the paper gradually dries, areas are rewet to receive washes. Applications of

Translucent delicate flowers and illusive transparent glass are more convincing when understated.

Wet-in-Wet Painting

Wet one 3-inch (7.6 cm) square of watercolor at a time and try the following experiments:

Charge in a single color and manipulate it so that it smoothly fills the square.

Charge in a single color and do not manipulate it.

Charge in several colors and let the water blend them.

Charge in several colors and let the water blend them. After about one minute, drop in clean water with a loaded brush.

wet, flowing transparent color are applied to a drier and drier surface to achieve crisper edges and detail.

For illustration purposes, it is far better to wet each portion of the paper just before it is worked. This provides greater control over bleeding color, which flows from one area into another only where the water is placed. Crisp, precise details need not be achieved only with a dry brush. Tiny shapes can be wet so that even the details can be translucent and watery. Logic dictates placement of water up to the spot where sharp edges are needed to describe the subject. The greatest advantage of wetting small areas is that both crisp and soft edges can be obtained. A painting that is consistently soft and blurry is less dramatic and more difficult to reproduce. Consider, too, how difficult it is to keep a large area sufficiently wet until it is worked. By wetting each area just before working it you know exactly how wet it is and, therefore, how much the pigment will spread. You take fewer chances and gain greater control.

To use this technique, lay the board absolutely flat. Then, with a loaded brush, generously place water within a defined shape. Immediately charge, or float, pigment into this area. Since water carries the pigment to the edges, where it stops, it does the work of blending color smoothly without manipulation. This area-by-area, wet-in-wet technique eliminates streaking, unwanted edges, rushing, and constant redipping into pools of already mixed pigment. There is plenty of time to vary color and value by charging in more or darker pigment, and even several colors.

Allow the area to dry thoroughly before wetting or working an adjacent area; even a damp area will react to pigment next to it. Sometimes such accidents are extremely beautiful, and welcome, when they occur in a fortuitous place. For the moment, however, select a distant area to work next, taking into consideration the basic wisdom of working from the known into the unknown.

Wetting one 3-inch (7.6-cm) square at a time, try the following experiments:

Into the first square, charge a single dark color and manipulate it so that it smoothly fills the square, becoming a flat wash, an application of wet, flowing, transparent color. Before it dries, charge into it a drop of crystal clear water and see if it creates a feathery, lighter backwash. If it doesn't, do an identical flat wash and allow less time for drying before trying another backwash.

Into the second freshly wet square, immediately charge two different colors by simply touching the tip of the brush to the wet surface. Allow the water to do the rest and watch the magic occur.

In a third square try a rainbow. Place red, yellow, green, blue, and violet in streaks, allowing sufficient space between them for the water to blend them together. To appreciate the importance of the amount of water to achieve desired effects, try to charge pigment into other squares that are less wet and see the difference in the behavior of the pigment.

Speedy Tilted Washes

Washes may also be applied to dry paper, another classical watercolor technique. This method requires a tilted board so that gravity aids the flow of pigment. You must mix enough color beforehand so that you do not have to stop to replenish it. When you are working on a dry surface, speed is essential to avoid streaking.

For a flat wash, load a brush with premixed liquidy pigment. Starting at the top of the paper, stroke horizontally. Leave a generous bead or puddle at the bottom of each stroke to keep the edge wet while you redip the brush into the premixed pigment. With each stroke, overlap half the previous stroke, allowing the bead to reform at the bottom of each stroke. Redip and repeat until the area is filled. With one hand, dry the brush, using the top flat surface of a roll of toilet paper, and use the brush to pick up the excess bead at the bottom. This wash should dry perfectly flat, free of streaks. If it doesn't, try again, selecting another, perhaps more workable, color and using more juice; make sure the board is slanted sufficiently and each stroke overlaps the one above it. Compare this flat wash to the one done with the wet-in-wet method.

For a graduated wash, proceed in exactly the same way as for a flat wash, on a tilted board, overlapping horizontal strokes and allowing the formation of a generous bead at the bottom. The difference is that you gradually add clear water instead of premixed pigment as you move from top to bottom. The water creates, as the term implies, a gradual transition from dark to light. Each additional horizontal stroke makes the color lighter, more transparent, until the water is perfectly clear.

Make the first three horizontal strokes by dipping into the same premixed pigment. For the fourth and succeeding strokes, dip the brush into clean water

Rainbow Wet-in-Wet
Premoisten and mix a red, an orange, a yellow, a green, a blue, and a violet. Wet a 3-inch (7.6 cm) square of watercolor paper and into a wet arc, with a number 5 brush, make single stroke stripes of each color in the order above. As the water causes them to blend, in-between colors are created.

A flat tilted wash on dry paper.

A graduated wash.

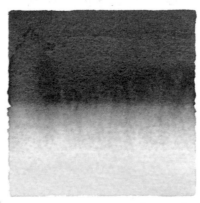

A backwash created by doing a dark flat wash, then turning the paper upside down and doing a pale flat wash up to and touching the already set, but not dry, dark wash.

23

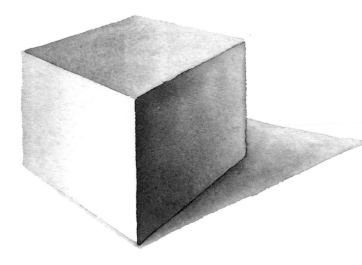

without shaking out the pigment already in the brush. If, out of habit, the brush is accidentally washed free of pigment, the wash will change value too suddenly. For the last two strokes, however, wash the brush free of color and dip the brush into a container of clean water. The results will be an evenly graduated progression from dark to almost white.

Then dry the brush and pick up the excess bead of water at the bottom. You may find as you near the bottom that reducing the tilt of the board helps keep the richer color at the top of the paper. You can also roll the toilet paper along the bottom edge of the watercolor paper. Imagine how convincing this method is for executing a sky, a field, or any flat plane on which the light gradually changes.

A graduated wash can also be made to appear to move from side to side. Simply turn the board so that each stroke can be made horizontally from top to bottom.

Drawing with Water

Drawing with water is not a classical method. I developed it in my efforts to achieve smooth modeling for tight illustrations using concentrated watercolor, which is more difficult than pigment to control because of its dyeing properties. Once down, it stays. Drawing with water makes the dyes easier to control. It is less necessary with pigment, but it has the virtue of leaving the paper much fresher, directly watery, and more vital than does blotting to achieve transparency and vignetted edges.

With a soft pencil, define the area to receive color. Load a round brush with clean, clear water that is kept in a separate container. Draw with this water precisely over the pencil lines, leaving a generous bead so that no portion of the line dries before the section is painted. In other words, surround the area to be painted with an outline of water, but keep the area dry. Immediately stroke color from the center up to the edges of the wet bead and allow it to bleed into the water. As with the wet-in-wet technique, holding the board flat should allow the color to travel no farther than the outer edge of the water bead. The value of the center of the shape may be quite dark, but the watered edges will be soft and lighter. As in the graduated wash, you may immediately add additional clean water to an edge to soften it out to a clean white, or you may pick up the excess bead and immediately blot that edge to assure a soft vignette. With careful planning, you need not go into this area again, but

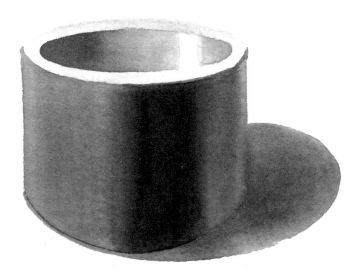

The cube was created with three graduated washes. The contrast appears most dramatic at the edge where two sides meet.

Create the cylinder by drawing two vertical lines of water at both edges of the dark core shadow. Apply the core shadow directly on the dry paper, working it up to the beads of water. When the pigment touches the water it will lighten and soften. Then add more water to both sides to make the change from dark to light gradual.

*When drawing with water, make sure
that all letters and marks made with
water connect with one another. Touch
the water with pigment on the tip of
your brush without manipulation.*

To do an outwash, begin by painting a tree. After the tree is painted but still wet, apply water from the outside in, up to and meeting the wet tree. Some of the tree pigment will flow outward into the shape created with the water.

Next paint an imaginary landscape leaving some things the white of the paper, possibly a church, stars, or a cow. Place water only where you intend to have color, one area at a time, and charge more than one color into each wet area. The pigment will not move beyond the pre-wet area if your surface is not tilted.

once it is dry, any number of over-washes can be done in the same "drawing with water" manner to all or to part of this area, especially to describe details.

A useful variation of this method is to describe with the bead of clean water only one or two edges of a dark shape as the core shadow of the cylinder. The watered edges become soft and diffused while the others become sharp and crisp all in a single step. One advantage is speed, but most important is that the paper and painting remain fresh.

Another variation is literally to draw with the bead of clear water to achieve a linear quality. Holding the board flat, load a round brush with clean water, then write your initials without picking up your brush so that the letters flow into one another. Be sure to leave a generous wet bead. If the beginning starts to dry before you have finished, simply touch the tip of your brush loaded with water on those drying portions and charge in more water without changing the original strokes. Then, immediately dip the dried brush into moist color and touch the upper portions of the initials, letting it bleed.

Next, dip into another color, touching the tip of the brush into the lower portion of the bead. Then try writing your whole name in connecting script. Subsequently use as many colors as you desire. The results are more effective when portions of the word are allowed to remain free of pigment. The clean, clear water itself changes the paper so the word is completely readable and the look more magical. Colors can be placed in a rainbow fashion so that they run pleasingly into one another. This method is effective for borders, flowers, and anything requiring a direct linear feeling.

These methods—wet-in-wet, washes, and drawing with water—can be used in combination within a single painting. With practice you can adapt these methods for individual styles and goals. The most difficult part, in the midst of the excitement of painting, is for you to remember to put down water prior to pigment. Take heart; it does become habit.

Retouching Techniques

After you have laid down a color, there are a number of ways that you can retouch it. You can blot wet color or lighten dry color by scrubbing, bleaching, or scraping.

Since concentrated watercolors are almost impossible to lift or scrub after they are dry, it is best to blot

them immediately. Several blotted, thin over-washes are preferable to one heavy wash, since dyes retain their transparency more than pigments do. Because all the color is not removed but only lightens and softens, the entire shape can be blotted. For this purpose, use a roll of toilet paper. Be sure it is smooth and texture-free. Use the paper on the roll. For a firm, continuous blotter that does not leave unwanted edges, place the first sheet flat on the watercolor paper so that it unwinds freely without stopping.

To blot pigment color, the same rolling motion works well along the edges of shapes to vignette the edges out to white. Used over the entire painted shape, however, it lifts almost all the color. On the roll, the toilet paper can be used for spot or area lightening and as a drawing tool to reinforce an edge. Of course, sheets can also be torn off to be crumpled and used as one would facial tissue. It is also helpful to wrap a sheet around the edge of a postcard or matchbook cover to blot a thin sharp edge.

In spite of slow, careful working and a tendency to understatement, some areas, edges, and highlights may require adjustment after a painting is dry. It is best to make these changes in smaller areas.

The best way to lighten larger areas of pigment is to lift it off the paper by scrubbing. Apply water to the area and, while wet, use your stiff bristle brush or the brush end of a typewriter eraser gently to loosen the color; blot it with the roll of toilet paper. Repeated applications of water and scrubbing may be necessary. While it is tempting to resort to opaque white for tiny areas, it is not recommended. In larger areas, the resultant haphazard opacity does not work next to the gleaming transparency of the rest of the painting.

Bleaching, rather than scrubbing, works with dyes. Scrubbing does not lighten concentrated colors because there is no sediment to scrub off and because the dye sinks completely into the paper and tints it. Bleach does not work with watercolor.

In an opaque plastic jar that has a tight-fitting cover, mix half liquid household bleach with half water. The mixture can be strengthened as needed, but in such a container it can be kept and reused without weakening. Always use a synthetic rather than a sable brush for this process.

Prepare the area to be lightened just as you would for applying color. Imagine the bleach mixture is color and describe the area either by drawing around it with clean water or by filling it with water as in the wet-in-wet technique. Dip the brush into the bleach mixture, and, with the tip, touch or charge the area. Wait some moments, watching it lighten, then roll the toilet paper over it to blot. You may need to repeat the application several times.

An intense highlight or sparkle may require a stronger solution, perhaps even a 100 percent bleach solution. Be warned; it is better to apply bleach repeatedly to lighten the area slowly to the desired value. Working fresh colors over the bleached area rarely works. Bleach changes the texture of the paper and yellows color applied over it. If the area is not repeatedly washed with clean water after bleaching, the fresh color applied to it also bleaches out. Change water before any additional painting; the small amount of bleach in the water affects newly applied color as well.

Scraping is useful to obtain white highlights or edges after everything is absolutely dry. Use a sharp, single-edge razor blade or a blade with a holder. Far more effective than areas painted with opaque white, scraped areas look like fresh paper and do not show at all in reproduction. To be certain that there is no visible change in the surface texture on a larger area, gently sand the area and then rub the white plastic eraser over it. Magically, marks disappear leaving seemingly untouched paper. You cannot, however, apply color over this area because the altered surface accepts color differently from unaltered paper.

3

Light and Perception

Watercolor is used for illustration in many diverse ways. No other medium seems better suited to express visually spontaneity, joy, sensitivity, and a captured moment. To communicate narrative and mood, however, clarity and conviction are necessary. Therefore, the illustrator must be able to portray a subject realistically, although that is not the only means of visual communication. Watercolor is especially well suited to conveying form convincingly, depending even more than other media do on the awareness of light.

Watercolor is about light and the translucency of white paper through color. Light, or its behavior as it falls on form, tells all about the form. To portray form, you must first perceive it. After you have seen it, you can easily draw it. Realistic painting relies on the perception of light and shadow on three-dimensional objects even more than it relies on perception of proportion and contour. We paint not what is but rather what we perceive.

Observing the Behavior of Light

Light, the quality best expressed by the watercolor medium, is the single most important factor in achieving the illusion of dimension and reality. Light is defined as "something that makes things visible or affords illumination." Perception of color depends on light.

Imagine that there is no light. Your eyes experience nothingness. Without light, there is no visual sense of dimension. The only means of perceiving objects or obstacles is touch or, perhaps, sound bouncing off something solid. Remember that night you awakened in a dark room thankful for the weak light from a street lamp or from the moon? It was enough to catch the

Convincing form depends more on the perception of light and shadow than it does upon correct proportion or contour. This study of a model was done during class with dyes on Arches paper.

29

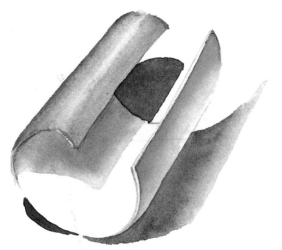

Gradual change on rounded forms.

Dramatic changes of sharp edges.

Multiple edges.

The behavior of the light communicates the nature of the form.

edges of forms, indicating where to avoid collision. The behavior of the light wave from the street light told you all you needed to know about the location, distance from you, and relative size of any obstacles in your path. There was no need to touch or grope. The way the light traveled also told you how sharp, how round, how textured, how soft, and how hard forms were. Rarely is anyone fooled by the light. This knowledge is a combination of lifelong experience that is tactile and simultaneously visual. It is universal knowledge among the sighted. Therefore it is the artist's tool, the means of communicating space and dimension convincingly.

The problem is to convey the illusion of three-dimensional space on a two-dimensional surface. The solution is to paint the particular way the light travels across those three-dimensional forms. Observe on each form the quality of the light's behavior: the way the light gradually or suddenly becomes shadow, the shadow the object casts, and the reflected light.

Light to Shadow

When light bathes an object from one side, there is a point at which the light stops and becomes shadow. How gradual or abrupt the transition is tells how round or sharp the form is. When light is cast on a round form, such as a ball or a bowl, the transition from light to shadow is gentle, gradual. The darkest portion of the shadow, called the core shadow, is found nearest the brightest light and away from the edge, or contour, of the form. When light is cast on a sharp form, such as a box, an abrupt change from light to shadow says there is an edge. Here, the darkest dark is at the edge of the whitest white. The way light ceases to travel and shadow takes over the form is what we call the passage from light to shadow. It is the most essential behavior of light to observe.

Cast Shadow

Cast shadow is more obvious; the shape, already closer to a two-dimensional form, is easier to observe precisely. It says that the object is blocking the path of light, convincing proof that the object exists in space. The size of the cast shadow tells about the mass of the object and its proximity to the light source. The density, or relative darkness, of the shadow also indicates how opaque or transparent the object is. A longer cast shadow be-

speaks a low light source such as a sunrise or a sunset. Conversely, a short cast shadow implies that the sun is high in the sky. Cast shadow is useful in conjunction with the light and shadow transition on the form; alone, it conveys the illusion of a thin cardboard cutout blocking the flow of light.

Reflected Light

Reflected light is found within the shadow portion of the object. It is the light that manages to travel around the dark edge of the form or is reflected off another surface. Reflected light is not light in value, just lighter than the darkest portion of the form. This subtlety is necessary. Without it, or with too much darkness at the edge, the form appears flat. Initial attempts to paint reflected light, however, often result in too strong a treatment, causing the reflection to become confused with the main or lightest light and thus destroying the sense of unity or integrity of the form. Reflected light, therefore, should be subtly rendered and always compared in value to the lightest light. For a colored object, it is often better expressed by a warmer or cooler color rather than by a lighter value.

The Absence of Light

In a watercolor the white of the paper must be visible through the paint. If the white is not seen, the special quality of watercolor is lost; the object sits like a heavy blob in the middle of the paper. The light-bathed portions of forms are the perfect areas to leave white. Nothing can be lighter than the white of the paper. Transparent pigment is placed where the form is not receiving light, where the path of light is blocked, and where there is shadow. Observe accurately the shapes made by the light or the absence of light. Then transfer these shapes to the two-dimensional paper, drawing the contours and then the solid shapes of the darks.

Imagine your subject photographed and then projected on the two-dimensional surface. Actually using a projector, as many illustrators do, simplifies the transfer of three-dimensional forms to a two-dimensional surface. Photography, however, can be imprisoning. It is best to translate three-dimensional shadow shapes to two-dimensional shapes through your own perception. The following techniques aid the eyes, and with just a little practice, both drawing and painting become vastly improved.

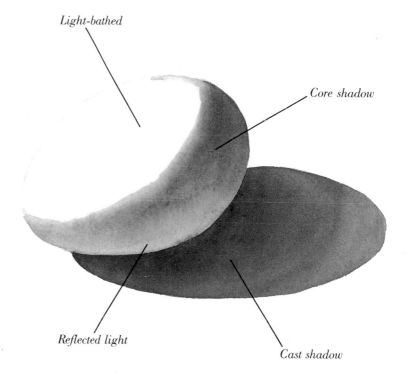

Light-bathed

Core shadow

Reflected light

Cast shadow

Miss America #7 is one of a series of cast paper forms that I painted and assemblaged. It was a difficult subject to photograph for reproduction because the camera has difficulty seeing three dimensions and painted details at the same time.

Seeing Contours and Shadow Shapes

The problem is how to distinguish the contours of the subject from the shapes of the shadows. These two different aspects of a subject become confusing when observed simultaneously.

Imagine, for example, a three-dimensional object that is painted on its surface, such as a doll, or perhaps a decorated dish, or a motorcycle. You are supposed to photograph it for a magazine article. The photo should show that the object is three-dimensional, not a painting. Some dramatic lighting is necessary to convey its volume in the photo by causing cast shadows. To highlight the painted detail on the object, however, requires more diffused, overall lighting, minimizing shadow. To solve this problem, the light and camera will compromise between these two types of seeing. Like eyes, however, the camera functions better when it focuses on one type or the other. Our eyes are the same, as will be experienced with your first painting of white forms. Select simple, opaque white forms, free of decoration, pattern, texture, reflection, or transparency.

One way to help you distinguish contours from shadow shapes is to use a mirror to concentrate on the contours. Many old masters are reputed to have painted from the subject's reflection in a mirror. A mirror, like a photograph, flattens what we see. It is easier to transfer the reflected image, already two dimensional, to a two-dimensional surface, maintaining the illusion of the third dimension. The transfer, or drawing, of the contours of a three-dimensional subject to a two-dimensional surface can also be made simpler by using one eye. If it takes two eyes to perceive distance, depth, the third dimension, why not use your stronger eye to flatten your perception?

To discover which is your stronger eye, cover one eye with the palm of your hand. Look with the other eye at a smaller white object some distance in front of a larger one. Note the position of the smaller relative to that of the larger, especially where their contours intersect or overlap. Then, without changing in the slightest the arrangement of the objects, cover the other eye. Again, observe well the relationship of the contour of one object to the other. You will notice two things. The first is that the relationship of the smaller object to the larger appears to shift with the shift in the eye. The left eye perceives the relationship differently from the right eye. Drawing with both eyes simultaneously leaves you vulnerable to this confusion.

Where is one contour in relation to the other? The other thing you will notice is that you rely on one of your eyes more often than on the other; it is your stronger eye.

A way to be certain which of your eyes is the stronger is to puncture a sheet of paper with a hole the diameter of a pencil. Hold the paper out at arms' length with locked elbows, far enough from your eyes so that the same two objects can be seen through the hole with both eyes. If necessary enlarge the hole. Then, close one eye and look with the other, then repeat with the other eye. Which eye alone still sees the two objects through the hole? That is the stronger, more used eye. Rely on this eye alone for drawing contours. Using just the stronger eye is also helpful for drawing convincing foreshortening and for drawing contours without the continual shift in object relationships. Though you might feel ridiculous, use masking tape to hold a piece of paper over your

weaker eye. You'll be impressed when you see the results of your efforts.

Another way to distinguish contours from shadow shapes is to squint both eyes to concentrate on the shadows. Squinting helps to eliminate unimportant information, texture, and even color. Contours are hardly discernible. All that can be seen are the shapes of light and shadow, easily translatable to two-dimensional shapes. Squinting also clarifies the grouping of the darks into dark and light patterns, and simplifies the variety of values.

By using your strong eye for seeing contours and squinting both eyes for seeing the behavior of light in making shadows, your perception for the drawing and painting process is already much improved. The painting of simple white forms may initially seem uninteresting, but it is an essential experience to build upon. You may discover, as I have, that they are among the most inspiring of subjects.

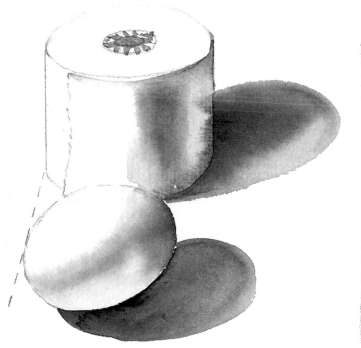
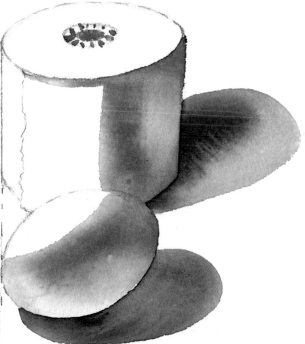

Contours of objects shift in relationship to one another, depending upon which eye is doing the seeing.

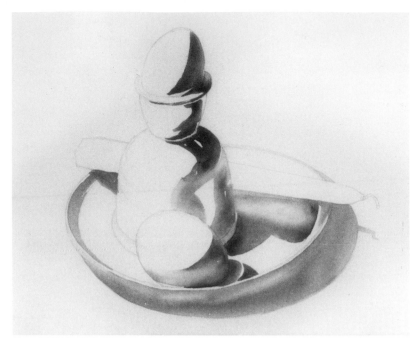

Simple solid white forms may initially seem to be dull subjects, but painting them is an essential experience to build upon.

Arrange three or four opaque white forms that interest you. Set up a single, strong artificial light source, manipulating the lamp until the shapes of the light and the shadows are clear and pleasing. Then draw their contours with a 2B pencil using only your strong eye to judge the overlapping of forms.

Next, by squinting, observe the shapes of the darkest shadows and draw their contours accurately on your contour drawing. Select a shadow shape that is not too large to stay wet. Load a large round brush with clean water and fill the inside of this shape generously with the water. Pay attention to the accuracy of the edges. Use more rather than less water. The wetter and more precise the shape of the water, the more convincing the form and more aqueous the painting.

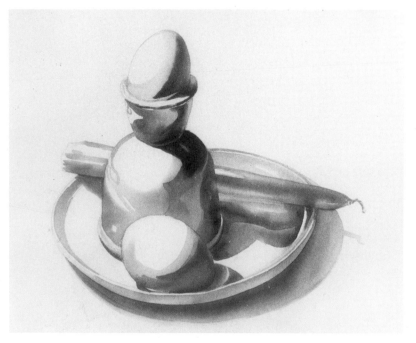

While the shape is soaking wet, charge in a pre-mixed medium value blue-gray (Payne's gray or indigo). Darker pigment can be charged into the very darkest portions of the shape while it remains wet. The magic of watercolor is enhanced by variation of value within a single shape. If an area seems to be drying too rapidly, charge in more water. If an area becomes too wet, roll your dried round brush into it to pick up the excess water without lifting pigment. Blotting lifts the pigment with the water and can leave a distinct texture.

Select another shadow area not adjacent to the first to avoid bleeding and seepage, and repeat the same process for each of the dark areas. A hairdryer can be used to speed up the drying time.

Pre-mix a lighter blue-gray value for the more subtle areas. Select an area not too large to remain wet and with a large, loaded brush place clean water over this lighter area and the already dried adjacent dark to avoid any unwanted edges. The already dried pigment will not move. While soaking wet, charge in the lighter tone.

It is your choice whether to charge in another layer of pigment over the darker portion to deepen it. Values do dry lighter than they appear while wet, but you do not want opaque watercolor. If an area becomes too dark while it's wet, charge in clean, clear water. As an area begins to dry and color runs less freely, charge in smaller areas of dark where emphasis is needed. Before areas dry, edges that are too sharp may be softened by adding clear water and blotting with toilet paper on its roll. If too sharp an edge is already dry, rewet it and loosen the pigment with a stiff typewriter eraser brush and then blot.

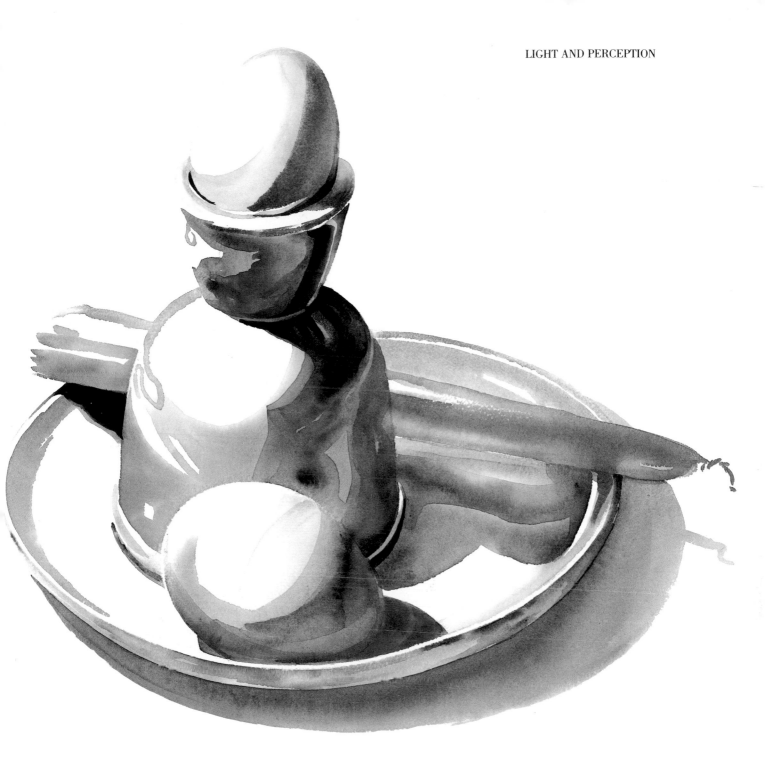

At the final stages it's helpful to view the painting through a reducing glass or from across a large room. When it's dry enough to prevent drips, the painting can be lifted to a mirror to view. The flopped image aids objectivity, as though you are the critic of someone else's painting. Any additions to darks can be made as long as water is applied again over the entire shape prior to charging in any pigment.

After the painting is thoroughly dry, erase all unnecessary pencil lines. Even white forms on white paper do not need a background to define the contours. Note that it is not the contours that are crucial to conveying form. The loss of edges is actually how we see. After erasing, I used a single-edge razor blade to clean up the right-hand edge of the cast shadow.

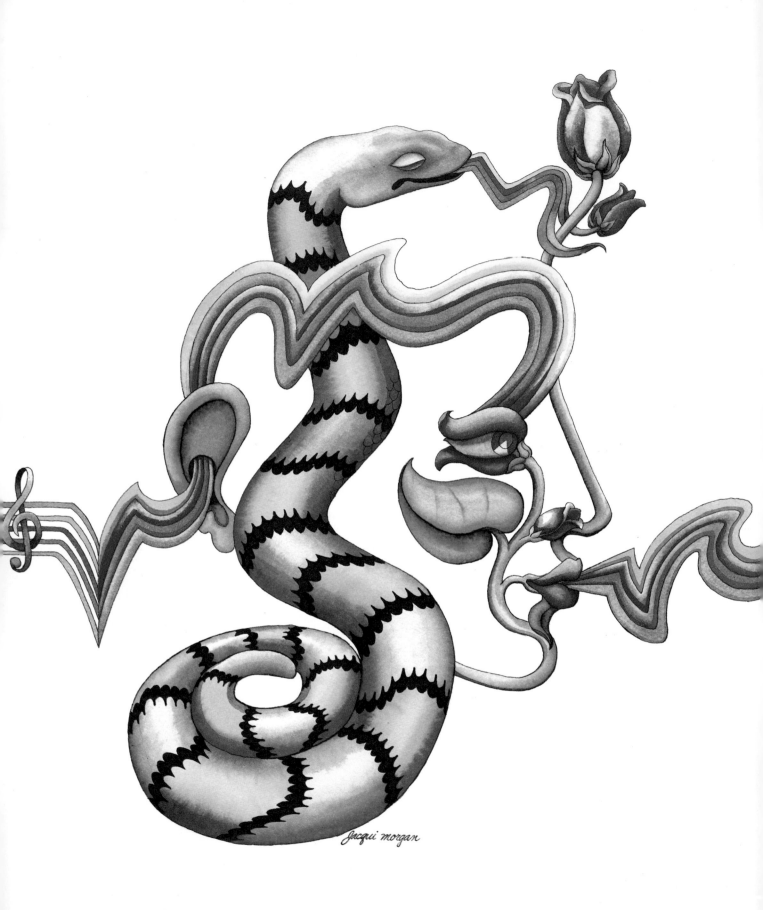

Jacqui morgan

4

Local Color and Shadow Color

Snake Charmer *is done with Luma dyes and india ink on Arches paper. It was originally painted for a Sidewinders album for RCA, but was not published.*

The number of illustrators who avoid using color or use it minimally always amazes me. Perhaps color theory could do more to help us use color to create the illusions we desire in our own work. Perhaps color theory is presented in too complex or scientific a manner, as though it were a complete art unto itself. More likely, not enough of us take the time to observe the color around us and to experiment.

I lay the major blame on the child's first experience with color in kindergarten. He or she is handed a green crayon and told to draw grass; grass is green. And here is a blue crayon; the sky is blue. Yes, children do need to learn the names of colors, but more important they need to be encouraged to look at the world for themselves. At the age of four or five a child knows so little that if someone says that grass is green the child happily accepts the information without disputing it. It's a pity, because that child might not really perceive the grass as green. Is it green in the shadow? Is it green in the distance? Is it green at night?

To make color serve our picture-making needs, we don't need a complex theory, only a few serviceable facts. Our eyes, encouraged to see, do the rest.

Color is an aspect of magical illusion entirely separate from light and shadow; it is a flickering jewel conveying mood and emotion. Do you remember playing as a child with crayons or colored pencils, changing their order, experimenting with the way they flow from one to the other, or grabbing your favorite in a visceral urge? Color has a mysterious power over our physical sense of well-being and our perception. Perhaps light rays bounce off a particular hue in a strength or rhythm that matches our metabolism,

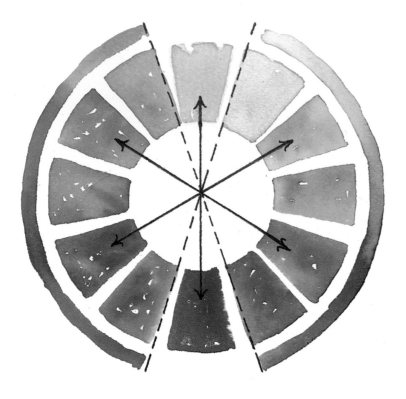

The Color Wheel

The primaries—red, yellow, and blue—each have their complementary color directly opposite on the color wheel. The complementary color is the mixture of the remaining two primaries. (The complement of blue, for example, is orange, the mixture of red and yellow.) The mixture of two primaries creates the secondaries— orange, green, and violet. Most useful for the painter are the two outer bands. On the band on the right of the wheel, the range from yellow-green through blue-violet, are the cool colors. On the band on the left, which ranges from yellow-orange through red-violet, are the warm colors. Basically, any color that has more blue than red in it is a cool color and any color with more red than blue in it is warm. Yellow and violet are considered neutral in terms of temperature perception.

causing that color to be preferred. Certainly our perception of color is affected by Earth's atmosphere and by adjacent colors.

Cool Shadow Color

You can observe the effect of one color on another in the painting of pure white forms. The use of bluish-gray for shadows, instead of a neutral gray, causes the neutral white to take on the qualities of a warmer color; it appears to move forward, closer to the viewer. Observe the white areas inside a form, especially portions closest to the bluish tone; they appear rounder. The bluish tone causes the white paper to increase the illusion of volume and space, even though color is used so minimally.

Observe an object on a white surface. The color of the cast shadow in reality is a cool color: bluish, purplish, or greenish. Ninety-five percent of the time shadows are a cool color. Shadow color relates to the source of light, not to the color of the object. Shadows are the complement of the light source; that is, they are the color opposite the color of the light source on the color wheel. Indoor incandescent lamps, for example, give off a golden or an orange-yellow light. Its complement is blue. The complement of yellow is violet. Daylight, a somewhat cooler color, also produces a bluish-violet shadow.

Note the cast shadows the next time you are in a delicatessen. If some of the ceiling lights are pink or reddish, to make the meat appear more red and appetizing, the cast shadow, its complement, is green. If the green shadow falls on the tomatoes, the results can be unappetizing. Color is an aid to conveying three-dimensional form on a two-dimensional surface. If ignored, it can work against the illusion you want to convey.

Cool Colors

The entire magic of advancing and receding color is within your grasp when you understand cool and warm colors. Anything with a predominance of blue is a cool color. On the color wheel those colors analogous, or adjacent, to blue are cool. They include blue-green, green, blue-violet, and all the grayed versions of these. Any color containing more blue than red is a cool color. It may be helpful to remember that the ocean, bluish-green, is never hot but cool and refreshing.

Cool colors seem to recede from the picture plane, perhaps because this planet has a blue sky. Observe

color photos and the countryside during your next outing; as fields and mountains recede into the distance, they take on an increasingly blue cast. As a result of this experience, we are conditioned to assume that if something appears bluer or cooler, it must be farther away from us. Applying this principle to a painting, we usually treat the forms or shapes we wish to recede or be less important with cool color. Shadows fall into this category of recessive or unimportant forms because they are not usually the subject but simply a foil for the subject.

In a painting of white objects, the use of cool shadow color gives the illusion that the neutral white paper, nearest the cool shadows, is, by contrast, relatively warmer, therefore more dimensional and closer to the viewer. To state it another way, the white forms that are given a cool shadow take on the appearance of a warm color perhaps because our eyes seek the opposite to find balance. Cool colors also make warm colors appear even warmer and more intensely rich by contrast

Warm Colors

Warm colors are those analogous or adjacent to red on the color wheel. A warm color is any color containing more red than blue—orange, rust, brown, red-violet, and yellows that have a reddish cast. Some color theories consider yellow a warm color; others consider yellow a neutral, as many do the color violet. It's clearest to think of both yellow and violet in terms of whether they contain more red (and are therefore warm), or more blue (and are therefore cool). Accordingly, red added to yellow gives it a warm, orange cast; blue gives yellow a cool, greenish cast.

As cool colors appear to recede, warm colors appear to advance toward the viewer. If they are intense, they can give the illusion of piercing the picture plane, leaping out at the viewer. It may be helpful to associate warm colors with "red hot" and fire. Gazing at the same landscape of trees, fields, and mountains that you observed before, notice the portion of field nearer to you; it gradually becomes less blue, more green, then golden, and orangey the closer it comes to you. Similarly, an intense orange-colored object becomes less intense as its distance from the picture plane increases, as though additional transparent curtains of blue atmosphere are dropped between it and the viewer.

A word of caution: a cool color, meant to recede, is

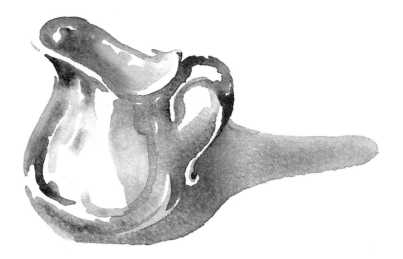

The white pitcher has the illusion of more roundness because of its cool shadow treatment. Neutral black or gray would make it appear flatter.

The suggestion of a landscape demonstrates our perception that cools recede into the distance and warms approach the frontal plane.

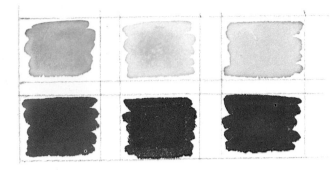

The neutrals yellow and violet, top, are made warmer by the addition of red to the left, and cooler by the addition of blue to the right.

On top, the warm is, as expected, a more intense color than the adjacent cool. Beneath, the warm is less intense than its adjacent cool creating a color reversal, that is, the cool moves closer to the picture plane.

expected to be less chromatic, less intense than the nearby warm color. If the cool color is a raw, intense turquoise blue, for example, and the warm color is pale, perhaps a subtle brown, the expected effect will not occur. The result is called a color reversal. It can cause discomfort and tension simply because we expect the blue to recede, not advance, and here its intensity causes it to appear closer to the picture plane. While this phenomenon can be used to advantage, generally cool shade or shadow tones are best kept low in intensity or grayed.

Colors are clearly perceived as warmer or cooler in relationship to one another. It is this relationship that painters, illustrators, designers, and photographers work with constantly. For example, red-violet, containing more red, is warmer than blue-violet, but cooler than red because it contains more blue. The variations are almost infinite, important even when subtle and highly visible even in hues of gray. Many painters, from Vermeer to Otto Dix, have used an awareness of perception of warm and cool to make one shoulder of a person appear to advance by painting it in a warmer color.

Obviously, labeling colors according to temperature is not an exact science, but it is less important to label a color than it is to know how to make it warmer or cooler to enhance a mood and especially to manipulate spatial illusions.

Color Terms and Guidelines

The perception of color is as universal as the reading of form through the way light behaves around it. There are, however, a few precise terms that ensure understanding, as well as working guidelines that unveil much of the mystery of using color.

Local color is the color of the subject of a painting, as for example, a lemon is yellow; a lettuce, green; a cherry, red. To paint the subject only in its local color, however, results in a decorative, unrealistic, even cartoonlike two-dimensional image. To create the illusion of real, three-dimensional space, you must use other colors as well. If you use black or gray to express the absence of light, you will have a muddiness that distorts the effect of darkness on the local color. As you have already seen in the painting of white forms, using a cool color for the absence of light enhances the illusion of the volume of the objects and of reality.

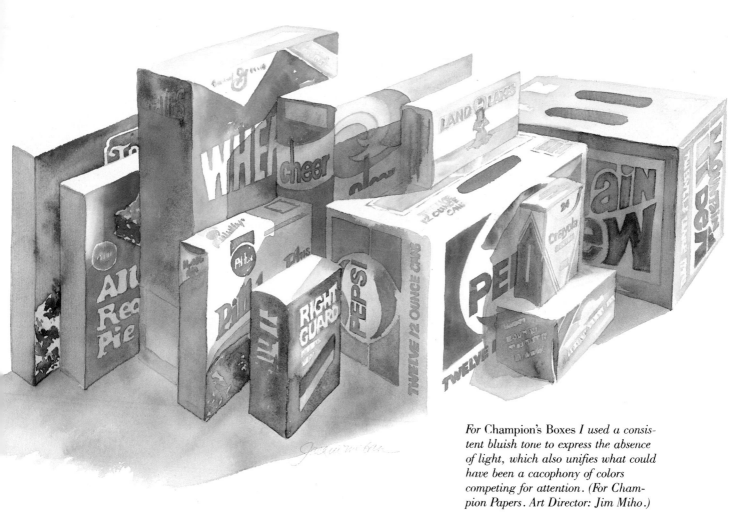

For Champion's Boxes *I used a consistent bluish tone to express the absence of light, which also unifies what could have been a cacophony of colors competing for attention. (For Champion Papers. Art Director: Jim Miho.)*

The addition of blue to a local color creates a convincing shadow color. For example, to portray a yellow lemon, use a mixture of yellow and blue, actually green, for its shadow. To paint a red cherry, make its shadow red plus blue, giving violet. The advantage of this approach to shadow is that you avoid any muddiness of color. By allowing the cool analogous shadow to bleed into the local color, you assure a smooth, colorful blend that evokes form and is spatially convincing.

Another way to handle color to express form is to use a bluish tone for shade and cast shadow throughout the entire composition, regardless of local color. This provides spatial illusion and, at the same time, a means of unifying the entire composition. It is the basic treatment in the painting of pure white forms and is consistent in theory with the use of a cool analogous color. As in that painting, lay in all the darks in one step. When they are dry, paint over a second layer using variations of each local color. This approach is particularly successful when used with dyes because their complete transparency prevents problems of overworking or heaviness. Once dry, dyes are almost impossible to lift, so there is no muddiness

caused by the first layer mixing with the second. If you try to layer pigments, which do lift, too many layers can easily become opaque and murky.

Painting darks with the complementary color, opposite the color of object on the color wheel, has the advantage of appearing to intensify the local color. Violet, for example, intensifies yellow, blue intensifies orange, and green intensifies red. This approach seems to work best when the local color is a warm hue and the complementary shadow is a cool hue because we expect the shadow color to recede. Actually, a cool-colored object, such as a blueberry, may work with a subdued orange shadow, such as a rusty brown; a violet eggplant could work with a subdued yellow shadow, a golden brown. Problematic, but not impossible, is a situation when a warm shadow complement is chromatically more intense than the cool local color. With this method of using complementary colors there is no layering, because mixed complements create gray or dirty brown. They are best put down at the same time, but with some care to avoid too much bleeding into one another. This method is effective with both pigment colors and dyes.

The addition of blue to the local color of the watermelon or its analogous cool is a way to say shadow without making mud. It is also the truth. (Dyes on Arches paper.)

The orange color of the canteloupe is intensified by using its complement, blue, for the cast shadow. Inside the melon, blue would have made mud, so the analogous cool, violet, expresses the shadows and keeps the warm appetizing feeling. (Dyes on Arches paper with Clorox to bleach out the veiny moisture lines made with colored pencil in the cast shadow.)

In the study in yellow-greens, left, I experimented with a warm, almost complementary cast shadow to see if it would intensify the greens. When a warm cast shadow is so intense, it can be a problem, competing with the subject of the painting. (Watercolor on Arches paper.)

The green study right works better because the shadows are less chromatic. (Watercolor on Arches paper.)

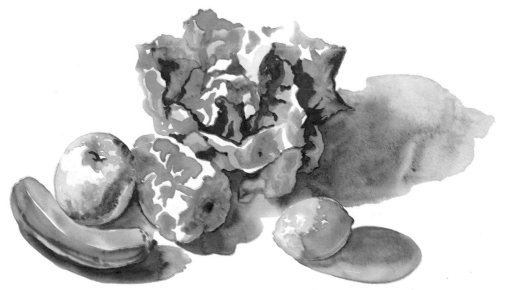

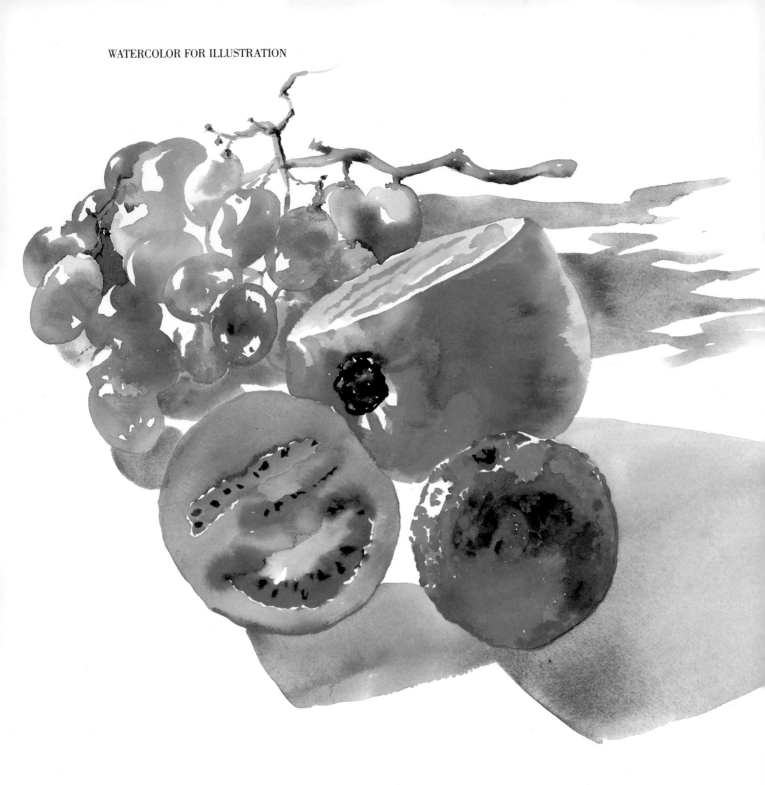

Within the grapes and tomatoes several analogous colors are used, making the color seem brighter. The cast shadows are also treated with the analogous cool blending with a reflection of the local color. (Watercolor on Arches paper.)

Although the complementary color for cast shadow intensifies the local color, if it is used to describe the darks within the form, it can too easily become muddy. Try then to use the complement for the cast shadow and the cool analogous color for the form in shadow. This combination approach results in the most brilliantly colorful solution.

Visualize a red strawberry with its complement, a green cast shadow. Now, instead of employing green for the core shadow, use its analogous color, a violet. The cool analogous color works well for all objects in a relatively warm local color, but what about an object in a blue local color, such as a blueberry? Because the shadow is best treated as a receding foil to the blueberry, try leaving all shadows blue and use colors analogous to blue in the fruit itself, such as violet or turquoise, to make it rounder and more brilliant.

Easily observed in the works of the Impressionists is the use of analogous colors to intensify the brilliance of the hues. When red is to be conveyed, use orange, red, and red-violet; the result is a richer red. The multiple analogous-color approach compensates for the diminished intensity of transparent watercolor; it also ends up being closer to reality since nature does not paint anything in one flat color.

The approach you choose depends not only upon personal taste but also on your goals, including intensity of color, setting a mood, creating sparkle, or color experimentation.

Selecting a Palette of Pigment Colors

A palette, used with tube paints, is usually preferred to pan pigment for studio work because of the availability and selection of tubes. And, since the paint is already soft, your brushes receive less punishment.

The ideal selection of colors for your palette enables you to create any color by mixing basic starter colors. The fewer colors you choose, the simpler it will be to familiarize yourself with all mixing possibilities and reach the desired hue with ease and speed. Theoretically, all you need is a warmer and a cooler version of each primary color—red, yellow, and blue. You may also have a cool and a warm neutral. The total then equals eight colors. Be aware, however, that the secondary colors—orange, green, and violet—arrived at by mixing, are not as intense as those bought in tubes. Also, because ideally watercolor is used transparently, watered down, the more

The strawberry combines two treatments, an analogous cool for the darks within the berry and the complementary, less intense green for the cast shadow to make the berry read redder. (Dyes with Clorox on Arches paper.)

The local color of the peach ranges from yellow to orange to red. The analogous cool, violet, was used for the darks and the cast shadow, except where green was used to express the yellow in shadow. (Dyes with colored pencil on Arches paper.)

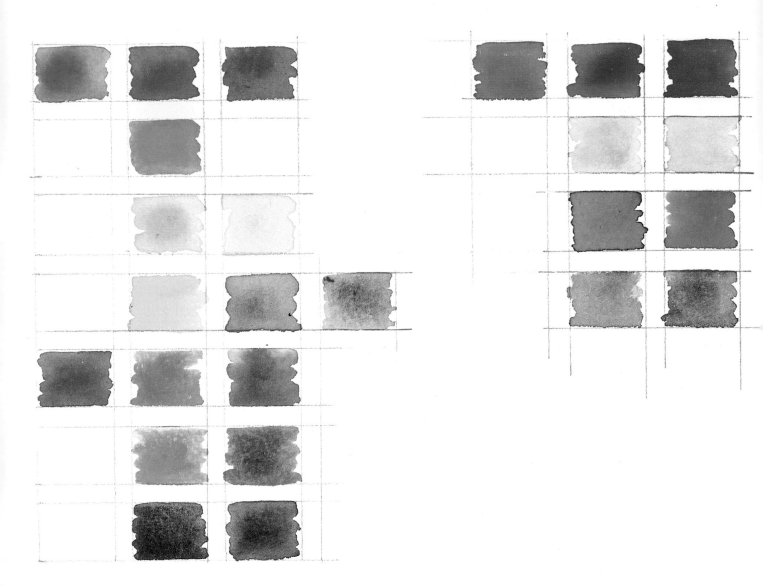

The more extensive palette on the left is pigment watercolor for which it's recommended that you buy the secondary colors. The dyes palette on the right requires only a warm and cool version of each of the primary colors and neutrals.

intense the initial hues, the clearer and brighter the painting. Therefore the purchase of secondary colors is recommended.

The following example is a satisfying palette:

	warmer	cooler
Red:	scarlet lake or vermilion and cadmium red deep, permanent red, or Winsor red	alizarin crimson, permanent magenta, or permanent rose
Orange:	permanent yellow-orange	
Yellow:	chrome yellow deep or new gamboge	lemon or Winsor yellow
Green:	chrome green light or permanent green no. 1	Winsor green or viridian green tint
Blue:	Winsor blue, cobalt blue, or ultramarine	phthalo blue, manganese blue, or peacock blue
Violet:	cobalt violet or opera or mineral violet	Winsor violet or permanent violet
Neutral:	lamp black	Payne's gray or indigo

Fourteen colors would be too many for any other paint medium and is unnecessary for concentrated watercolor. I find that extra browns or neutrals, though beautiful, are an unnecessary expense. And they are more interesting if they are mixed. If you use great quantities of a particular brown or neutral, however, you may decide to buy it to avoid so much mixing and possibly waste of more expensive colors. Our workshop in Tuscany required burnt sienna, and the one in Vermont, sap green and Hooker's green.

For pigment watercolors, permanence, intensity, and transparency are considerations. Better manufacturers have charts available at retail stores showing colors graded according to permanency. All watercolors fade when exposed to direct sunlight, although not necessarily to reflected or indirect sunlight. In

These studies of Il Duomo in Florence range from the minimal essence to the more detailed. The roofs of Tuscany were easier to paint with burnt sienna, vermilion, and scarlet lake or brown madder.

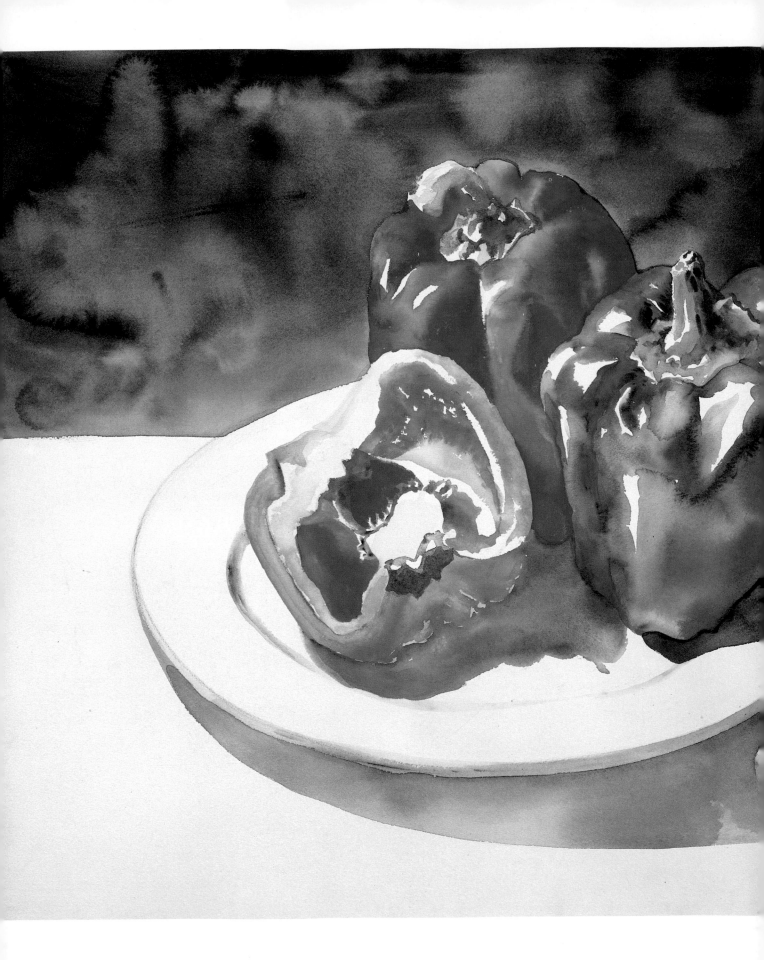

48

fact, all paint media fade under those conditions, but media with more sediment are slower to do so. Since the most permanent colors are not necessarily the more expensive, why not give your work greater longevity by choosing more permanent pigments?

Some colors at richest intensity tend to be overpoweringly opaque and require blotting to weigh in with other colors. All colors preceded by cadmium—cadmium yellow, cadmium orange, and cadmium red—fall into this category. It can be preferable to substitute such similar colors as Naples yellow, new gamboge, vermilion, scarlet lake, or permanent red.

Selecting a Palette of Concentrated Colors

After achieving some expertise with pigment colors, you can try concentrated colors, or dyes.

Dyes are truly intense, often too intense. You can modify them to create any desired color by selecting basic colors on the same theory as for tube colors: choose a warm and cool of each primary and a warm and cool neutral. The following are recommended:

	warmer	cooler
Red:	tangerine or flame red	rose Tyrian or pansy
Yellow:	daffodil yellow	lemon yellow
Blue:	juniper green	true blue
Neutral:	sepia	black

For the peppers I worked freely, avoiding any layering and using the cool analogous of each of the local colors. In the cast shadows I tried to capture the sense of the reflected local color.

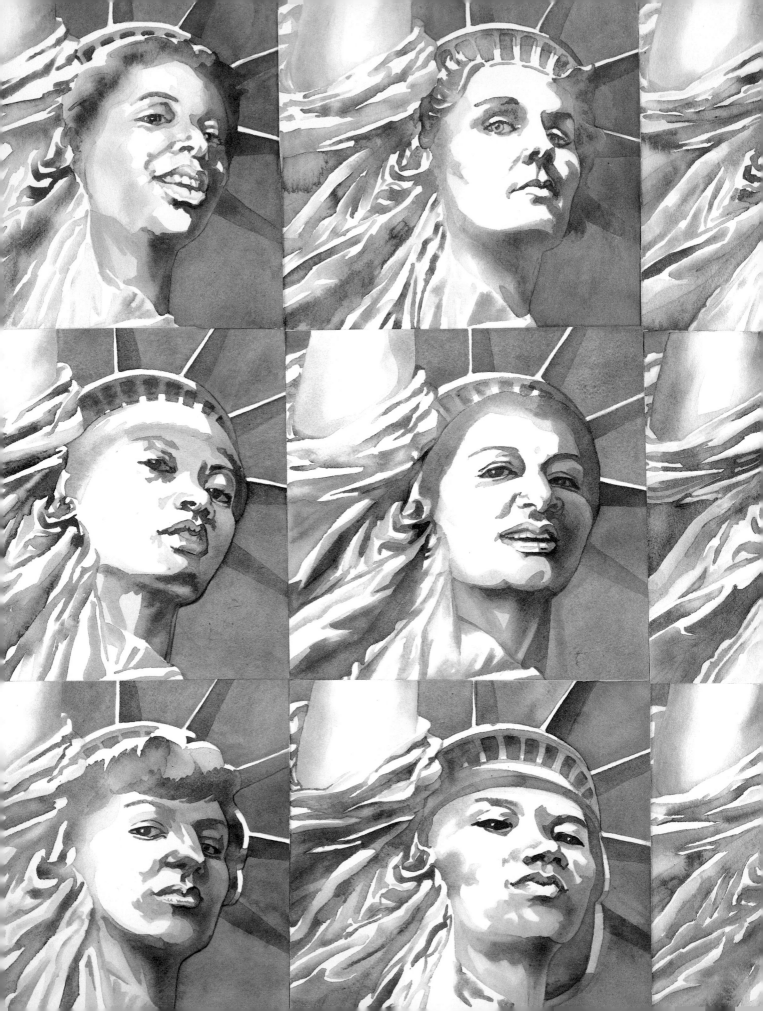

5

Flesh Tones and the Figure

During workshops, as participants are confronted with an inspiring model and are impatient to paint, they frequently ask what colors to choose to arrive at a convincing flesh tone. They also ask about achieving a likeness, especially an accurate depiction of the colors of the skin and hair.

A person's skin certainly has more subtle color than fruit. Consequently, skin color is more dramatically changed by lighting. Convincing skin color depends more on the behavior of the light than it does on local color. The shapes of apples and lemons resemble other fruit shapes, so important identifying features are their rich local color. The unique form of the human body, however, has many distinguishing structural characteristics; local color is not a prominent recognition factor. Since a black-and-white drawing or photograph evokes recognition, how important is accurate local color? Think about it for a moment; is it not the accuracy of the form that is crucial?

When painting from a nude model during a workshop, you should begin with quick, single-color paintings of the shadows in a cool tone to clarify your perception of form and to familiarize yourself with the model. It is also an opportunity to exaggerate the gesture of the figure and the foreshortening without getting bogged down in details.

Single-Color Painting

For this initial figure painting, select a well-lit black-and-white photograph of a nude or work from a model. Arrange the lighting so that it best reveals the volume of forms and creates a clear contrast between light-bathed areas and those in deep

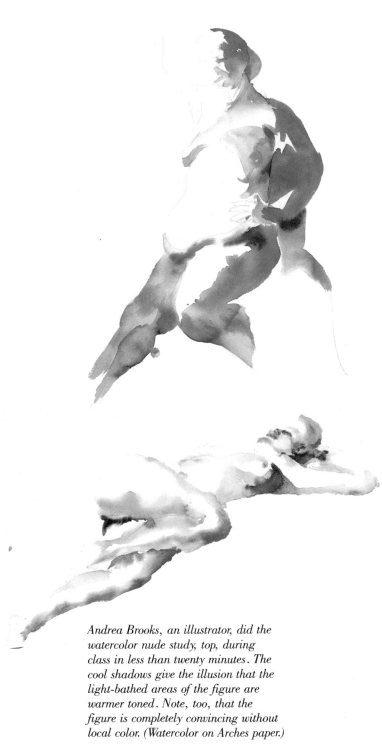

Andrea Brooks, an illustrator, did the watercolor nude study, top, during class in less than twenty minutes. The cool shadows give the illusion that the light-bathed areas of the figure are warmer toned. Note, too, that the figure is completely convincing without local color. (Watercolor on Arches paper.)

Francine Alheid, an architect, did the lower study in class from a model in thirty minutes using one warm and one cool color. Warm zones in shadow can be both warm and cool by layering the two or charging in both and letting them blend. (Watercolor on Arches paper.)

shadow. Before you start to work, make sure both light-bathed and shadow areas are visible from your point of view.

Begin with a gestural, skeletal drawing to increase the sense of direction and weight of the figure, since most people tend to understate a pose or to bring the figure back to a symmetrical, at-rest position. Then draw the contours of the figure, looking at it with your strong eye only. Maintain the emphasis on gesture and foreshortening and erase misleading lines. Squint your eyes to draw the shapes of the shadows. Ensure integrity of form by making the darks visually connect with one another. Within the shapes of the darks include anything that is not light-bathed. Remember how essential it is to use the white of the paper to express light-bathed areas. Shadow areas should be a cooler version of the local skin color, and the small amount of middle value is where the warmest skin color is placed. Look at the nude simply as another fruit, or as a pure white form.

Having completed your drawing, you are ready to paint. Mix a substantial amount of a cool color—a grayed blue, green, or blue-violet. Within manageable proportions, wet one or two dark shapes and immediately charge in the selected cool shadow color. As the darks vary from deep to middle tones, charge more and deeper pigment into the darkest areas. Avoid becoming opaque, but be sure the darkest darks are sufficiently strong to make the light-bathed areas shimmer with light. Watercolor appears darker while wet; however, should an area become too dark, clean water can be charged into it before it dries. The darks should weigh in with one another as well as connect for convincing integrity of form.

Pick up excess juice with the dried brush and tape the painting to a wall so you can look at it from some distance. To avoid dripping paint or impatient waiting for paint to dry, use a hair dryer plugged in in the studio area. You'll notice that, regardless of local color, the result of your work is convincing form in light and space. These exercises with shadow tend to be more successful than those concerned with rendering local color because the consistent value of shadows preserves integrity of form.

Next, try a painting using two or three cool colors to express only the shadow areas. Follow the same steps of wetting one or two shadow areas, then charging in almost simultaneously all three colors, allowing them to bleed into one another through the fluidity of the water alone. Break the habit of stroking on the paint.

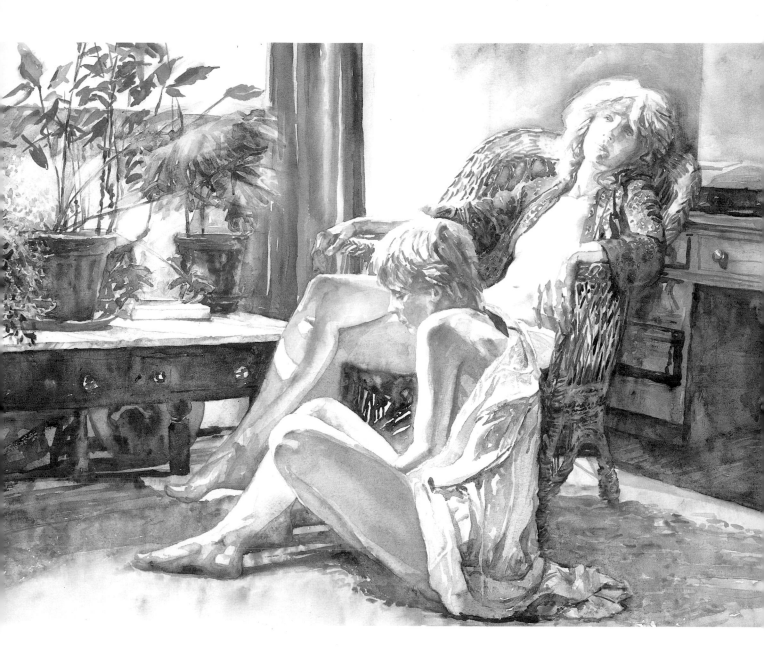

Brian Sanders, a British illustrator, did this painting for his own exhibition at the Association of Illustrators Gallery, London. For the nearer figure he used complementary green for the skin in shadow, while for the other figure he used analogous violets. Note the warm tones in the upper arms where the bone is near the surface of the skin. (Watercolor on rough 1950 Whatman paper.)

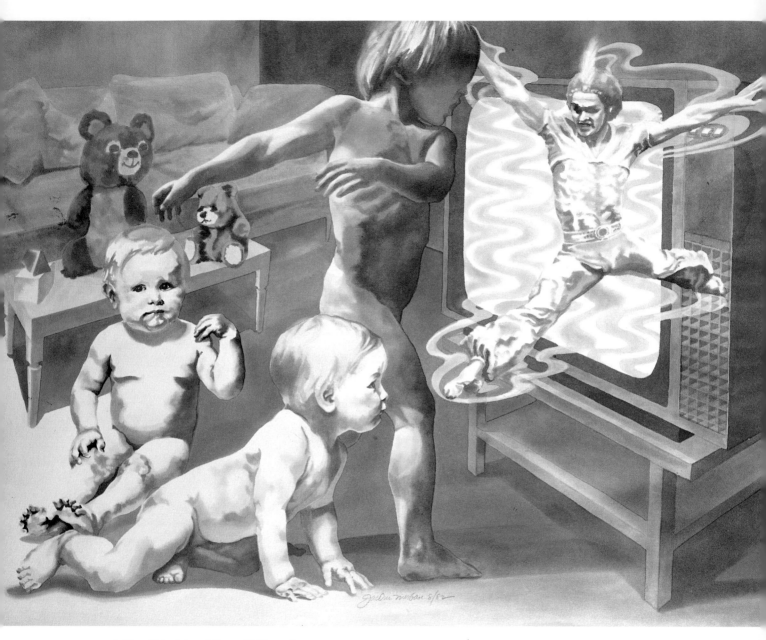

In How Television Affects Children *I
used the full range of cools to indicate
absence of light. The extent of the
middle value of warm flesh tone
depends upon how light-bathed the
figure is. For the central figure,
farthest from the bright light source,
which has the most local color/middle
value, I used primarily alizarin and
burnt sienna. These figures have fair,
thin-skinned alizarin complexions.
(Dyes on Arches paper.)*

Simply touch the wet surface of the paper with the tip of the brush loaded with pigment.

Local Color and Flesh Tones

Before you experiment with painting a nude in local color, study the structure of your own face. Hold a mirror before you. Place a single light source to one side to create lights and darks. Suspend preconceived notions and trust your eyes. Locate the coolest tones in the darkest, or core shadow areas of the rounder forms. Also notice how the light stops abruptly where the bone protrudes, the nose for example, and how the darkest cool takes over. The darkest dark, whether cool or warm and cool, is found closest to the lightest light. Forms become warmer and lighter as they move farther away from the light and the core shadow; reflected light filters around the dark side.

When you work with a model or a well-lit color photograph, look at the upper arms, thighs, and breasts; on the rounder forms, the light change is gradual, and warm color is perceived as the bridge from a light area to a dark cool color. Note, too, that wherever bone is close to the skin surface, the local color is warmest: at the nose, cheek-bones, elbows, ankles, and knuckles. The area across the face from ear to ear is perceived as warmer, especially in younger people; consequently it is referred to as the warm zone. Rather than memorizing these observations, use them as guides to the way you look at a subject and essentially trust what you see. If you paint exactly what you perceive, nothing more, nothing less, the viewer will be totally convinced, and the result will actually be hyperrealistic.

Basically skin color falls into three types: fair, yellow or olive, and black. The fair type, characteristic of Nordic peoples, has the thinnest skin; the blue veins and red arteries are apparent through the skin and affect its local color. Cosmetically speaking, this complexion is often referred to as "blue-red" and alizarin crimson represents it well. Try charging in that color with a touch of burnt sienna or a warmer red in the warm-toned areas. The shadows of the blue-red complexion appear bluer than on any other skin color type because it comes closest to being a white form. Experiment with grayed-down blues, perhaps Payne's gray with a touch of phthalo blue.

The second major skin color type includes that of Mediterranean and Oriental peoples. It is perceived as having more yellow, ranging from yellow-orange to

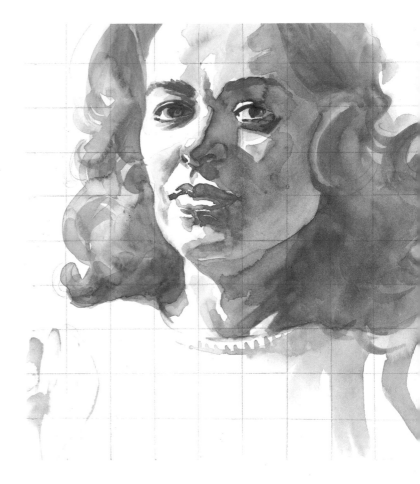

Although Pam DeSpain could be included in the Mediterranean skin category, I chose to use a more blue than green tone to express shadow. (Watercolor on textured Bristol, a resistant surface.)

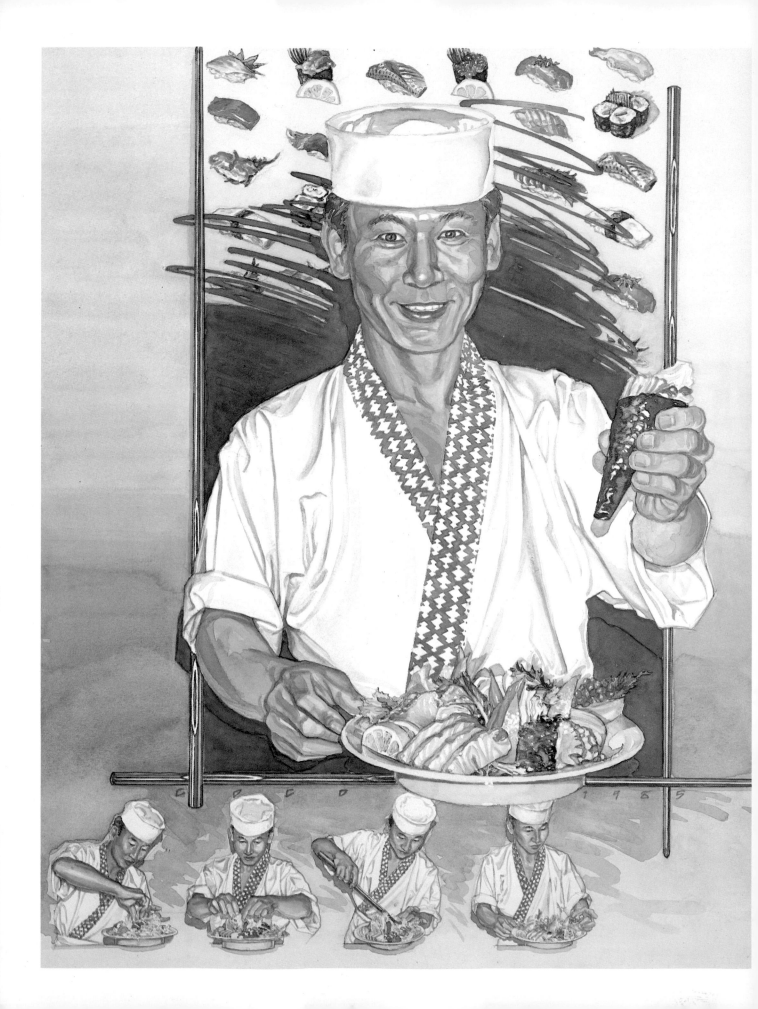

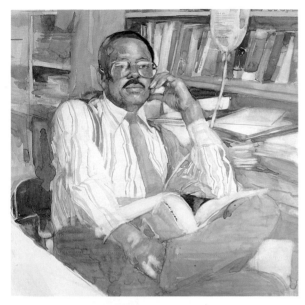

Coco Cummings, a storyboard artist and illustrator, chose to express the absence of light on Oriental skin, left, with warms, but the light-bathed portions are the white of the paper.

Burt Silverman, an illustrator who is a master of realism, used violet to show absence of light on black skin, rich local color and almost the white of the paper to express light-bathed areas in

the painting top left. (Watercolor on plate Bristol paper, for Baxter Travenol Labs Annual Report. Art Director: Henry Robertz, Robertz and Webb, Chicago.)

Another example of Burt Silverman's use of rich analogous color for skin tones is this album cover of Louis Satchmo Armstrong, bottom left. (Watercolor on gesso-coated illustration board, for Literary Guild Records.)

In the poster for the Scott Joplin stamp, Jerry Pinkney, an illustrator, used green instead of violet to convey the absence of light. Since the green is complementary, it intensifies the rich warms. (Watercolor and pencil on Arches paper, for the U.S. Postal Service. Art Directors: Terry McCaffrey and Dave Foot.)

red-orange. For the warm-toned areas try mixing a raw sienna or a grayed warm yellow with a drop of burnt sienna or vermilion. Into the warmest areas charge additional vermilion. For the shadows try a grayed or umbered viridian green. Shadows of these complexions are best expressed by greener cools.

For the third color type, black, for people of African descent, much richer color can be used. For the warm-colored areas, try burnt sienna with some scarlet lake and other analogous reds. Cool shadows are effectively treated with violets or blue-violets.

The theory of choosing the shadow color for skin is based on using the cool analogous color of the local color, that is, a bluer version of the local color. For example, use blue shadow for the whitest skin, green for the yellowest skin, and violet for the reddest skin. Such shadows help to convey the sense of the local skin color even when it is primarily light-bathed or in shadow. Almost any choice of a warm and a cool color, however, depicts flesh and the human form convincingly as long as the warm color is more intensely chromatic than the cool color. Consistency of treatment throughout the face or figure leads to perception of integrity of form. For your next painting, observe your model and select one cool color for the dark shadows and one warm color for the middle-value and warmest areas of local color. Draw the contours and shapes of the darks, including all middle-toned but not light-bathed areas. Regardless of local color, leave the white of the paper for the light-bathed areas.

Within manageable proportions, wet one or two shadow areas and immediately charge in the cool color in varying degrees of depth corresponding to how you perceive your subject. Then, a few seconds later, while the color is still wet, always referring back to the model, charge in the smaller bridges and overlapping areas of warm color. An area can be both warm and cool, warm in local color but cool in shadow. To avoid overworking the painting, stop intermittently and place it so that you can view it from some distance before proceeding. Suspend judgment until you can look at it when it is dry and you are free of too much memory of the painting process.

You can try subsequent experiments using three different cools for the shadows, the most bluish for the deepest cools and two or more warmer cools—violets or greens. Depend less upon layering and more upon charging in each color as perceived in a single-layer painting. The result is fresh and sparkling, inspiring experimentation that is more personal.

Workshop experience has revealed the most common pitfalls. Whenever the model is a redhead, for example, many students rush to lay in the hair color before any other because it is perceived first; it is the model's most obvious color characteristic. They overlook how cool the red hair becomes in shadow, as though a wash of blue has been laid over it on the shadow side of the head. By stressing the continuous warmth of the mass of red hair they do not allow the white paper to show through where the hair is light-bathed. The entire painting becomes unbalanced, even when the rest of the figure is treated with the same approach applied to depicting pure white forms. Frequently, the skin of a redhead is so subtle that it is hardly different in local color from a pure white form. Eyebrows and pubic hair succumb to students' same fixation on local color, resulting in a corresponding loss of the illusion of three-dimensional form.

Lips, especially women's lips, inspire a similar response from students—a single flat color. The result is not only naive, but the effect of painted-on lipstick tends to separate the lips from the rest of the painting. In reality, the form and expressiveness of the muscles that form the lips give them their prominent shape. Their color is hardly different from that of the surrounding skin and, with age, the difference diminishes.

Manipulate the light source and observe on your own face how light moves around your lips; it is the sharp in-and-out direction of their contour that makes them so dramatic. When the light source comes from above, the upper lip, which slants sharply in and under, causing it to be in shadow, appears darker than the lower lip. The lower lip protrudes, catches the light, and appears even lighter than the surrounding skin. The lower lip is then light-bathed: white paper expresses it best, while the portion beneath it is in shadow.

Unlike the lips, the pupil of the eye is not a separate form but a transparent spot of local color on the eyeball. It is important to remember that the eye is a sphere. Consequently, the side of the eyeball farthest from the light source turns into shadow; instead of being white it's dark.

Move the light full front; note that the corners of the eyeball are in shadow and also are not perceived as white. Now move the light source to one side and notice how the local color of the pupil farthest from the light becomes lighter. The pupil appears overly prominent when its local color is rendered flat adja-

cent to that flat white of the eyeball. The strong contrast makes the eye seem naively painted, unrealistic and unbelievable. Notice how light from above causes the upper eyelid to cast a shadow on the eyeball. It is as dark as the pupil itself and actually connects with it in value. Showing this integration of tone between the pupil and the shadows of the eyeball and eyelids gives credibility to a painting.

Paint only what you perceive, not what you assume. It is also more convincing to understate the existence of local color and the contour of the pupil. Cast shadows from the eyelids, variation of value in the white of the eyeball and the pupil itself, and liquidy highlights provide several means of integrating the pupil with the overall form of the eye. In the most convincingly realistic and successful heads, these shadows are rendered equally as dark as the local color of the pupil, sometimes darker.

Proportions of the Head

Transparent watercolor does something unique for portraiture. Look at the watercolor likenesses here; the paintings endow each personality with a vitality and immediacy unobtainable by photography or by any other paint medium.

Painting likenesses for black-and-white reproduction is hardly more difficult than painting simple white forms. Painting likenesses for color reproduction is like painting the nude.

To understand the behavior of light over facial planes, consider the entire head as a single form, the shape of an egg. The shapes of the light-bathed areas and the shadows connect with one another to convey the wholeness of a single form. Think of a nose as being carved out of the egg shape, blocking the passage of light to the other side of the face. The dark side of the face should be as consistent as the dark side of the egg, a single color form. Therefore, remember to reduce the importance of local color in hair, brows, lashes, pupils, and lips. Hair in shadow exists in absence of light; it is not drastically different in value from skin in shadow. For best results, treat hair less fully than you treat eyes, nose, and mouth, which are more important. Consider hair, eyebrows, mustache, and beard as part of the form of the head, as they are on a marble bust.

Looking at the model, notice the thrust of the head, that is, the imaginary center line from the forehead down between the eyes and through the center of the nose, lips, and chin. This plumb line assures a

Lips are prominent because of the form and expressiveness of the muscles. Their color is hardly different from the surrounding skin, and with age the difference diminishes. When there is a light source from above, the upper lip, which slants sharply inward, appears darker than the lower because it falls in shadow. The lower lip often catches this light and appears lighter than the surrounding skin. The pupils of the eyes are not form, but a translucent spot of local color on the eyeball. Underplay the local color of the pupil and the white of the eye by integrating them with the shadows caused by the upper eyelid and the portion of the eyeball that turns into the shadow.

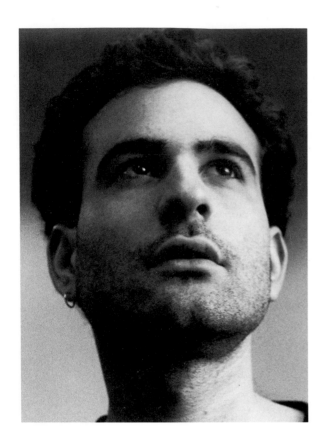

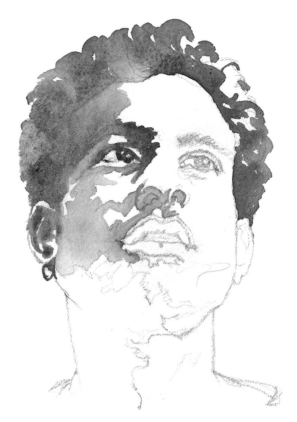

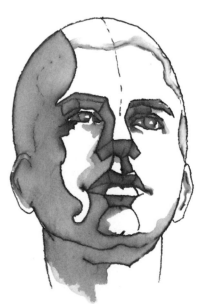

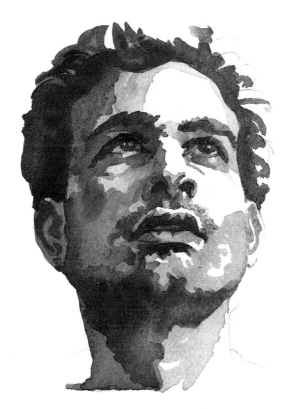

It's best, whenever possible, to take your own photographs and control the lighting so that it reveals the structure of the features, as can be seen in the photograph I took of Marc Hellman, above left. From the photograph I did a pencil drawing, above center, of the shapes where the water and pigment would be applied and then began the painting. Above is the finished portrait. The redundant pencil lines have been erased.

The drawings, left, show the structure of the head in the photograph above. The drawing far left shows the basic egg shape with the center plumb line indicating the thrust of the head. The horizontals indicate placement of the eyes, tip of the nose, lips, chin, and brow. The other two drawings show how the verticals help to locate the width of the features and the frontal plane, making it easier to see where the forms turn and change from light-bathed to shadow.

correct alignment of features. Draw an egg shape with the same thrust, adding the plumb line to indicate the center.

Next, look for the horizontal to indicate placement of the eyes. Viewed straight on, you would expect to find it in the center of the egg shape, but foreshortening can make it appear higher or lower. To make the measurement more precise, stretch out one arm full length with locked elbow, holding a pencil or brush perpendicular to the arm and parallel to the model. Measure with your thumbnail the relative distance between the top of the head and the eyes and between the tip of the chin and the eyes. If the distances are equal, find the center of the egg shape and place a horizontal line there. If the upper distance is a third of the whole head and the lower distance is two thirds, place the horizontal on your drawing accordingly.

Next, locate the tip of the nose in the same manner by measuring its distance from the eyes and the tip of the chin. On the egg shape place a corresponding horizontal to indicate the tip of the nose. Then locate the meeting of the upper and lower lip by judging its relative position between the nose tip and the chin.

Last, find and indicate with horizontals the top of the upper lip, the bottom of the lower lip, the indentation between the bottom lip and the chin, the eyebrows, and the eye sockets or the top of the upper eyelids. All horizontals are parallel to one another and perpendicular to the plumb line except for the minimal effect perspective would have.

After you have decided on the placement of features from top to bottom of the egg shape you can indicate the width of each feature and the frontal planes as an aid to placing light and shadow. To do so, place verticals parallel to the center line, beginning with two verticals indicating the width of the bridge of the nose at the horizontal eye line. Continue these downward, tapering or expanding them through the nostrils, through the cleft between nose and upper lip. There the lines conveniently meet the two highest points of the upper lip and appear to continue downward through both lips, describing their foremost planes; they then become the indentation between the lower lip and the beginning of the chin. Continue the two lines to the bottom of the head to describe the squareness or pointedness of the chin. Then, from the horizontal eye line, notice the frontal plane of the forehead and place two verticals from the eyebrow arch to the top of the head.

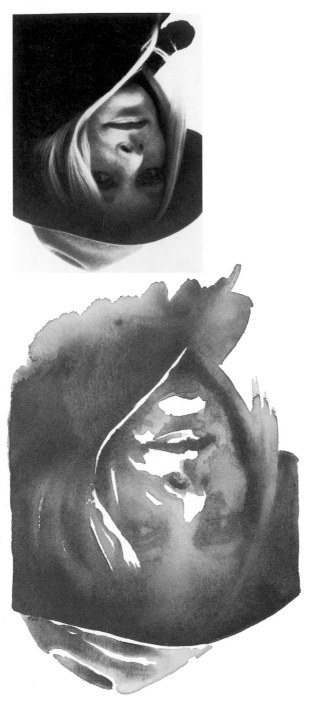

The painting above was done upside down from the photograph. This is an essential exercise, which will actually encourage you to trust your eyes instead of accumulated knowledge. (Photograph taken by Art Director Marvin Fierman.)

Other useful vertical indications are from the inner corners of each eye down to the outside of each nostril and from the center of each eye to the outermost corners of the mouth.

Each face is different. Use these guides to aid you in seeing the placement of features on a particular individual, whether you are painting from life or from a photograph.

Using the Right Side of Your Brain

An amazingly successful and liberating exercise is doing an entire portrait from an upside-down photograph. Relative novices are astonished by their excellent results. This procedure is commonly referred to as drawing from the right side of the brain. The individual is unencumbered by logic, knowledge, or previous experience or expectations. From a dramatically lit upside-down photograph, it is difficult to say, "This is a nose, and this is a lip." He or she is forced to rely on what the eyes perceive and thus learns to trust perception of spatial relations in abstract situations.

Draw the shapes of the lights and darks as you perceive them to relate to one another and complete the entire painting process with both the photograph and the painting upside down. This experiment should confirm for you the necessity of trusting your eyes and of painting what you see, not what you know.

The Clothed Figure

Painting the clothed figure is more complex than painting the nude because the form of the body is more difficult to perceive beneath garments. Careful observation of the way the clothing drapes, however, can help you increase the sense of the figure's form, gesture, and movement.

Observe the most important folds by squinting. Note the tension point from which each group of folds radiates; the folds are never parallel to one another. Select the most prominent two or three folds to portray; eliminate the others. Remember the goal is to express the forms beneath. See these forms in terms of the shadows they create and draw only those. Keep in mind that even with folds the darks connect. Boldly patterned clothing, stripes, and checks increase the likelihood of exaggerating local color to the detriment of convincing form. Squint to see light and shadow more easily, regardless of pattern and local color. Complete the drawing of all shadow shapes.

Now the question arises of how to deal with the

*Milton Glaser, a designer and il-
lustrator, used colored ink and tempera
for Shirley, Annie & Mr. Hoffman.
Note how the behavior of light and a
minimum of drape express the form
beneath, as well as the way the
blanket pattern becomes more difficult
to see where the light is intense and
the shadows are deep. (All design and
illustration copyrights are held by
Milton Glaser.)*

shadows of the various local colors. I recommend that you do an initial series of paintings in a single cool color, as you did for the nude, to become acquainted with the many advantages garments and their folds contribute to rendering the figure. The next step is to paint the local color by layering it over the cool shadow colors. The most challenging part of this process is to let the pattern disappear in the light-bathed areas. As local color bleaches out in light-bathed areas, so, too, do patterns. Surprising as it may seem, the viewer knows the pattern continues, even though it appears to have vanished in the intense light. Actually, little of the pattern need be expressed, and then only in the middle-value areas. The most challenging approach is to use a cool analogous color of each local color in the pattern, keeping in mind that all of them must weigh in with one another to convey integrity of form.

Burt Silverman's Digging, *above left, is a good example of how pattern is most visible in the middle value range and becomes bleached out in bright light. The shadow portions, treated with a rich blue wash, increase the sense of form and diminish the sense of pattern or local color. (Watercolor on plate Bristol paper. Part of a corporate promotion for New York Real Estate developer, Edw. S. Gorden Co. Art Director: Chermayeff and Geismar.)*

James McMullan, among the best contemporary watercolor illustrators, did the western scene, left, for The Songs of Paul Cotton, *an album cover for the rock group Poco. This painting demonstrates how light bleaches out local color and pattern and how much cooler the local color appears in shadow. (Art Director: Paula Scher.)*

For Peach Robe and Sofa, *right, I chose only the essential drapes that best describe the forms beneath. The local color, peach, was placed only where the forms are not bathed in light, at the middle value. For the shadow color, I chose the analogous cool, violet, to maintain a more decadent mood. However, blues or greens would also work. (Watercolor and dyes on Whatman paper.)*

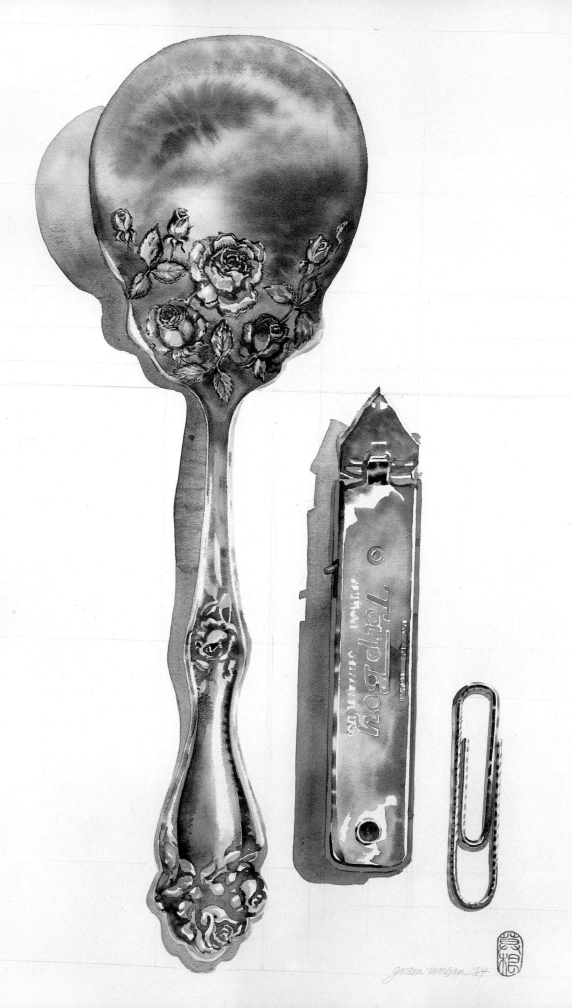

6

Transparent and Reflective Forms

Spoon, Opener and Clip *is painted considerably larger than life, 22″ × 30″ (56 × 76 cm). Except for the relief decoration on the spoon, all the pigment was loosely charged into very wet areas. (Payne's gray and cadmium red light watercolor on Arches paper.)*

Probably the most challenging subjects to paint are either transparent, reflective or both. Think about the abundance of mundane objects that fall into this category. Look around the room—there are windows, pipes, a stereo, household or studio appliances. And on your person, observe a watch, a ring with a stone, eyeglasses.

Transparency is the see-through quality that is the essential characteristic of glass, water, some plastics, sheer fabrics, and many flowers. Transparency is traveling light—delicate, there and not there.

Reflective surfaces are visually dramatic, definitely there, capriciously changing with light, dependent upon surrounding objects and the slightest alteration in the viewer's angle of vision. The ultimate reflective surfaces are polished metals— gold, silver, copper, brass, bronze, stainless steel, and chrome. Many materials are both transparent and reflective— some plastics, glass, water, shiny, sheer fabric, and some shiny precious stones. You would miss painting much of the universe if you were to avoid the exciting challenge of depicting transparent and reflective materials. The secret of success is to trust your eyes, not preconceived knowledge.

Glass

Glass catches the light. Transparent, illusive, it is there and it is not. Irrational and capricious, it plays with the light reflections, tricking the eyes. We know that a drinking glass has sides, a bottom, a rim, and thickness, and it holds liquid. Tactile memory tells more than the momentary visual experience, and artists tend to give far more information in their paintings than the eyes alone perceive. This tendency results in a less convincing image.

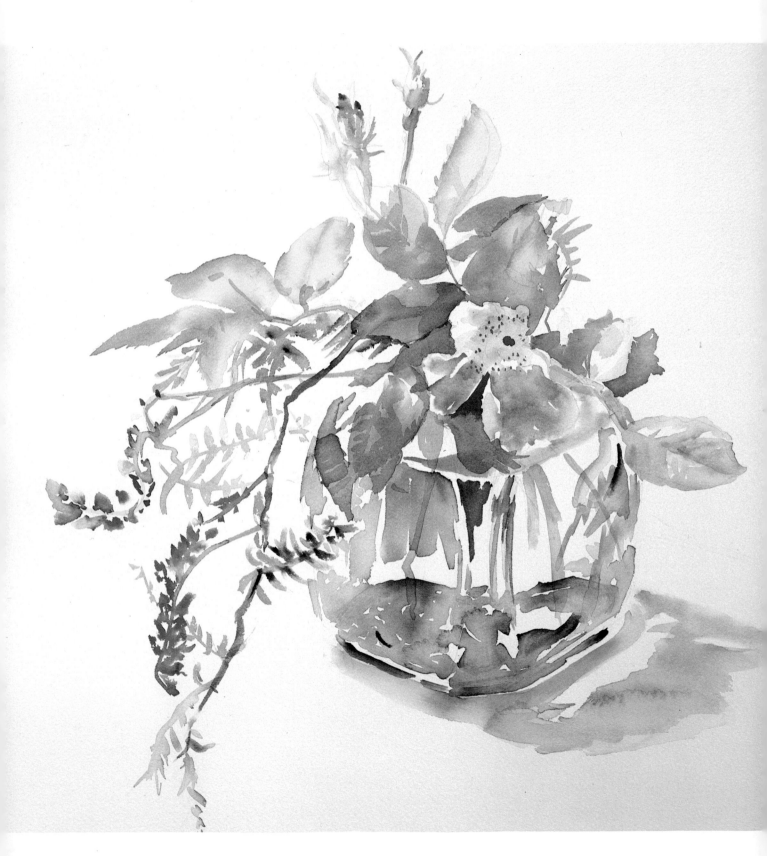

Half fill a drinking glass with clear water, and place it under a strong light. Unlike opaque mat surfaces, glass fragments the light, catches it, and ignores it. A single edge of the drinking glass varies dramatically and unpredictably. Observe the rim; some portions are very dark, even black and others seem to disappear. Because the eye completes and connects fragments of any known or experienced object, we know, without seeing it, that the entire edge exists.

Much depends upon the shape of the glass; the more faceted, the more edges it has, the more darks and brilliant whites. As on other surfaces, the behavior of the light on the edges varies with a change of plane. The difference with glass lies in the inconsistency of the change. Observe a single vertical edge; the upper portion can appear white on one side, black on the other, but by the time the eyes follow this edge down to the bottom, the white side can become black and the black side can become white.

Another distinct phenomenon occurs within the body of the drinking glass. Not only are there dramatic value changes, but the edges are sharp, not vignetted. The shapes are liquidy, feeling like heavy fluid such as mercury. Within these sharply defined, liquidy shapes there are also subtle variations of value that help convince the viewer that the object depicted is glass.

It is most important in portraying glass to be sufficiently bold to let the portions your eyes cannot perceive disappear on the paper, without even a graphite line. Like your eye, the eye of the viewer connects the darks and completes the image. Stating less of the subject also involves the viewer in creating the image, so that he lingers longer over the painting and is more convinced of its reality.

Wild Flowers/Glass Vase *is a painting of fragile subjects. Both flowers and glass are more convincing when understated. (Watercolor on Arches paper.)*

Antique Bottles *shows how the delicate glass faceting can fragment the light and also affect the cast shadows. The watercolor was charged into generously wet areas without manipulation. In the detail you can see that the fluid internal shapes of glass are particularly well suited to the watercolor medium.*

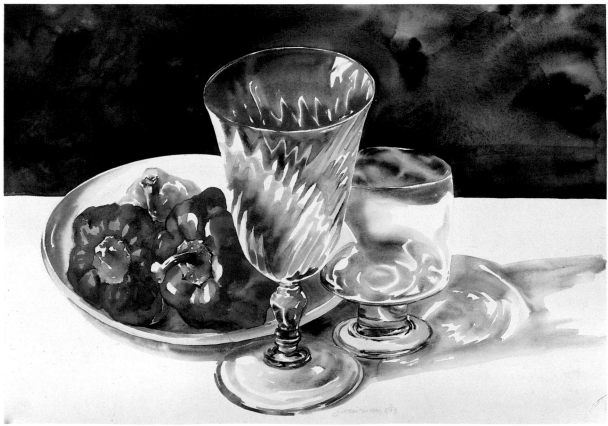

There are instances where you must make aesthetic choices, where, for example, you must choose between rendering a highlight or transparency. The white of the paper can either express highlights or complete transparency, but not both. To have a highlight, you must place tone around it. The choice is between more and heavier tone, minimalizing the sense of transparent glass, or making a more minimal statement. Often, especially in watercolor, the essence or minimal statement, losing the highlight, is the more effective.

Also try setting other objects behind the glass, allowing the glass faceting to distort and fragment another object and introducing other color. Then paint the distorted image in the glass, rather than the glass. The secret of rendering glass is to draw what you know, but paint only what you see. The result is a greater illusion of glass.

Water

Like glass, water is transparent and reflective. Next to the half-filled drinking glass, place an empty identical glass and compare the two. The upper horizontal surface of water in one glass is perceived as an additional plane off which the light bounces as though it, too, were glass. Without this plane, the eyes would not perceive the water's existence. Paint only the minimal darks that your eyes perceive, but make them as deep as you see them, much darker in fact than you expect.

In painting both glass and water, the more aqueous and fluid your treatment, the more convincing your painting will be. This is why watercolor is so well suited to the expression of these materials. It is perhaps with these subjects that you will most fully

The pale blue of the Soda Bottle *is reflected in the stemware, and the table edge, visible through all the objects, becomes distorted by the green bottle on the right.*

Wine Glasses and Peppers *illustrates what some artists say: "Don't paint glass; paint the way it's affected by its surroundings." Place objects behind glass to become distorted and fragmented by faceting and fluting. In this painting, the glass picks up the white of the plate and table edge as well as the red of the pepper.*

appreciate the success of charging in paint, rather than stroking it on the surface. Dryness results from direct stroking. It is the one quality that exists neither in glass nor in any other transparent or reflective surface. Charging or touching the bead of water with the top of the brush results in a liquidy, flowing appearance.

Transparent and Reflective Fabrics

Transparent fabrics are those often associated with romance and mystery—voiles, nylons, sheer silks, and chiffons. They become more visible and opaque when layered. These fabrics, like glass, are best handled minimally, actually ignored where the behavior of light does not reveal their existence. Therefore, paint only where folds or drapery causes shadows or where the fabric appears to thicken, as do stretched tights when they go around the leg at the sides. Black tights are frequently used in theater, for while they sometimes appear alluringly transparent, these edges where the fabric turns around the legs become more opaque and blacker, causing the legs to appear more slender. To paint anything more than the merest suggestion of tights would be overkill.

Shiny tights or leotards may also be transparent. Their shininess, however, makes them also reflective surfaces, creating highlights and more extreme value changes. As a result, they more clearly define the sculptural form they cover, revealing with greater clarity the whites and darks on the figure.

Plastics

Transparent plastics are perceived much like glass, except that there is less crystalline clarity in the abstract liquid shapes they contain. The edges of the value changes are, therefore, a little less sharp. Lucite, used often in place of glass for framing, appears different from glass when viewed closely, especially when it becomes scratched and therefore cloudy. Opaque shiny plastics may best be treated as reflective surfaces, with brilliant white highlights. They, too, are composed of liquidy internal shapes.

Observe plastic dishes, mugs, telephones, and jewelry. It is the play of light on any material that reveals its nature. Trust your perception, most of all when it seems illogical. Remember that you must make the material or surface recognizable by sight without use of the tactile sense.

Flowers

Flowers are surprisingly difficult to portray. Floral essence, a wisp of transparency fluttering in response to the merest breeze, is a fleeting illusion of color and light, fragile, delicate loveliness, here this moment, gone the next. How can flowers be made more beautiful than they already are? How can a painting do them justice? Like a mirage, flowers are best conveyed by less concrete painting, by eliminating any unnecessary detail, by understatement.

Desire for accuracy motivates depiction of each overlapping petal, often resulting in too much opacity. The richness and variation of local color is so seductive that by conscientiously rendering it you too easily make the flower unfloral, heavy, indelicate, about as convincing as its artificial plastic counterpart. To capture its richness of color without loss of its transparency is a difficult challenge. As with all other forms, it is essential to leave the white of the paper free of paint to express the light-bathed portion of a flower.

The question remains: How do you express the color richness without losing the sense of light and transparency? There is a limited area left in which to lay color. Here is one situation where the awareness of warm and cool versions of the same color and the use of analogous colors are especially helpful. Minimal use of pigment will create the illusion of rich color as well as of receding and advancing portions of the flower.

A pale magenta morning glory, for example, will look realistic with a touch of its cool analogous blue in the shadow of the deep receding cup. The blue increases the illusion that the cup portion recedes from the picture plane. Its warm analogous color, alizarin, can be placed in the middle-tone portion, closest to the picture plane, since the warmer color increases the illusion of its advancing toward the viewer. The visual mixture of the blue and alizarin approximates magenta.

Another example is a rich, red rose. How do you convey rich red while expressing the light-bathed portions and the shadows? The richest way to say red is to charge in many analogous reds, from orange to magenta, and to use violet for the shadows. Do not manipulate the blend from one color to another. Charge in dabs; let each color exist independently of the others. Viewed from some distance, the totality says red, a far redder red than any single color could

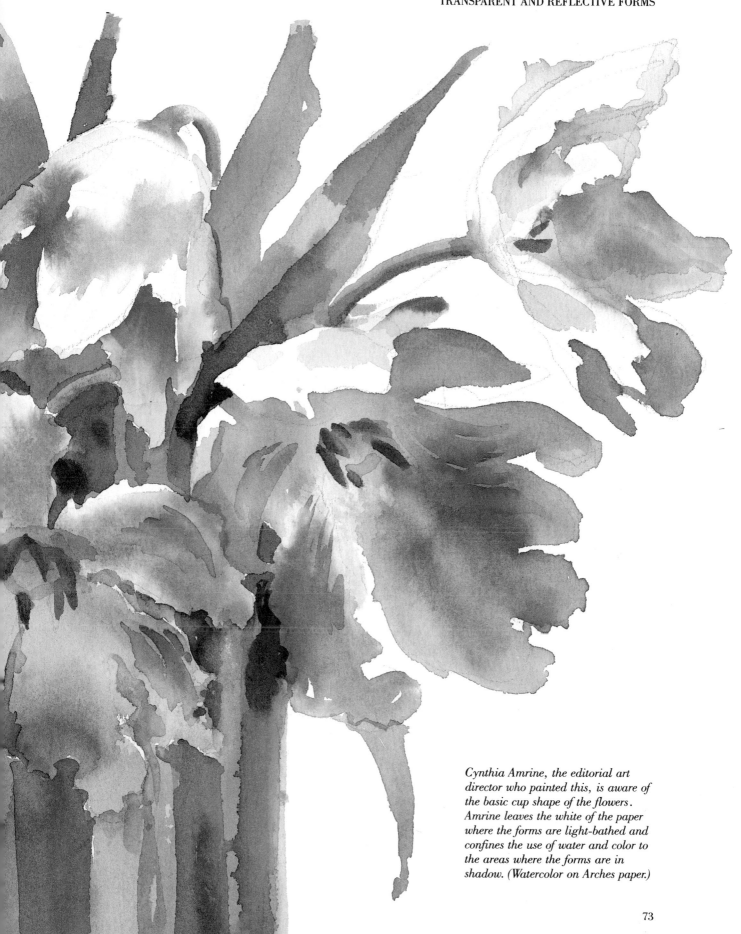

Cynthia Amrine, the editorial art director who painted this, is aware of the basic cup shape of the flowers. Amrine leaves the white of the paper where the forms are light-bathed and confines the use of water and color to the areas where the forms are in shadow. (Watercolor on Arches paper.)

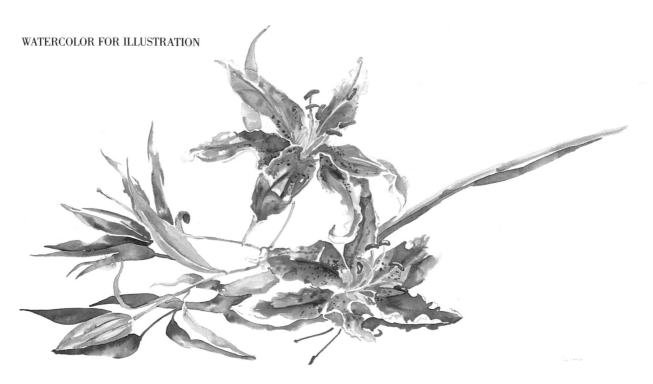

be. Probably you will have to take one painting to extremes and get too heavy for you to have a sense of how far you can go. Floral painting, especially, is judged by what is omitted; less is more.

Polished Metal

Regardless of the metal—silver, gold, brass, copper, or chrome—the more highly polished the surface, the more brilliantly reflective. To aid perception and give the work additional sparkle and vitality, polish the object before you paint it. Like glass, metal has the characteristics of unpredictable value changes on a single edge or plane as well as the fluid, abstract shapes of molten metal. Metal has, however, strong·r and more dramatic value changes, from the blackest black to the whitest white. The more extreme and sudden the value change, the more convincing is the metallic surface. The darkest dark is usually found adjacent to the brightest light. The whites cannot appear to sparkle without the adjacent deep darks. A timid approach, painting them lighter in value, provides insufficient contrast for the whites to sparkle as they are perceived on shiny metal.

Conversely, entirely filling in a silver or stainless steel object with a local gray color eliminates the shiny reflective characteristic. It is precisely the tendency to put in that middle gray that destroys the illusion of shine. Most often it is the large areas of white paper juxtaposed with deep, watery darks that create the effect of shiny metal. What cannot be said too often is, "Trust your eyes, trust your perception." Again, the more aqueous the watercolor painting, the more convincing the rendition.

Draw first with pencil and then with water the contours of the liquidy shapes. The drawing-with-water approach makes deeper darks than the wet-in-wet method. Then, charge in the darks with minimal manipulation of the pigment. The resulting dots or dabs blend somewhat within the wet area, creating variation of value within the sharply defined dark shapes, and portray a more liquidy metallic feeling.

The shadow colors of metals follow the same guidelines as those of opaque forms; they are a bluer version of the local color. Brass or gold, yellowish in local color, appears deep green in shadow; try Hooker's and viridian green. Copper, pinkish in local color, appears violet in shadow; try violets. Silver, neutral in local color, appears deep bluish, perhaps Payne's gray, in shadow.

Since the color of cast shadows is related more to the light source, a yellow-orange incandescent light source causes the cast shadows to take on the hue of its complement, blue. Nearer the object the cast shadow will contain reflections of the object's local color. Therefore, the cast shadow for a copper, or pinkish, object with an incandescent light source would range from pink, nearer the object, to blue farther away.

Under the same circumstances, a gold or brass object would have a cast shadow ranging from yellow or orange nearer the object to blue farther away. One of the most pleasurable painting experiences is to lay down water over the entire shape of the cast shadow and charge in the local reflected color nearer the object and the bluish color at the farthest edge of the shadow shape. The water takes over beautifully and convincingly, doing a far superior job of blending than the most painstaking treatment with an airbrush.

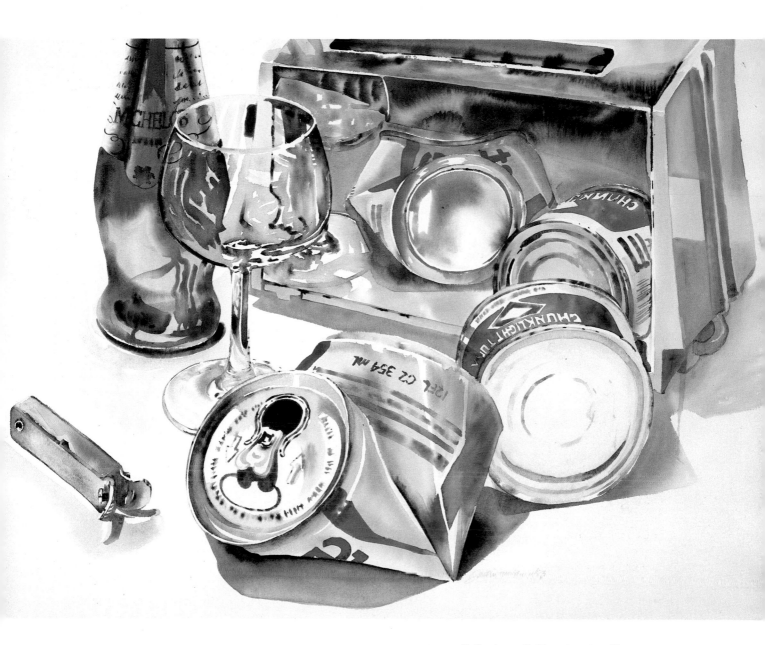

Lonnie Smith, a fashion illustrator and graphic designer, effectively made use of analogous color to describe the floral forms, above left. The cooler the color, the more the forms recede from the picture plane and read without being overworked or requiring a background to clarify the contours. (Dyes on Arches paper.)

Reflections of objects in mirrorlike surfaces are unfortunately clearer, sharper, and more contrasty than the objects themselves. The curved form of the toaster, in Crushed Can with Toaster, above, helps to differentiate the real objects from their reflections. Reduced from its original 22" × 30" (56 × 76 cm) it appears to be tightly rendered, but the pigment was only touched or dabbed into wet areas. Compare the handling of the glass and the metal.

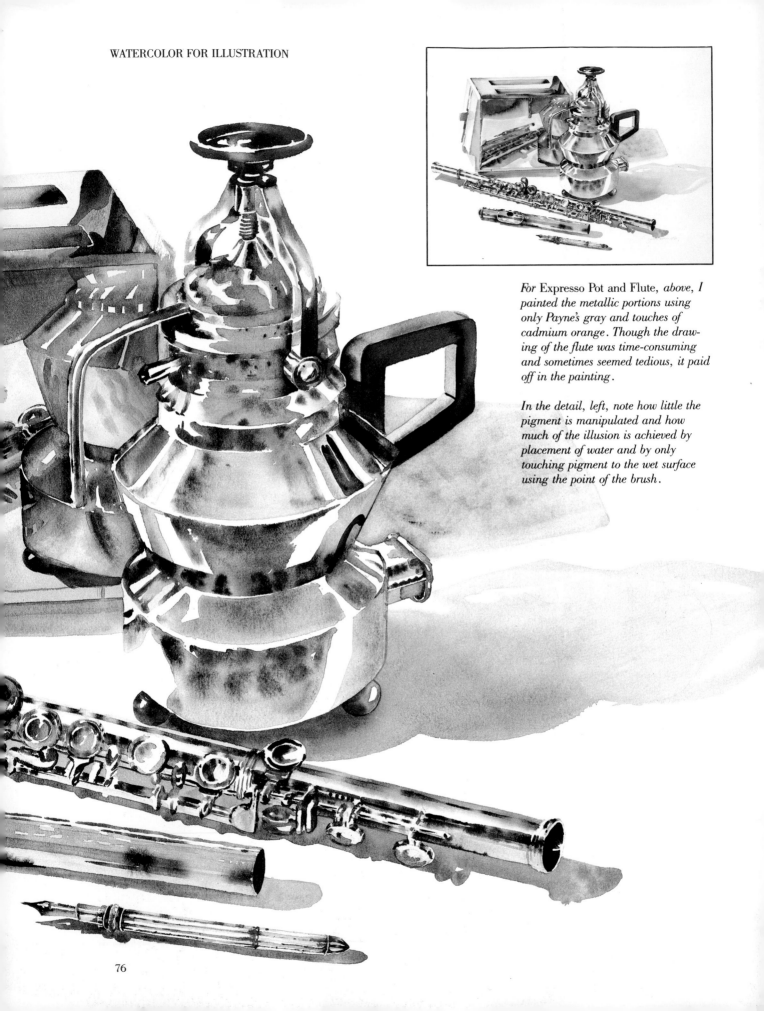

For Expresso Pot and Flute, *above, I painted the metallic portions using only Payne's gray and touches of cadmium orange. Though the drawing of the flute was time-consuming and sometimes seemed tedious, it paid off in the painting.*

In the detail, left, note how little the pigment is manipulated and how much of the illusion is achieved by placement of water and by only touching pigment to the wet surface using the point of the brush.

76

In Silver Plate, Magnifier and Reducer, *right, it is the pure white of the paper within the silver plate that says reflective surface. To fill it in with a gray local color would have destroyed the illusion.*

In the detail below you can see that since reflections are no less sharp than an object, it can cause confusion unless the reflection is a distortion of the object.

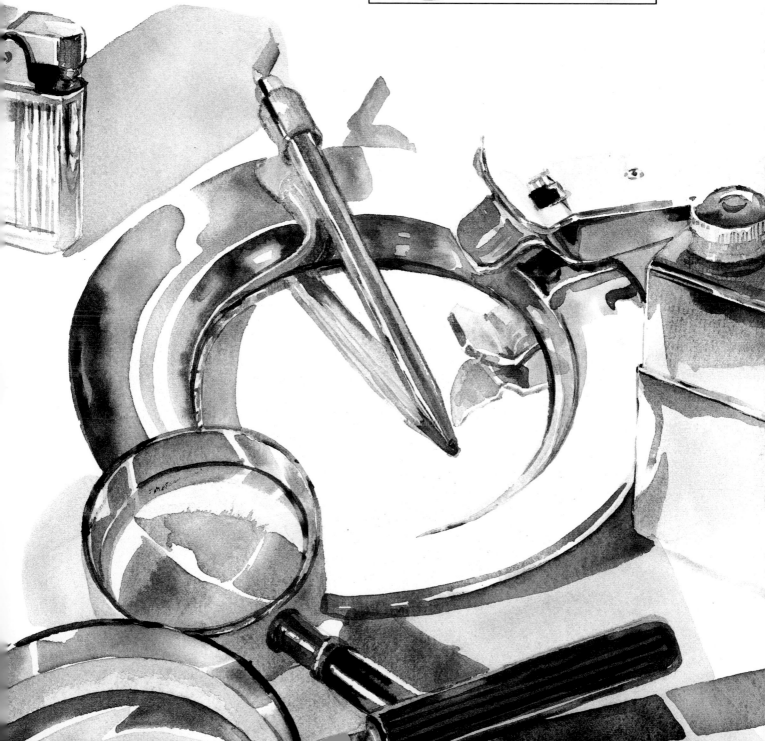

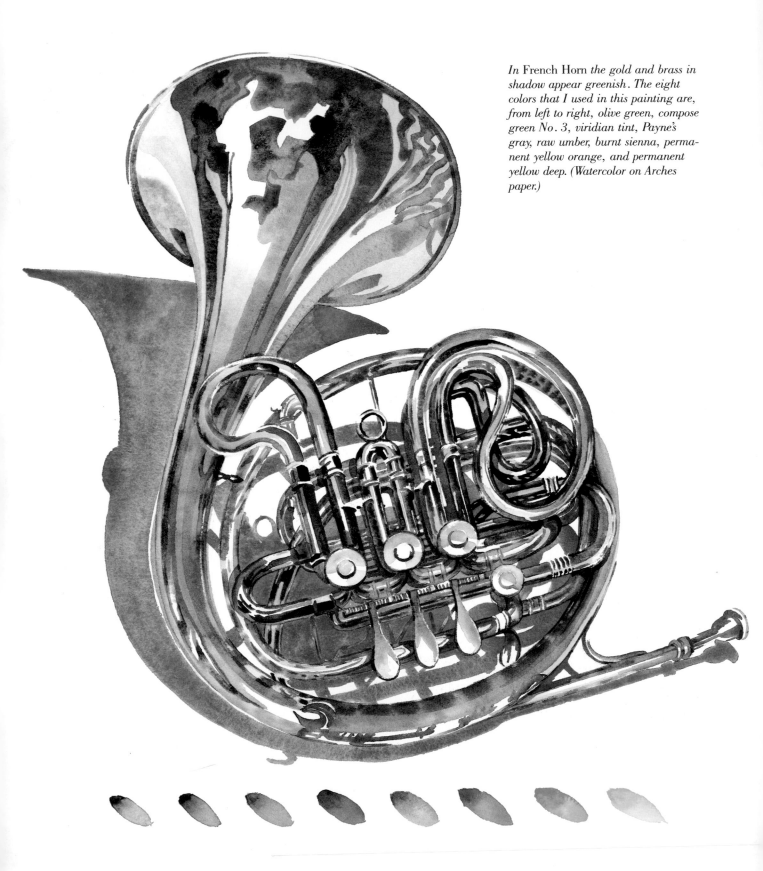

In French Horn *the gold and brass in shadow appear greenish. The eight colors that I used in this painting are, from left to right, olive green, compose green No. 3, viridian tint, Payne's gray, raw umber, burnt sienna, permanent yellow orange, and permanent yellow deep. (Watercolor on Arches paper.)*

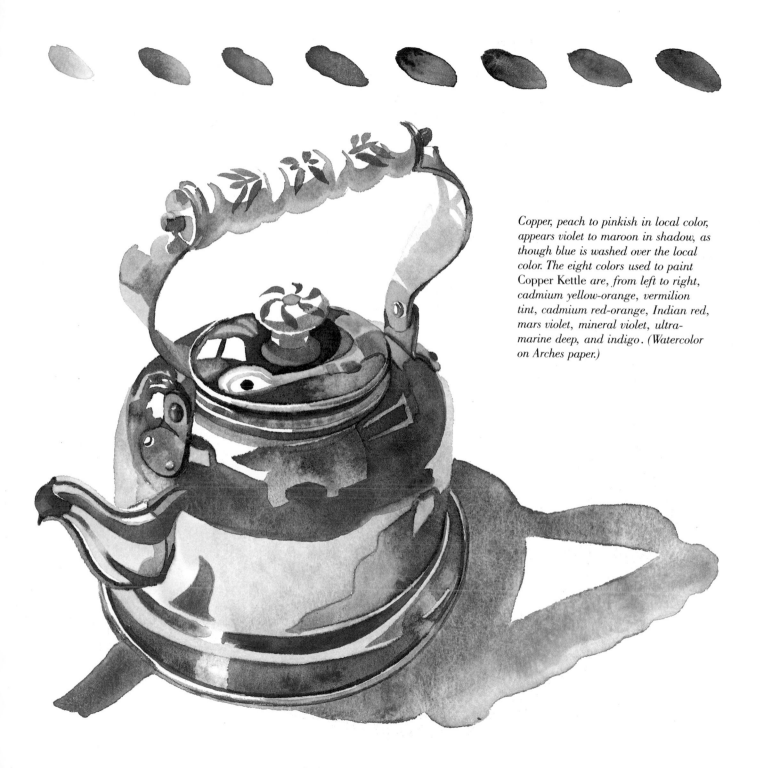

Copper, peach to pinkish in local color, appears violet to maroon in shadow, as though blue is washed over the local color. The eight colors used to paint Copper Kettle are, from left to right, cadmium yellow-orange, vermilion tint, cadmium red-orange, Indian red, mars violet, mineral violet, ultramarine deep, and indigo. (Watercolor on Arches paper.)

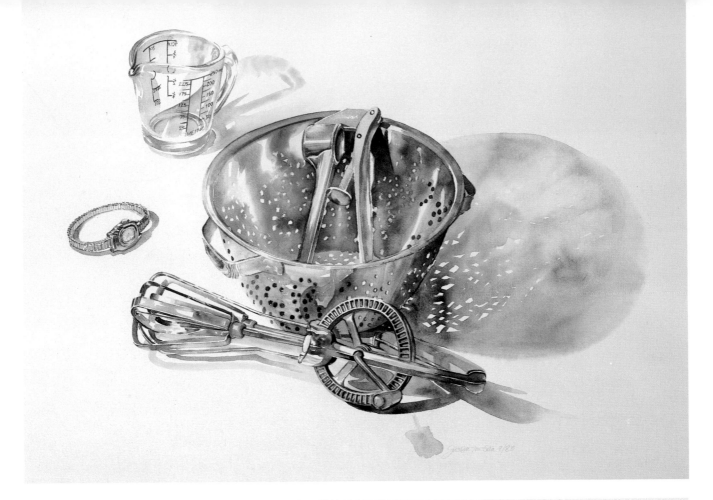

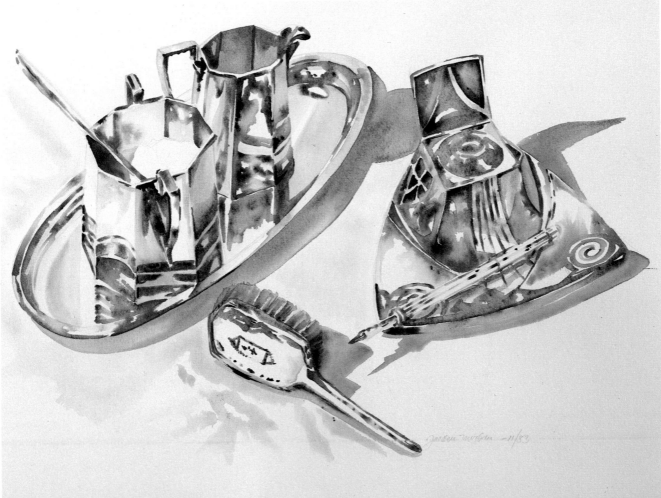

When designing the arrangement of metal objects, consider their placement not only relative to the light source but also to any surrounding objects. Reflections of these become frozen and distorted in the metallic surface. This phenomenon can be used to advantage, especially with neutral silver, for metals are most convincing with cool darks and pale warms. Placement of any warm-colored object near enough to reflect in the silver object can provide this desirable warm reflection. The paper itself becomes the brilliant highlights. Often the most brilliant lights appear to be the local color of gold or copper. In this situation, I often decide to distort my perception of reality for the sake of the painting. The warmest color can then be placed in a thin wash over the less brilliant light areas. Since any color is darker than white, the most brilliant highlights are often best left as the white of the paper to provide maximum contrast.

Metal objects are heavy looking, possibly because of our tactile experience of them. It is therefore surprising to discover that watercolor is the consummate choice of media to depict them. Both subject and medium are liquidy. There is no reason to pass up this exciting experience because of intimidation. Patient drawing that includes accumulated knowledge, combined with painting that trusts in perception, results in astoundingly effective paintings that are convincingly metallic and freely watery, as watercolor is at its best. That is why metals are among my favorite subjects.

The parts of The Colander, *above left, that excite me the most are the sparks of white paper remaining within the cast shadow and the colander itself. I did this during the application of water by leaving these spots free of water. As pigment was charged into the large areas, the portions free of water received no pigment. (Watercolor on Whatman paper.)*

Sugar, Creamer and Inkwell, *left, are all silver or nickel-plated objects. Since silver really has no local color it's particularly effective to place warm-colored objects nearby so that their reflections appear in the metal. (Watercolor on Whatman paper.)*

In James McMullan's illustration of La Recolte *restaurant, right, note not only the reflective silver service but also the simplicity of the treatment of the white apron. (Done for New York magazine. Art Director: Robert Best.)*

7

Other Painting Surfaces and Other Media

Experimentation with different painting surfaces and the introduction of other media are additional means of devising a uniquely personal approach to watercolor. Avoid mixing other media as a crutch to compensate for feelings of inadequacy or impatience with watercolor. Ideally, such exploration expands your watercolor skills, not limits their development. Add another medium to enhance the qualities unique to transparent watercolor, not to disguise them. Two of the contributions other media can make to watercolor are increased surface tension and textural richness.

Experimenting with Surfaces

Other painting surfaces can enhance watercolor's special qualities; for some people they make the watercolor appear closer to what was originally envisioned. Furthermore, other media are often at their best on other surfaces. For watercolor alone or with additional media, experience with other surfaces is essential. Make every attempt to convey realistic images and complete a work on each new surface to truly test its control potential; then put it aside, temporarily, for future reference.

Smooth, nonabsorbent, slick-surfaced papers, referred to as resist surfaces, increase the puddling and watery effects so seductive in watercolor. Papers prepared especially for pen and ink are among those resistant to watercolor absorption. Many such papers are available. Among the most frequently used is plate-finish Bristol. Select heavier weights or boards because the increased puddling can cause extreme rippling in thinner resist papers. Tape the paper

Medaglia d'Oro *was painted with dyes on resistant croquille paper. Dyes are quite controllable on croquille paper, which works better with dyes than with watercolor.*

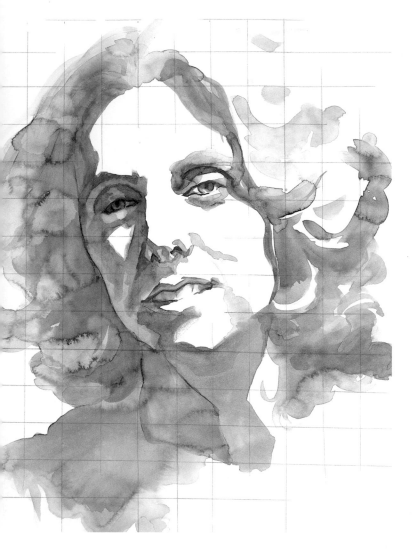

Peggy, *above, was painted with water-color on plate-finished Bristol, which is very resistant and creates more puddling than watercolor papers and therefore enhances the wateriness of the medium. Resistant papers seem to work faster, but dry slower.*

Breakfast, *right, was painted with dyes on thickly textured, gessoed, corrugated board. The gesso is so resistant that the dyes stain it but mostly fall into the valleys. Work done with dyes on gesso resemble oil paintings. Gesso can be applied to any surface, and easily creates drips. (Collection of Jerold Jay Wichtel.)*

down, select a still life, and draw it carefully. Use more pigment and less water and make every effort to portray the subject convincingly to test the paper's control potential.

The initial experience with resist papers is frequently frustrating and frightening. There is the sense that the watercolor does not stay where it is put. Try lifting or lightening areas by scrubbing and blotting. You can remove color far more easily on resist surfaces than on watercolor paper. Layering is therefore more difficult because of the tendency of previous layers to move. You can spray the initial layer with a mat fixative, lightly, from a distance, and with adequate ventilation, and allow it to dry. A hair dryer can speed up the process. Then work over the next layer. If the surface becomes too repellent because of too much fixative, rub down the painting with a firm eraser to make the surface more receptive. Complete the work and observe it from a distance. Surprisingly, the result is more readable and convincing than the process might lead you to believe.

Using the same methods, experiment with other Bristol finishes, as well as with vellums, mylar, and foam core, an inexpensive, smooth, and rigid board. Try for the most finished results and again put them aside for future reference.

You can create your own resist surfaces by applying gesso or latex paint to any available rigid surface or colored board. Gesso, an opaque white used for underpainting in preparation for acrylics and oils, is available in art supply stores. Latex, a fast-drying, water-based wall paint, available in white, is similar to gesso but less expensive in large quantities. It is available at hardware stores and home improvement centers. For a smooth surface, apply either gesso or latex in thin layers and allow it to dry thoroughly. For additional smoothness and receptivity, both surfaces can be sanded.

Since there is no such thing as a permanent mistake with gesso and latex, they are popular among illustrators. Completely resistant, even repellent, both gesso and latex permit complete removal of any watercolor-painted area, leaving no trace. Some concentrated watercolors leave a pale tint, since they stain even gesso. If undesirable, remove the dye stain with household bleach.

You might also try placing an incomplete painting under a running faucet for a moment. Remove it, tip the board, and allow the loosened color to run. Some runs may be an asset to the painting, so remove only

Jacqui Morgan '83

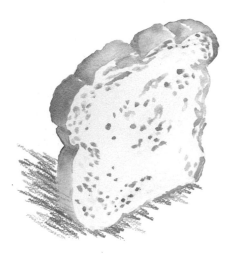
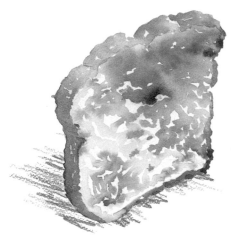
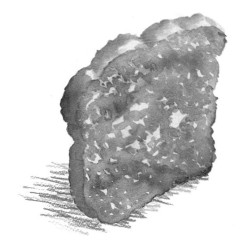

The Importance of Toast, *top, con-*
trasts the transparent halftones of
watercolor on Arches paper with the
opaque linear action of colored pen-
cils. (For Outlook, *a quarterly pub-*
lication of Booz-Allen & Hamilton. Art
Director: Tomas Gonda, Gonda De-
sign, Inc.)

Daniel Schwartz achieved the drips on
the painting above with watercolor on
a resistant board. It was done for the
Mead Paper Company as part of a
series called Good Morning America.

those undesirable drips. Allow the painting to dry
thoroughly, perhaps with the aid of a hair dryer, and
spray this, too, with mat fixative. Testing will indicate
how many light coats of spray are necessary to prevent
movement of the color and how many are too much,
causing the surface to be unreceptive to the next layer
of pigment or dyes.

When the fixative is dry, some painters brush on a
coat of mat polymer medium. It dries into a trans-
parent plastic coat, increasing color brilliance and
separation of layers. If the under layer of fixative is not
completely dry before this application, the damp
portions of color can move, creating sometimes desir-
able, sometimes undesirable, effects.

Dry the polymer, test for paint receptivity, and use
fine sandpaper to create a tooth to accept the pigment
or dyes. Work up the next layer, removing and adding
as necessary until you are satisfied, and spray with
fixative.

The entire process—gesso, watercolor, fixative,
and polymer—can be repeated again and again.
Dyes are preferable for multiple layers because of
their exceptional brilliance and transparency; they
make it difficult to overwork a piece into muddiness
and opacity.

Using the same materials, you can create more
textured, painterly surfaces. Apply either gesso or
latex in a thick textural way instead of in thin, smooth
layers. Use a large, stiff, house-paint brush or a straw
broom. Experiment, too, with combs and wire
brushes. Application can be in a single direction, in
swirls, or irregular. Allow more drying time for the
additional thickness. Prepare several boards at one

time for future use. Still resistant, pigment tends to collect in the valleys, increasing the visibility of the texture. The finished product is often difficult to distinguish from oil painting. Treat these surfaces in the same way—dry, fix, and possibly apply polymer between each layer.

Spraying a watercolor surface with fixative is another means of making it more resistant; try fixative on watercolor papers. Conversely, an extremely resistant surface can be made more receptive by a light application of the same fixative because it creates a pebbly tooth. Since polymer mat medium is transparent, it, too, can be used to transform any white surface into a resistant one. A pale color base can be made by mixing dyes into it before application. This base requires more erasing or sandpapering prior to painting than do gesso and latex, and it requires fixative between layers of polymer. The result is reminiscent of stained glass and is a very workable vehicle for combining other media with watercolor. Because each layer is virtually sealed off from the area below and the one above, any media can be used over any other, its visibility dependent upon the transparency of the subsequent layer.

Exploring Media Combinations

Equipped with reasonable control of watercolor alone on a variety of surfaces, you are now ready to explore combinations of watercolor with a variety of other media. Since watercolor is put to its best use describing shapes, by contrast, linear media are best used to enhance the loose, transparent, and watery shapes of watercolor.

Loie Livengood Glasser's Squashed Blackberries *has drips on Arches paper. (Collection of Jerry Pritchett— Stephen Gray.)*

87

Linear Media

Watercolor is classically seen with a graphite pencil base drawing visible through the transparent washes. Rather than a detraction, the graphite appears to make a positive contribution to the sense of immediacy, possibly because the entire process is visible. More relevant is how well the graphite line work contrasts with the watery shapes and permits greater freedom with the watercolor.

For your initial exploration of this media, apply additional graphite lines over the dried watercolor shapes. Maintain the line as individual marks moving in a consistent direction, avoiding any smudging to create other halftones (medium-value tones). Use graphite minimally, not arbitrarily covering the watercolor painting, but trying to distribute it so that it moves through the entire painting. Pin up the finished work and observe it at some distance. Does the graphite improve the visual effect? Does it accentuate the watercolor properties? As always, put it aside for future reference and delayed judgment.

Since the goal is to contrast watercolor's large, soft, halftone areas with pencil's hard, vigorous, energetic, and opaque linear action, the hue and the depth of value of colored pencils make them a more dramatic addition to watercolor. Redundancy occurs when two different media do the identical job, as when both watercolor and colored pencil are used to create solid color shapes within the same painting. Watercolor is more suitable for that task; colored pencil is too laborious a method. There would also be redundancy if both media were used linearly when it is the colored pencil that is better suited for line work. Thus, if each medium is to do its appropriate job, let watercolor describe the halftone shapes and let colored pencils make only linear marks. Given this principle, each artist arrives at a unique solution. Keep in mind, with any mixture of media, to seek a means of distribution resulting in a cohesive whole.

Colored pencil can be at a disadvantage on such rougher surfaces as watercolor paper. Picking up the pebbly hills and not the valleys, the line can become too textural for the watercolor passages. Try one painting on smoother, hot-press watercolor paper and another on a smooth Strathmore Bristol plate finish, excellent for the pencil and more resistant to the watercolor.

Try laying in all the washes and allowing them to dry thoroughly before applying the colored pencils.

Simms Taback used dyes with a colored-ink outline for his Pets *poster, left, for Scholastic's* Let's Find Out *magazine.*

For Suga Salon, *above, I used a black india ink outline with dyes on Arches paper.*

Think about color experimentally, overlaying the washes with line work in a complementary or analogous color. If it is desirable for the colored pencil to describe or deepen a shape, maintain its linear quality and the direction of the line, allowing the white paper or the watercolor wash to show through in between each stroke. If too much texture or tension results, another watercolor wash can be applied to subdue the contrast. The opposite, too, is worth trying.

Use colored pencils before applying pigment or dye washes of a complementary or analogous color. While the grease of the colored pencils repels both pigment and dye, leaving the hue of the line work unchanged, dyes, having no sediment, leave no film at all. Only the receptive paper between each stroke picks up the color, creating a richly woven visual mix.

Black waterproof india ink is popular with illustrators because it can be laid down first, indicating the drawing, and when thoroughly dry, dyes or pigments can be laid over it without bleeding. India ink line is sometimes used to describe contours and to contain shapes. As such, the ink line seems to help keep the filled-in color from flowing outside the shapes by repelling it. Other times the ink line is used more elaborately to describe planes by creating half-tones through the grouping of lines in one or two directions and cross-hatching. The ink can be applied before and after the washes, although the result may appear freer when the color is placed before the line.

All inks work with greater liquidity on smoother surfaces. Try the hot-press watercolor papers, ink papers, and boards.

Colored inks can be waterproof or water soluble. Since waterproof inks do not move or bleed when a water medium is washed over them, they are more popular, but try water-soluble inks, too. Like colored pencils, colored inks open further horizons for color enrichment. Since the inks more nearly resemble the smoothness and transparency of dyes, there is less tension created by mixing watercolor with them. Washes can be applied over or under the ink or both. Ink color alters with the overlay of wash because colored inks are not opaque.

Watercolor washes over water-soluble colored inks are more exciting and experimental because these ink lines can blur or wash out. Less of a risk is the water-soluble ink line applied over washes or waterproof india inks. Inks can also be used to create washes.

Don Weller used ink elaborately, above left, in his historical figures of Park City, Utah, for a cover of Lodestar magazine.

Milton Glaser used colored inks and dyes in his poster, left, for the School of Visual Arts in New York, 1968. (All design and illustration copyrights held by Milton Glaser.)

Jacob Landau used watercolor and dyes on rice paper over pastel pencils in his Burn Blood Brother, above, one of a series of his works reproduced in an issue of Ramparts magazine. (Collection of Dr. and Mrs. Jack Blumenthal.)

Oil-base crayons, or oil pastels, unlike those used traditionally by children, are turpentine soluble. More so than colored pencil, their texture can overpower an image. Thus, the smoother the surface used, the better. Since these surfaces are difficult to work over, lay in the pigment or dyes and follow with a light coat of fixative to keep the watercolor clean. Once dry, work in deeper and lighter values linearly with the crayons. Then use turpentine or rectified mineral spirits to manipulate and spread the crayon as though it is oil paint. If desirable, all of the oil pastel line can be softened into a partially transparent upper layer. Take care, because these crayons can be worked over to opacity, eliminating the visibility of the watercolor. They are very seductive.

Area Media

Oil-base crayons do cross the line from linear to area media. While they are not for the watercolor purist, many find experimentation with area media in combination with watercolor expansive, resulting in effects that may even be translated into watercolor itself.

Pastel, too, is both a linear and an area medium. Depending on how it is used, the results are referred to both as pastel drawings and pastel paintings. Workable on such textured surfaces as watercolor paper, many illustrators apply pastel over watercolor as line and then blend it in to create soft, transparent planes. Softer in appearance than watercolor, pastel, by contrast, can enhance it. Of course, fixative is a necessity and does tend to deepen the lightest pastel colors. As with other experiments, unimagined effects can be arrived at through a mixture of media that can then be tried by using watercolor alone.

Gouache resembles transparent watercolor when it is used transparently. As such, it is similar to the first experience in building up watercolor during straightening, correcting, and defining details. The opaque areas come into being where there is error or lack of definition. With skill and forethought, however, opaque areas can be distributed to achieve a cohesive whole. The coexistence of transparency and opacity can be mutually enhancing. Gouache is classically used more linearly to build up layers that do not completely cover the previous layers. The color of the lower layer tends to bleed through into the next, creating a unified work. As gouache is used less wet, a smoother watercolor surface, possibly watercolor board or illustration board, is best for the experiment.

Acrylic paint can cover a previous layer completely. Its uniqueness lies in its greater opacity, greater than that of any other medium. Acrylic also dries faster and does not bleed through. There are, however, acrylic paintings that strongly resemble transparent watercolor. Used with a drying retardant that looks like Chinese duck sauce, the pigment appears less chalky and can be used like transparent watercolor. With much water, it can be applied to a gesso-prepared canvas and allowed to run and puddle effectively.

Many artists use acrylic transparently for the initial layers, building up slowly and selectively to opaque areas. On heavier board, investigate laying down thin acrylic washes. Observe the differences and your preferences. If the chalkiness is bothersome, a layer of polymer as the final glaze could be a solution or the use of a drying retardant during painting. To experiment with acrylic over watercolor, try a layer of fixative prior to the layer of acrylic to prevent staining and allow more time for manipulation. Transparent watercolor on watercolor paper varies in appearance dramatically from artist to artist. Add to that the variety of surfaces available. Then, consider it in combination with another one or maybe two media, and the possibilities multiply geometrically. Find the adventurer within yourself and try anything convenient or stumbled upon. Experimentation and exploration are roads to expanding a personal method of working and a unique visual language.

Seymour Chwast used colored pencil and acrylic for Walking on 14th Street.

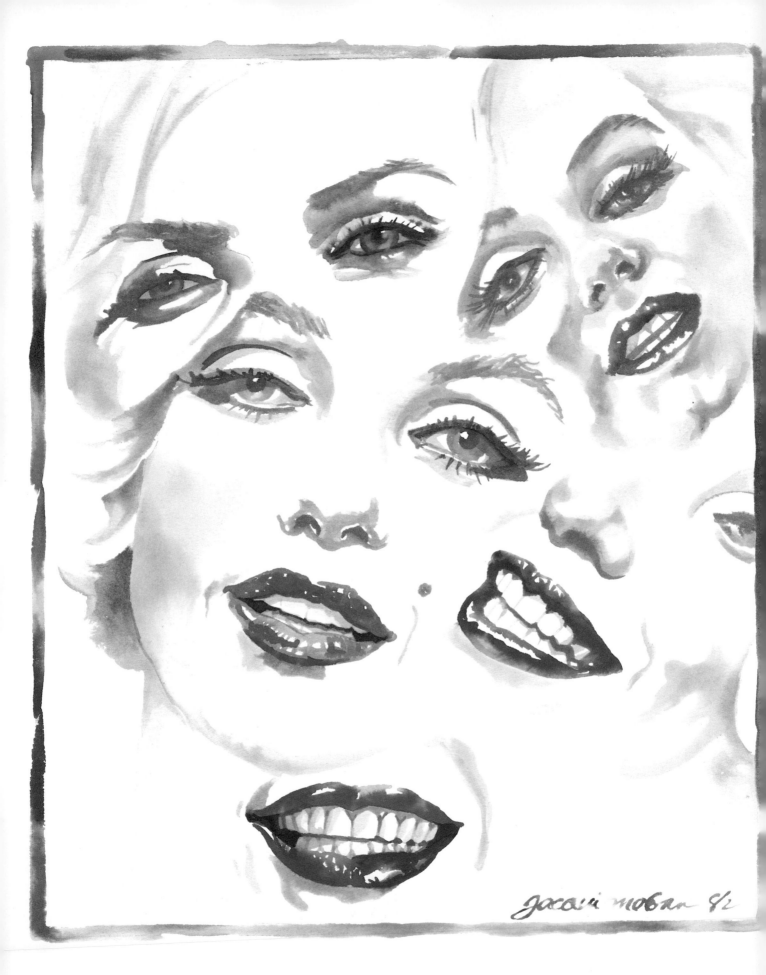

8

Technology for Illustrators

Rare are the times when an illustrator is able to draw or photograph a celebrity from life. Therefore, he or she frequently relies on the work of other photographers. The reference material may be provided by the client, or you can do research in a library picture collection or in a bookstore. Sometimes you can instruct a company photographer to take the pictures you need. While the choices may appear to be abundant, the specific needs of the watercolorist narrow the possibilities.

You will need several sharp photographs with one, or a maximum of two, distinct light sources. The goal is to enlarge, to create something more, not to copy a photographer's image. There is an additional impetus not to copy—possible copyright infringement. Therefore, the more information you can obtain from several photographs, the more liberated you will be. It is easier to achieve a convincing likeness when you are not enslaved by minuscule details perceptible in one photograph and not in another. In addition, photographs often lie by distorting the subject, frequently intentionally, sometimes not. Distortion may be due to the lens, to the extreme angle of the shot, or to the direction of the light source. The more diverse the source material you have, the more discerning you can be about painting choices.

Photographs for Research

As a rule, avoid wasting research time by looking through newspapers. The lack of size, sharpness, and detail in their photographs make it a losing battle. Only slightly less wasteful is the romantic, silver screen, diffused-lighting photograph. For all subjects, a strong, preferably single light source best defines the sculptural form.

Aspects of Marilyn *was done from several black and white photographs using an opaque projector to speed up the designing process and to vary the sizes of the different photographs. The border was done by charging several colors into a juicy bead of water. (Dyes on Arches paper.)*

After all these technical considerations, the mood, the public image, and the attitude of the subject is important. Look for the reference photograph that best represents the celebrity's public image in the context of the particular assignment. A public image is not necessarily the most truthful likeness but it is probably the one that is required for communication with viewers.

Obviously, research is time-consuming. Although it is sometimes provided by the client, most illustrators continuously collect and file potentially useful source material. As their picture morgues or personal libraries expand, their filing systems become more sophisticated and descriptive. For source material on people, for example, individual file folders may read: Famous, Children, Elderly, Exotic, Beautiful, Executive, Fashionable, and Exercising.

The Opaque Projector

The opaque projector permits a photograph or a reproduction from a book or magazine to be projected directly on the final painting surface by an arrangement of mirrors. The opaque projector can enlarge an image up to three times its original size or reduce it to one-third of that size. The contours, as well as the shapes of light and shadows, can be traced onto the final surface. The advantages are that you save time by eliminating any struggle redrawing in a different scale while maintaining correct proportions and that you are able to see immediately how several images from different sources can be used together by changing size and position. Another advantage is that you need not understand the structure of the head so thoroughly.

An opaque projector is certainly more efficient than a lucigraph, or luci, which is limited to projection of line. A luci requires tracing the photograph onto a sheet of tracing paper before transferring it to the final painting surface. A slide projector is not a substitute for an opaque projector because the slide projector cannot handle printed source material from a book or magazine unless a slide is shot and processed beforehand.

Perhaps the opaque projector makes the greatest contribution to the illustrator's work by enlarging thumbnail sketches and comprehensive drawings. Thumbnails, the tiny sketches made to scale that most illustrators do before they commit themselves to an idea, are usually fresh and gestural. Opaque projection can preserve these qualities. The successful

Burt Silverman painted Teng Comes Calling *for the cover of* Time *magazine with watercolor on plate Bristol. (Art Director: Walter Bernard.)*

portions of several thumbnails can be projected in a single step onto one surface, each retaining its own energy, thus facilitating the drawing and designing process.

Comprehensive drawings, called comps, are often required by clients prior to the final painting. These are usually done in reproduction size and can be enlarged accurately onto the final surface without use of a photostat or a grid. Most illustrators prefer to do the final art 150 percent larger than reproduction size. Painting is easier and freer, and when the work is reduced for reproduction it looks tighter and, by some criteria, more professional.

Two of the most popular opaque projectors are the Artograph DB 300 and the German-made Leisegang. Each has advantages and disadvantages. The Artograph is made for illustrators. It has a large copy area so that reference material up to 10 inches by 11 inches (25.4 cm by 27.9 cm) can be inserted and projected in a single step. This is a big advantage since it can be tedious and frustrating to cut, fold, or otherwise damage source material in order to project a single image in segments and assure accurate registration without distortion.

The advantage of the Leisegang is its excellent lens, which is so sharp that it is not necessary to darken the studio when using it. Precise detail can be projected. In addition, its compact design requires much less studio space. The only disadvantage is that its copy area is only about 5 inches (12.7 cm) square. The Artograph requires much more space, is not as well-machined, and has an inferior lens, which may distort a projected image at the edges.

Now that you have heard the praises of the opaque projector, you should be aware that dependence upon it has its drawbacks. The all-too-numerous illustrations and paintings that seem to scream the original photographs from which they were done can be blamed upon the illustrator's enslavement to either the opaque projector or the slide projector. A photograph sees much more than the human eye does. Faithful recording of minute surface detail does not compensate for the lack of structural understanding and a personal point of view. The struggle inherent in achieving a good drawing is a visible asset in the finished product. Until the illustrator's understanding of facial structure becomes visceral and his or her personal point of view second nature, the opaque projector can be an enslaving disadvantage and a means of stunting artistic development. Drawing from

life, drawing from a photograph taken by yourself, or drawing from a photograph without projection, are, in descending order, the better methods of working. The opaque projector's additional use for thumbnails and comps, however, can make it an extremely functional studio tool.

Personally, I do not enjoy the process of using an opaque projector or a slide projector. Both require time to make my naturally light studio dark enough to see the projected image. At that point it is difficult for me to see what I am drawing or painting. I also dislike the droning noise each makes while in use. They also take up precious space. Recently, therefore, I have begun to take advantage of two other studio tools instead—the rear projector and the personal copier.

The Rear Projector

The rear projector is a 9-inch by 12-inch by 6½-inch (22.8-cm by 30.5-cm by 16.5-cm) black box which enlarges the 35mm slide on a front screen without making any noise. The studio can be kept fully lit. The projector sets up quickly, stores easily, and requires no engineering talent to use. Its limitation is the maximum size of the projection which is 8 inches by 10 inches (20.3 cm by 25.4 cm), although there are models available that also magnify sections of the slide. The ideal situation is to build your own rear-view projection system with a large screen that can be dropped from the ceiling. Short of this, the Diastar by Osram is a useful studio tool.

The Personal Copier

Personal copiers are now available at prices reasonable for individuals. As with all technology, each year they will probably improve and cost less. I purchased the Canon PC 25, which enlarges and reduces to fixed percentages. There is no zoom lens. However, a copy can be fed in repeatedly to achieve an image of any size. Graphic designers require the more expensive zoom lens models because for them size is not a question of comfort but of precision for reproduction. The personal copier is virtually service-free because its cartridges are removed and replaced as a unit with the roller. As the salesman said: "It's a white glove operation." Cartridges are also available in colors, and both sides of a paper can be copied. Best of all, the personal copier is small, about 20 inches by 28 inches by 12 inches (50.8 cm by 71.1 cm by 30.5 cm). I suspect that the longer I own it the more uses I will find for it.

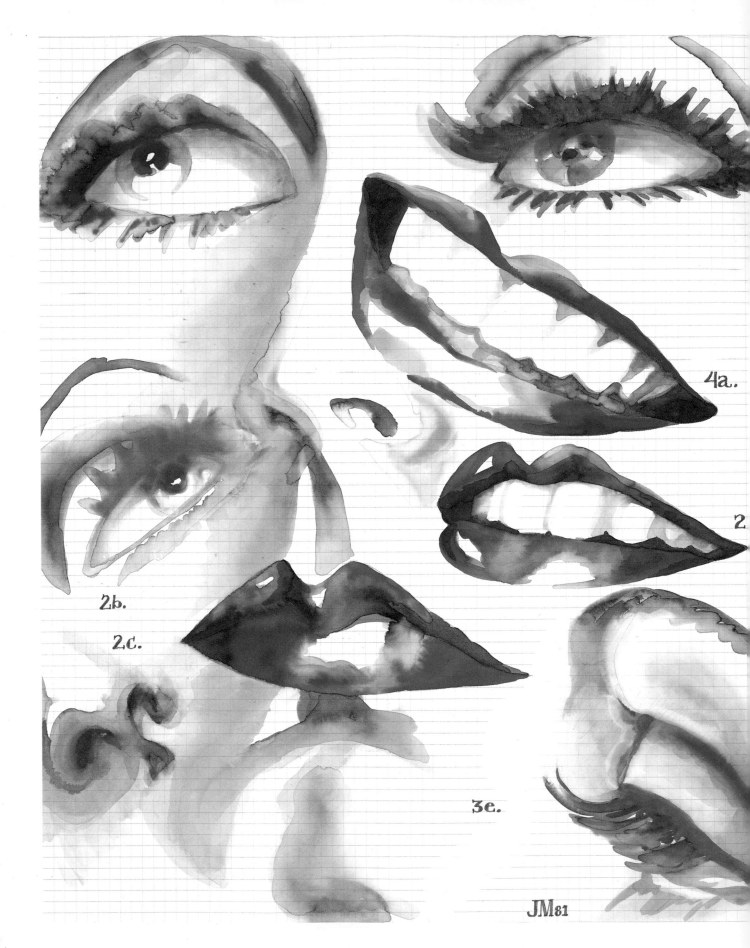

4a.

2

2b.

2c.

3e.

JM81

98

Before purchasing a personal copier, locate a local commercial copy shop that has a machine that enlarges and reduces. Patronize it and discover how many ways photocopies can help you. They cost pennies and are instant. For most of an illustrator's needs they are superior to photostats, which take longer and are costly. Photocopies enhance the pencil drawings I send to clients. Graphite line on tracing paper translates to black line on white paper. If a piece is large, it can be copied in sections and taped together. In this way, I can send a copy to the client and keep one for myself. Sketch adjustments can be discussed by telephone, and the original sketch need not be sent back prior to going to finish.

I also recommend a personal copier as the best method for doing color and value comps. Make several reduced copies of your drawing. These will encourage you to experiment with color and value treat-

Greta Garbo, *left, was done from a series of black and white photographs with the help of an opaque projector. The puddling of the dyes occurred because the painting was done on plate Bristol.*

The Garbo painting above was reduced on my personal copier.

ments in order to arrive at the best solution with the least tedium. Use of watercolor is possible but limited on this paper, which will probably take only two layers without fatiguing. But then it's so easy to grab another copy to paint because the drawing does not have to be redone. Other lightweight papers can be copied. Colored pencils and markers can be used. Even though I no longer use black line for my finished art, these comps are helpful not only to myself but also to art directors and clients who use them as a basis for discussions about treatments.

Finally, I take the approved "pencil" and enlarge it to a comfortable scale for painting. Taping the sections together with magic tape, I lay it over my light box, place watercolor paper over it, and trace or improve the drawing as I transfer it to the watercolor paper for painting.

In this way I save the time previously wasted rearranging the studio and retracing work. Too often the process of enlarging and reducing was so tedious I couldn't maintain my excitement about the job, and that lack of enthusiasm was visible in the finish. Using the copier and the rear projector are applications of technology that keep the fun in the picture-making process and enable me to use precious time far more effectively.

Taking Your Own Photographs

For the illustrator, photography provides reference material in the same way that reference books help a writer, especially when historical or technical accuracy is required. The illustrator can work from photographs as though drawing and painting from life, without tracing, using knowledge of form and structure in a loose, interpretive way. Photographs taken by others, of subjects too inaccessible to photograph yourself, may be incorporated into the painting, perhaps again utilizing the opaque projector for rapid visualization. And, as is often done for paperback book covers, a ministage can be set up, complete with authentically costumed models and backdrop, providing an agreed-upon point of departure for the art director and illustrator as well as for the publisher.

There is, however, danger in becoming enslaved to found source material. One risk is the possibility of copyright infringement; others are the less-than-perfect angle, mood, and point of view of a photograph, its flat lighting, and insufficiency of choices which amount to painting from another person's image and

way of seeing. If you are unable to draw and paint the subject from life, by taking your own photographs you begin the creative process at the source.

As the artist, you control the lighting, angles, and attitude of the photograph with the use of the finished painting in mind. There is no need to compromise. In addition, by taking your own photographs you avoid the often time-consuming, tedious, and frustratingly inadequate task of researching source material.

Types of Photographs

The choices of types of photographs range from instant film to black-and-white and color prints, to color transparencies, each with its own advantages. Consider your primary needs first, and then decide how much technical involvement is necessary before selecting a type of photograph. Use of color film requires slightly more technical know-how than does black-and-white. And control of lighting is the single most important ingredient for reference material for watercolor. With color film, it is necessary to become familiar with the temperatures of light bulbs in order to select the appropriate film to achieve the most authentic color. Knowledge of color filters may also be helpful.

For a painter-illustrator, however, such investment of energy into the technicalities of photography is probably misplaced. This is a watercolor book, and this section is intended to simplify the photography process as another tool for painting. A separate book dedicated only to photography would be necessary to cover the wide range of photographic possibilities. It is, therefore, advisable to make all photographic purchases from a shop whose clientele includes professional photographers. There it should be easy to obtain specific advice on the choice of film for the specific subject and light source.

Many illustrators use a Polaroid camera. By eliminating guesswork and processing time, it is an excellent solution for the overnight job. It also has the advantage of allowing you to see instantly a two-dimensional photograph of a concept, making it possible to change or recompose it immediately. Another advantage is the simplicity of operating a Polaroid. No one can be intimidated.

One disadvantage is the small size of the print. The opaque projector does not enlarge a Polaroid print very well because the image is rarely sharp enough to withstand much magnification. Flash attachments light only the planes parallel to the camera lens,

flattening and widening the forms. Color is also distorted. It is not uncommon to see red pupils and other color exaggerations that are not easily adjusted. In addition, an instant camera is rarely, if ever, a single-lens reflex camera. This means that the cropped view seen through the viewing lens is not what is photographed. Further, although Polaroid cameras are amazingly inexpensive, the film is not, because battery and processing chemicals are part of each pack of film. Finally, the film is often not perfect, requiring you to take more shots than expected.

Other illustrators use exclusively a 35mm single-lens reflex camera and positive, or slide, film not only to shoot on location and while traveling but also for interiors with models. As the name implies, there is no negative. The product is not a print but a transparency. Transparencies have the most authentic color and sharpest detail, and a great deal of information is captured. Some positive film can be processed within three hours, making it almost as convenient as instant film. For color authenticity there is no better choice.

To paint from 35mm transparencies you will need a slide projector, a darkened section of the studio, and a white screen on the wall. While the projector is running, you will hear the hum of its machine fan. The size of the projected image, however, is practically unlimited without loss of detail. If an enlargement of a 35mm slide to 8 inches by 10 inches (20.3 cm by 25.4 cm) suffices, the small rear projector will do the job. Osram manufactures the Diastar 200 as well as more elaborate projectors that can be used in a lighted studio and are silent.

If you prefer to paint from a print, prints can be made from selected transparencies, but there are disadvantages. A negative must be made from the transparency before making a print. Not only does this process use precious time, but the print is two steps removed from the sharpness and accuracy of the transparency.

Weigh for yourself the need for color information from source material. Many illustrators and painters who utilize photography prefer black-and-white prints. Lack of color aids their perception of light on form. For many people, color information is a distraction, hindering perception, personal visual development, and freedom. Black-and-white photographs are also easier to shoot. The temperature of the light source used makes no difference in the choice of film. Any type of bulb is usable, from quartz to fluorescent

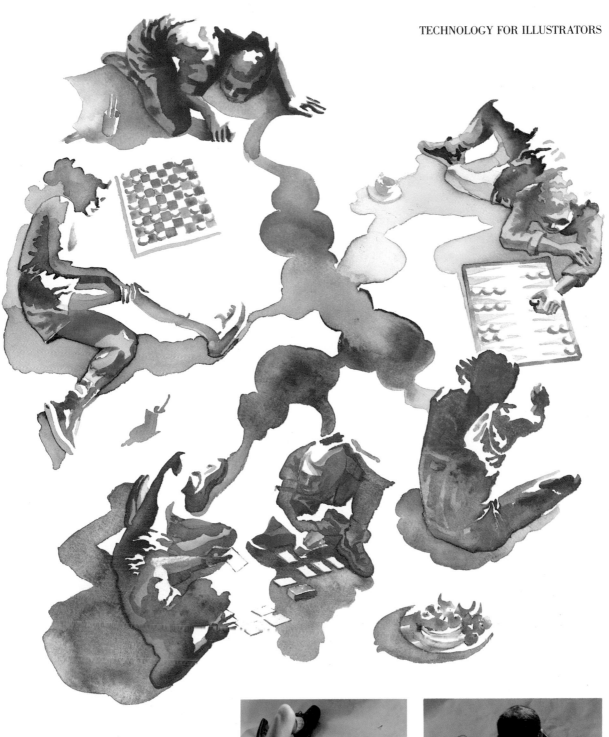

To have all figures playing board games in Watercolors Play Games, *it was necessary to see them from above. Since it would be quite impractical to paint from the top of a high ladder, I photographed a male model and made some gender changes in the drawing. (Dyes on Arches paper, for Champion Papers, Imagination 25. Art Director: Jim Miho.)*

Two of the prints I used as reference.

to incandescent. And, for many people, working from an 8-by-10 print is more flexible and pleasant.

Black-and-white print film, however, requires more time for processing and printing when it is sent to a lab. Unless you are expert at reading negatives, it is better to have a contact sheet made of all the negatives before you decide which of them to make into large prints. The delay between shooting and having the print to work from, originally perceived as a disadvantage when deadlines are tight, often turns out to be a positive aspect. You will view the results with a fresher and more objective eye, making your painting choices with greater clarity.

Color print film has the advantages of quick and inexpensive processing for 3-by-5 prints. While the color and detail do not compare to those of transparencies, the results can be quite adequate as a source to paint from. Several prints can be taped or tacked up in front of the work area to be referred to at will. All can be used in the service of creating a single painted image, providing more information and painting choices. Or several different shots may be incorporated into one illustration. Here, too, the opaque projector is useful to vary rapidly the sizes of images in relationship to one another and to allow you to try a variety of compositions.

The Camera as a Tool

The instant camera is so simple to operate that it need not be discussed here. The 35mm single-lens reflex camera needs some explanation. While simpler cameras are constantly being marketed, it is a wiser long-term investment to purchase a single-lens reflex camera that operates both automatically and manually. It can be used quite simply, and as you master the technical aspects and desire to do more sophisticated photography, the capabilities are already there. No trade-in for, or further investment in, or adjustment to, new equipment need be made. Although you could enroll in a short beginner's course to become accustomed to using the camera, referral to the handbook accompanying the camera and a minimum of practice are all that is necessary. The two items requiring adjustment that are of most concern to everyone are the f/stops and the shutter speed.

F/stop refers to the lens aperture and the depth of field. When you focus on a subject, not only is the subject itself in focus but objects both in front of and

I took black and white photographs of Marisela Godoy because I find it is easier to understand values when I am not distracted by color.

The painting is not a strong color statement, but almost any colors can be used as long as the values work.

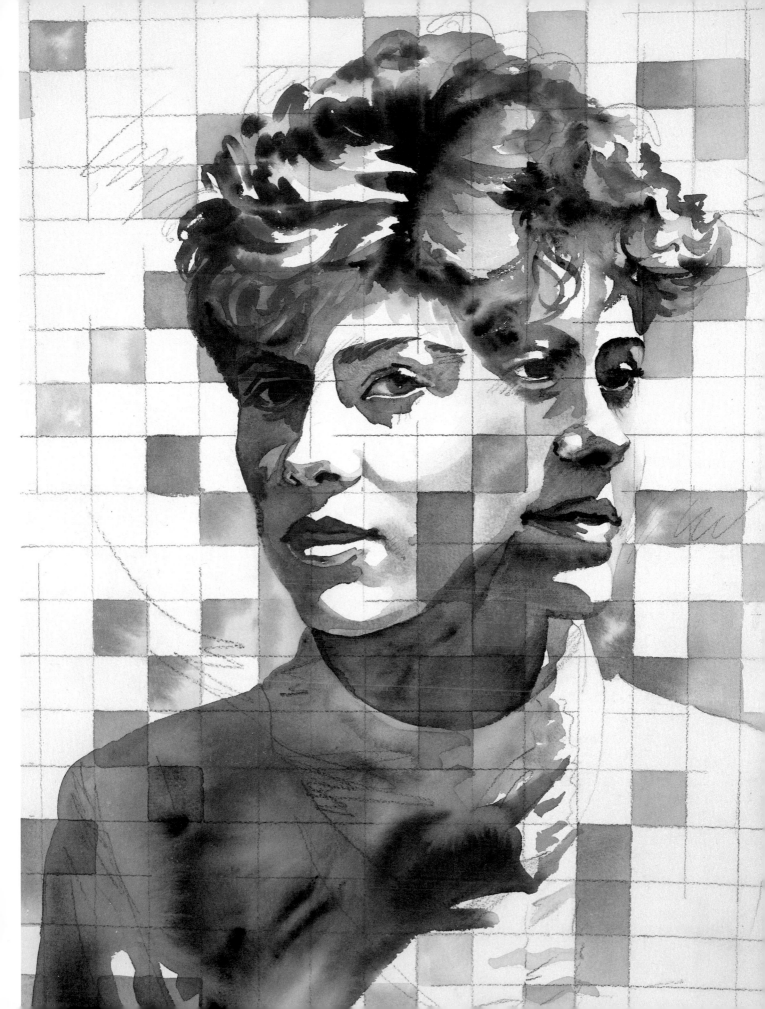

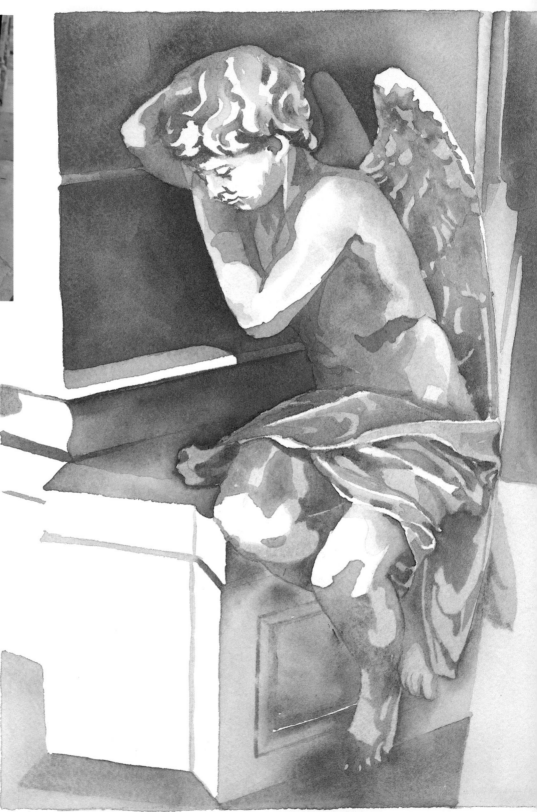

I took a 35mm slide of a portion of a tombstone in Buenos Aires. While painting, I used a small rear projector that blows up a 35mm to 8" × 10". One of the reasons I enjoy painting white or no-color forms is that I am freed to use color independently of any local color considerations. I can use it at whim or to increase the sense of form or to push some of the forms back and others forward toward the picture plane.

behind it are also in focus. This zone in focus is called depth of field. Depth of field varies mostly according to the subject's distance from the camera and the lens aperture, or f/stop, in use. The wider the aperture, the lower the f/stop number and the shallower the depth of field. The narrower the aperture, the higher the f/stop number and the deeper the depth of field. Also, the more closely you approach the subject, the shallower the depth of field and therefore the more crucial is precise focusing. The depth of field behind the subject is always larger than that in front. For painting reference purposes, concern with f/stop is minimal. Avoid the widest aperture, or lowest f/stop number. It is the subject that needs sharp, careful focusing.

Under controlled lighting, the shutter speed probably needs adjustment only once in the course of a shooting. The slower the shutter speed, the more light hits the film, but the greater the likelihood of the camera's shaking. The faster the shutter speed, the less light hits the film and the smaller the likelihood of a shaken, blurred image. The latter situation, however, requires a more intense light source. Sufficient light is the key in order to have both a low enough f/stop for depth of field and a high enough shutter speed to attain sharp detail.

As a rule, for hand-held photography, avoid shooting at a speed lower than 1/60th of a second. Set the shutter speed at 60 and adjust the f/stop for the correct exposure as indicated by the built-in light meter. Most often, it is a matter of lining up the f/stop needle with the shutter speed needle. If an adequate exposure cannot be achieved, then a stronger light source should be used. The camera handbook indicates with diagrams and photographs the location of all camera functions, including where to set the film speed of the particular film being used so that the built-in meter works accurately.

Film speed is a film's sensitivity of response during exposure to light. It varies with film type and is clearly marked on the package. Film speed is indicated by an ISO or ASA number. The lower the ISO number, the slower the film, that is, the more light is necessary for exposure. Film speed, or light sensitivity, ranges from ISO 12 to about ISO 4000. The slower the film speed, the finer the grain; the faster the film, the coarser the grain. Very coarse grain is effective for some photographs, but grain can distort the form of the subject so much when enlarged that the image fails to provide sharp detail for reference. If there is adequate light, ISO 64 through ISO 400 is a safe range for sharp results. To reiterate, more light makes it possible to use lower-number ISO ratings to achieve less grainy, sharper images.

For simplified shooting, after loading the film, set the appropriate ISO film speed number. Arrange the light on the subject so that the shapes of the shadowed areas define the form or set up the best communication. A single light source to one side of the subject reveals the most about its planes and form. The camera, however, sees darks much darker than the human eye, resulting in complete loss of detail in those areas. Therefore, it is necessary to place a large white board or a sheet of aluminum foil on the side opposite the light source to bounce enough light into the shadow to reveal detail. The difference should be clearly visible to the eye. Try also lighting the subject from directly above and below, because the moods created are so dramatically different.

Set the shutter speed at 60. Turn the battery on so that the light meter functions, and adjust the f/stop to the number it indicates. Then focus and shoot.

Next, apply a useful technique of professional photographers: bracket. Bracketing is shooting the identical situation two more times, one f/stop number higher and one f/stop number lower than the first shot. The choice of three exposures not only assures accuracy but also allows for taste and suitability of mood.

After the composition is resolved and transferred onto the final watercolor surface, prints can again be taped up for easy referral.

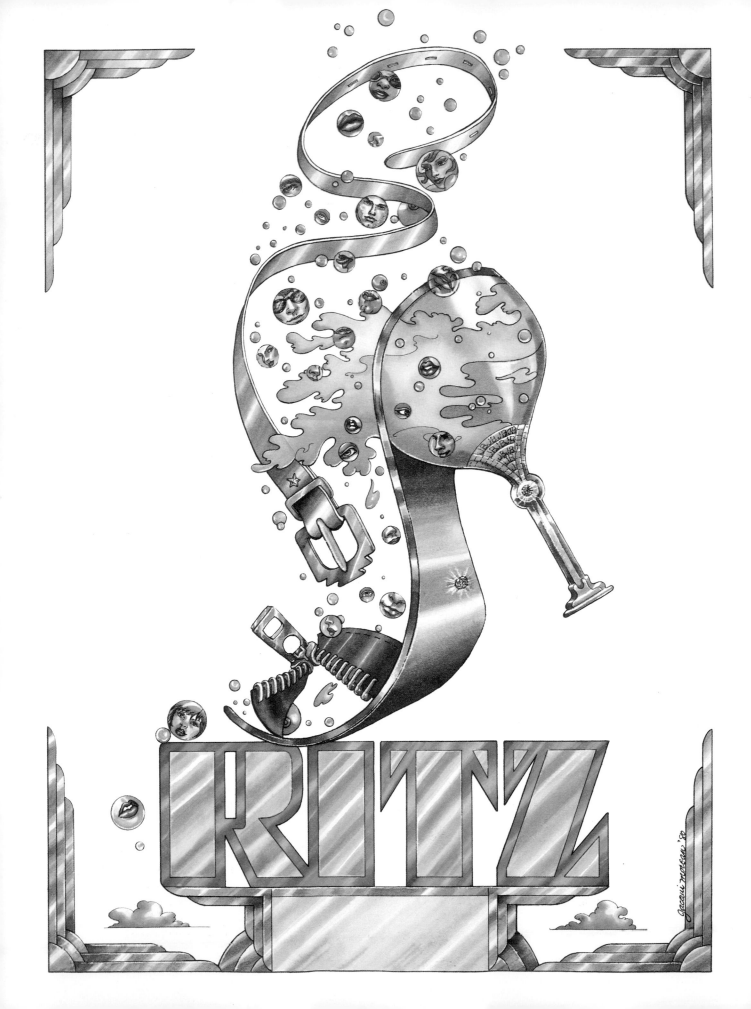

9

From Commission to Finish

The Ritz *was commissioned for the New York discotheque's opening invitation and the art was also used in black and white as full-page newspaper ads. Many of the small bubbles enclosing parts of faces were painted separately, cut out, and patched onto the large piece of artwork. (Dyes on Arches paper. Art Director: Jerry Brandt.)*

Every commission has its own idiosyncrasies, time frame, and limitations. It is this variety that makes an illustrator's work interesting and, on occasion, frustrating. One of the most variable aspects is how much of a job is conceived, resolved, and sold to a client before an illustrator is commissioned.

Often in advertising, a precise tissue, or layout, is given to the illustrator. On this, each element of the illustration, its location, and the projected amount of text will be indicated. The client will have already approved this layout. Major changes of design and imagery by the illustrator are not welcome. All that is required is skilled handling of the material. And, even then, the agency wishes to see a sketch, referred to as a "pencil," of the illustration before the illustrator does the finished artwork.

On other occasions, particularly for editorial jobs, the illustrator is given a manuscript, book, or synopsis of a plot or copy line and is then expected to provide original concept material. The initial presentation will be verbal. Later, visual sketches must be presented for selection. That can be followed by requests for more realized sketches, called comps, which are often in color and as thoroughly resolved as a finish. The difference between a comp and a finish is that the comp is done on a smaller scale and colored pencils or markers are often used rather than watercolor. Comps can also be done in watercolor.

As a rule, the larger and less visually oriented the approval committee, the more realized the comp must be. Some illustrators prefer doing a tightly realized comp because after it is approved, they are less apprehensive when working on the final leg of the job. Other illustrators hate to do what is, in essence, the same job twice. Therefore, they either avoid this type

107

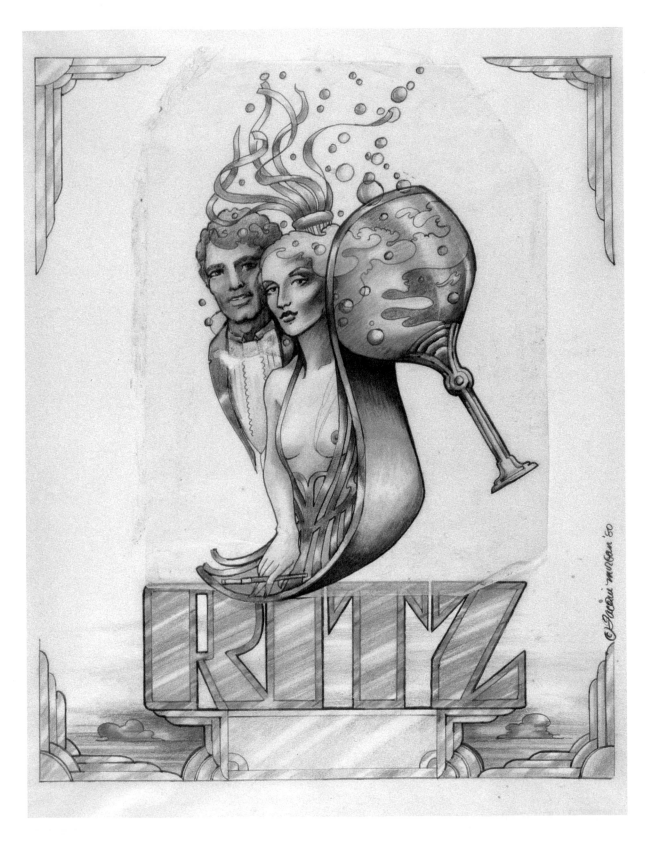

of job or prefer to make changes in the finish, though making such changes is never anyone's favorite thing to do. Some illustrators always work with the same people, who know what to expect and need not see sketches. And, too, there are those whose output is so consistent and professional that requests for redos are a rarity.

The time frame also varies. For a newspaper, a commission can span as few as twelve hours from inception to finish and delivery, allowing no time for sketch approval. Although this is not a preferred method of working for newspaper editors, it often occurs when there is a past history of successful telephone communication with the illustrator regarding concept and consistent excellence of solution. A forty-eight-hour newspaper job, however, may well include the submission of a sketch for editorial approval prior to final execution.

Other commissions for a single painting, such as those for a film or the theater, can span as much as a month or two. In that situation, several well-realized concepts are expected from the illustrator, for which he or she is paid whether or not the job moves into the final stage.

There are also those commissions involving a series of illustrations for corporate annual reports, house organs, books, and advertising campaigns, as well as animation designs for television commercials. These can allow for longer periods of time. All the exceptions notwithstanding, the average time frame is two weeks, the first week for presentation of concept and design, a day or more for approval, and the balance for execution of the finish. The brief time period and the variety of challenges are additional attractions of the illustration profession.

Each commission also has its limitations and requirements. The first is format, which is governed by the vehicle of communication; magazines, newspapers, posters, billboards, mailers, books, and films dictate their own proportions, color and production possibilities, and amount of text. Budget and design decisions modify these givens. Finishes must be done to precise proportions, but the actual size of the finish is usually considerably larger than reproduction size and is often determined by the illustrator.

Other limitations lie in the content, or communication, the purpose of the job. The visual is guided not only by the text but also by the audience to be reached and the image the advertiser or publication has decided to project. A periodical, like an advertiser, has a public image to uphold. Articles on the identical subject speak to their audience in accordance with the publication's point of view, that is, its public image. Some illustrations quite literally illustrate the accompanying text, but most have the purpose of provoking attention, stating the general problem or mood, or drawing the audience to read the text. It is useful, therefore, for the illustrator to be acquainted with the publication's point of view in order to seek work from visually sympathetic sources. It is also useful to learn how to listen, to read between the lines of what the designer, editor, and art director say, to get a feel for the unspoken portion of the communication.

It is helpful to keep in mind that a successful illustration, one that satisfies the illustrator and the client, depends upon a partnership—good communication and teaming of efforts. While the illustrator does the painting alone, the designer or art director often makes the crucial contribution, taking the solution out of the ordinary into the exceptional.

The first comp for The Ritz *was done on tracing paper with colored pencils, when it was thought that the original 1930s decor of the space would become a prime advertising theme.*

The original marquee art, above, was made into a huge transparency. In less than six months it faded from exposure to sunlight.

Poster: *The Tap Dance Kid*

1984
Broadway Show
Producer: Stanley White

The painted three-dimensional shoes, above, appeared in an article about my work in Graphis, *1978. (Acrylic and oils.)*

A COMMISSION to do a poster for the Broadway show *The Tap Dance Kid* had a relatively long time frame, beginning during development of the show. As such, it went through more than the average number of stages, but it well demonstrates the process from commission to finish.

Ed Marson, the initial designer, and Stanley White, the initiating producer of the show, telephoned me because of an article in *Graphis* that reproduced some of my painted women's shoes. The lighting of the shoe photographs was dramatic and theatrical, stimulating their idea to do something similar with tap dance shoes, a unique idea for a Broadway show. Among other limitations, the bottom of one shoe had to be visible to show a tap because the uppers of tap shoes are not recognizably those of dance shoes.

The show's story of a middle-class black family is complex to portray visually. The major conflict is between the nine-year-old son and the father. The boy hates school and does poorly in his studies. He dreams only of tap dancing, wanting to be a professional dancer, like his mother's brother. The father, a successful, upwardly mobile attorney, soon to be a judge, is horrified that his only son appears to be taking a step backward in black history. Forbidding his son to dance, he reenforces his expectation that his son will enter the law, like himself. A related side plot involves the only other child, an unusually intelligent but overweight daughter of thirteen, who wishes for nothing better than to be an attorney. Though at every opportunity she engages her father in legal discussion, the idea of a woman becoming an attorney appears ridiculous to him. Thus the entire family is in conflict with the visionary father, who has invested so much extraordinary effort to realize his own ambitions.

After reading *Nobody's Family is Going to Change* by Louise Fitzhugh, the novel upon which the show is based, I read the script and lyrics while they were in process. Seeking as much input as possible, I questioned the producer on casting to get more visual information. The response was his desires, which were for vague possibilities such as Diana Ross as the beautiful mother and James Earl Jones as the impressive father. For the boy, I knew the problem would be similar to that of the show *Annie*, which required several Annies, if the show became a long-term success. Armed with this information, I made tiny rough thumbnails, which evolved into the colored-pencil comps shown here.

Above are the original comps for the poster for the Broadway musical
The Tap Dance Kid. *Done with colored pencil on tracing paper, they*
explored the possibility of painting three-dimensional tap shoes.
Unfortunately, they more nearly represent serious drama or fiction
than they do the magical energy of a Broadway musical.

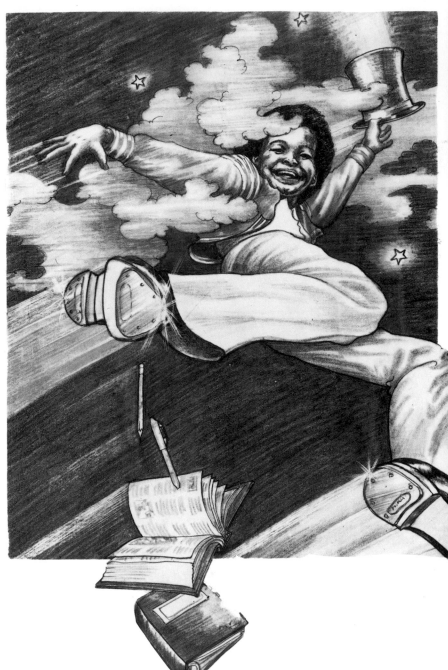

The photographs above are the results of a one-hour session with a model at the Bob Osonitch photographic studio. These black and white prints worked even better than I had hoped as reference for the watercolor poster.

The colored pencil comp combined parts of several photographs, discarded school books, exaggerated foreshortening, and enlarged tap shoes. I wanted it to say, "Leap to freedom, out from one world into another."

I found the concept challenging and exciting; if it could be made to work, it would be unique among Broadway theatrical posters. The resulting color comps, however, speak more of drama or even of magazine fiction. I was forced to accept that the static, three-dimensional shoe forms hampered any communication of energy and fantasy so necessary to the American musical genre. The presentation moment arrived, and, since a picture can be worth a thousand words, the visual concept was dropped without any further discussion of its merit.

My disappointment was probably equally shared by the designer and the producer. Almost immediately, I suggested a watercolor of the kid, seen from below, leaping into the clouds, with enough exaggerated foreshortening to show the taps visibly gleaming, the whole expressing boundless energy, freedom, and joy. No sooner was the concept verbalized than Ed Marson stated that it had been his original concept, though he had thought it could be executed photographically. Sometimes there is only one really appropriate solution, although each individual would handle the image differently. Certainly a painting provides more possibility for expressiveness and fantasy than does a photograph.

With enthusiasm almost equal to the first time around, it was agreed that I arrange to have photographed a suitable model to use as a point of departure. The photographic session for this first step of the illustration process began with the attempt to stop the action of leaping and record the spontaneity of the gesture. After about ten of the thirty-six black-and-white shots were thus spent, Bob Osonitsch, the photographer, suggested we seat the model at the edge of a high stool and have him imitate the jump, so that hands, feet, and facial expression could be guided.

From the contact sheet, I chose about three shots to be made into 8-by-10 prints. From these I combined the best portions of each, exaggerating the foreshortening so that the shoes and taps could be dramatically out of scale, but would still read as a convincing part of the figure. The colored-pencil comp included the discarding of the boy's school books and his leaping out of the frame to freedom, which was accentuated by rainbow bands of motion and his head among the clouds.

The next step was to simplify the image. The rather lengthy title of the show had not as yet been considered in this context. Combined with all the existing elements and the essential-to-the-mood sky in the

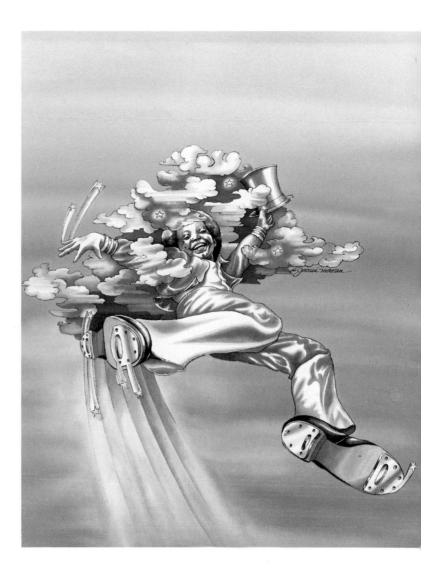

The first painted version of the poster was done with dyes with an india ink outline on Arches paper. The line, which makes this resemble my earlier work, creates a more graphic image for reduced newspaper reproduction, but lacks magic.

113

The comp of the title treatment done in dyes, top, mirrors the reflections of the shoe taps.

The poster as printed, above, has unauthorized changes made to the rainbow and stars shooting off the shoe. These were made by the agency with opaque pigments to allow more space for type. By patching I could have done it transparently, without any evidence of retouching in the reproduction.

The camera-ready art for the poster, right, has Broadway entertainment magic, and more emotional content. The painting was done in uniformly transparent dyes on Arches paper.

background, the image required simplification. Successful posters read and have impact from some distance. But perhaps the more relevant factor for a theater poster is that it must also read and have impact in newspapers, where it is reduced and poorly printed in black and white. The show title has to be large enough, relative to the overall image, to read in a newspaper ad 4¼ inches by 7 inches (10.8 cm by 17.8 cm) or less.

Keeping in mind the requirements of newspaper reproduction I began to eliminate elements without loss of mood. The next version, in dyes, was more graphic, enhancing the effect of the design for newspaper use, but it lacked magic, drama, and charm. The producers, by this time a group of people who were working with an advertising agency, provided a variety of information about the personality of the boy, his haircut, and his dress and wanted a more surrealistic, magical image. Naturally, some of the information was in conflict, but I wanted to try a more painterly watercolor, avoiding a tightly rendered image, maintaining the transparency of the concentrated watercolor while achieving drama.

After the poster image was completed to everyone's satisfaction, the third step was the placement and treatment of the show title. I tried variations of an arc motif, and I painted a few versions of type in watercolor, repeating the metallic reflections of the taps on the shoes. I was pleased with the result as a painting, but for newspaper reproduction the type was too complex. At this point, the advertising agency took over and the drop-out title is the result. Probably an even simpler, cleaner title would have been preferable.

Surprisingly, the advertising agency took it upon themselves to alter the stars shooting off the boy's right foot by adding opaque pigments, perhaps to allow room for type; I could have made those changes with transparent color.

Although changes or additions, especially on the original art, are unethical and unprofessional, the design is really no worse for the change. Although it is not visible to the average viewer, the original and reproduction are no longer uniformly transparent. Fortunately, I had the original art photographed before the change, so you may judge the relative loss for yourself.

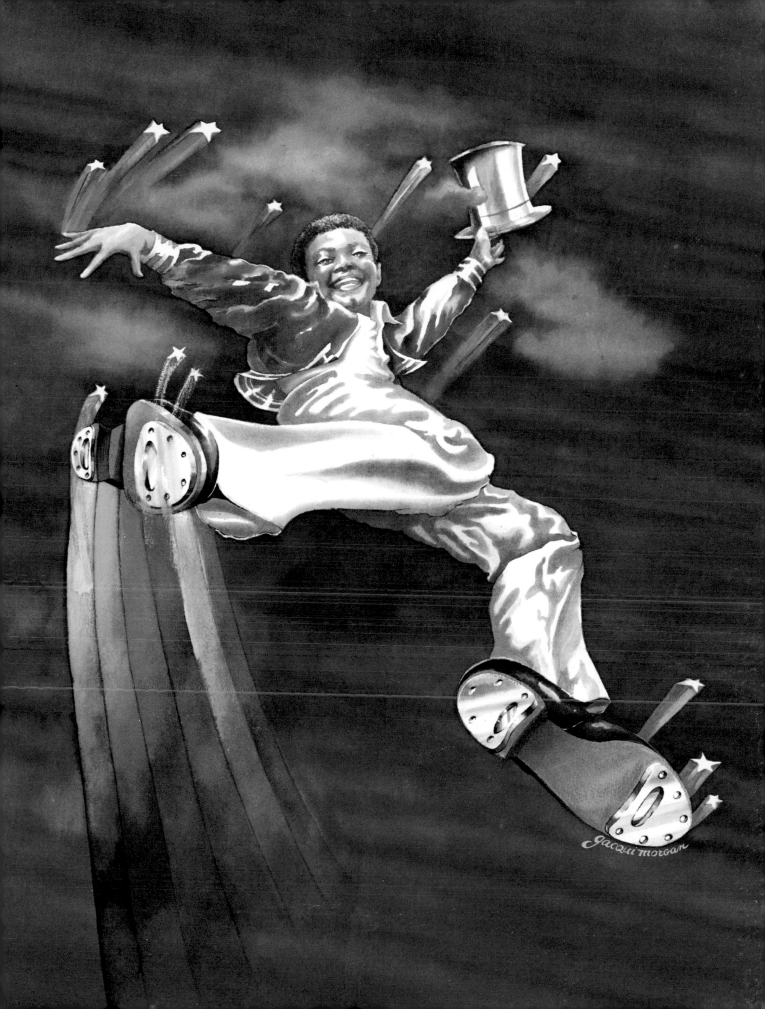

Poster: *The Joy of Seeing*

1973
American Optometric Association
Public Relations Director: Reynald Malmer

The Electric Circus *poster was done in 1967 for a new New York discotheque. I think the poster's memorability lies in the simplicity of its design, the concern with positive and negative space, and its then unique imagery for relatively mainstream advertising. (Dyes on Arches paper. Art Director: Jerry Brandt.)*

The first study for the Joy of Seeing *poster, a search for symbols for eye care, was done with colored pencils on tracing paper.*

The second study for the poster has the same symbols arranged more dramatically; they seem more aware of their source of nourishment.

WHEN Reynald Malmer telephoned and said I was recommended to him as a poster designer, it was the result of my Electric Circus commission of 1967. This poster had been well received, probably because it was the first of its kind of imagery to be used for relatively mainstream advertising. The poster's success brought me many commissions that were too much like it for my comfort, as well as photographic interpretations by others. I was typecast overnight. However, I think the poster's memorability lies in the simplicity of its design as well as in its then unique imagery.

Malmer said that the association's goal was to reach youth and make them aware of the gift of sight and the importance of regular eye examinations. They wanted a poster that reflected the copy line: "The Joy of Seeing." The phrasing and copy line left me no doubt that this was an invitation to come up with another breakthrough image like the one for the Electric Circus.

I had two weeks to do the thumbnail, so the pressure was on. I began the search within myself for that particular symbol that would best say that sight has a special importance among the senses. It conveys experiences unavailable to us through any other sense. In 1973, I was still looking exclusively inside myself for sources of inspiration. I didn't trust or have interest in external sources. This self-imposed creative pressure is always greater when there is the possibility of arriving at something that has never been done, when it will have great exposure and be produced on a large scale, 30 inches by 45 inches (76.2 cm by 114.3 cm).

I worked up studies during the search, because I knew that ideas rarely appear out of thin air but rather as a response to what is put down. The first study was of two eyes belonging to two intertwined flowers looking intensely at each other and being nourished by a watering can. Flower eyes seemed a good way of expressing eyes as something beautiful and fragile, as well as being close to my early symbolic repertoire. What interested me in this basic eye-care metaphor was also its weakness: the triple imagery that the two flower eyes could also be read as one person, unfortunately cross-eyed.

In the second version, the same symbols, arranged more dynamically within the rectangle of the poster, are more aware of their source of nourishment. Up to this point, the struggle was to emphasize the eye-care aspect of the message. Having done that, I could

depart from the too literal image to find a formalistically more exciting solution.

In the third version, the two flower eyes have grown into two human profiles. By replacing the foreheads with a rainbow device I emphasized the eye communication and heightened the emotional content.

I was bothered by the redundance, however, and by the symmetry of two identical images. I am a devout believer that less is more, that especially for a poster one of anything makes a stronger image than two or many. Therefore, in the fourth version I played with one profile alone, but I needed a device to focus attention on the eye.

Returning to my original search, I asked again what experience would people be unable to imagine if they had never been able to see? Then it came. The dove, that favorite symbol of peace and freedom, can fly at whim under its own power, a capacity we humans don't have and can only appreciate through sight. Accordingly, I added a dove on a rainbow issuing from the eye. The rainbow, an experience also limited to the sighted, carries the flight image into the

pupil and emerges from the lips as a song or musical scale.

The activity about the mouth was the most energetic portion of the visual and as such diminished the focus on the eye. So, for the fifth version, I eliminated the rainbow there, but the wonder and emotional content were not lost.

All five versions were sent off to the association headquarters in St. Louis, with a strong recommendation for the fifth version.

Malmer reported that his market response was based mainly on the reaction of his children, who unanimously agreed. To this day I am sorry that we never met. He also understood the need for clean, understated type for the message and the credit line. I suggested that we consult Jack Rennert, a collector and author of books on advertising posters, about printing and consumer distribution and sales, an additional outlet that could only help the association's goals. The poster was printed in eight colors and sold out.

Rennert also submitted *The Joy of Seeing* poster

along with others to the 1976 International Poster Biennale in Warsaw, Poland, where it received an award.

The most verbal response to the poster from the American Optometric Association was "inspired." Almost every optometrist had hung a framed one in his office and many ophthalmologists had hung one as well. We had to use legal means to stop at least one chain of opticians from using the image for newspaper advertising. It did what it was supposed to do, which was certainly more important than winning awards.

Today I am far more involved in the observation of reality in common everyday objects and what the watercolor medium can achieve in terms of painting. I am still pleased, however, with the minimalism and starkness of this image and the play of positive and negative space. The uncluttered quality is unusual for an American poster and makes it powerful in spite of the Art Nouveau quality and the anthropomorphic imagery.

By the third version, the flower-eyes grew into profiles. The rainbow device, replacing the foreheads, emphasized the eyes and heightened the emotional content, but the symmetry of the illustration bothered me.

Playing with one profile, I realized I needed a device to focus attention of the eye.

The Joy of Seeing *poster, right, as printed in eight colors, sold out at book stores, appeared in almost every optometrist's and ophthalmologist's office and won honors at the 1976 International Poster Biennale in Warsaw, Poland.*

THE JOY OF SEEING

American Optometric Association

Corporate Magazine Illustration: *Outlook*

1985
A quarterly publication of Booz-Allen & Hamilton Inc.
Designer: Tomas Gonda, Gonda Design, Inc., New York

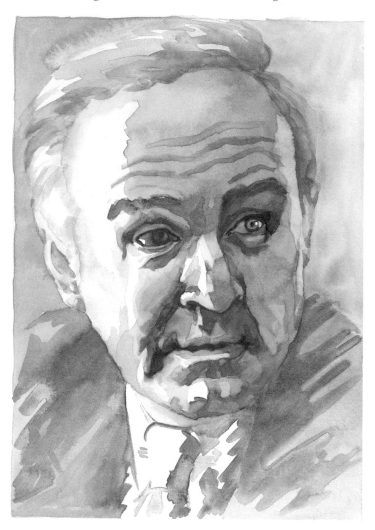

An earlier study of John F. Welch, Jr., above, was done on croquille paper, a resistant surface that doesn't allow for the building up of layers. The water and pigment puddle and force looser, more painterly, handling. I was pleased with the high contrast of color and value in the features versus the understatement of suit, shirt, and hair, but the likeness needed sharper details.

Arches paper made sharper edges in the study, right, and I also like the juxtaposition of the left side of the rectangle with the more gestural calligraphic right side, which allows the surrounding negative space to move into the subject. The response to this likeness was a unanimous rejection.

EARLY in 1985, before General Electric announced the acquisition of RCA and therefore of NBC, *Outlook* planned an interview with GE's chairman, John F. Welch, Jr., and, on designer Tom Gonda's suggestion, decided to use a painting of Welch instead of the usual interview photograph. There was ample time to arrange with GE's staff photographer to be present during the interview to photograph Welch unobtrusively with the side lighting and two-thirds head angle that for me best reveals the forms.

Selecting the appropriate attitude for the publication was another matter. I manage to stay quite ignorant of the big business movers and shakers, and these photos were my first exposure to Welch. Tom and I reviewed the 35mm slides and selected a few that were dignified and serious.

Not having done portraits of executives for business publications, I was excited and challenged. *Outlook* magazine is so beautifully designed and produced that I knew my contribution would be well printed.

I did the initial studies freely in watercolor while I looked at the slides enlarged to 8 by 10 (20.3 cm by 25.4 cm) by a small rear projector. I was looking for a loose, watery, dramatic likeness. It was most important to render the image in such a way that the watercolor could do what it does best—form an immediate painterly image. I also wanted to push the warms and cools to extremes. The earlier studies I tried on croquille paper, a resistant surface that does not allow for the building up of layers. The paint puddles and forces me to be loose in handling. What appealed to me was the high contrast in color and value in the features and the understatement of the suit, shirt, and hair.

It was obvious, however, that the likeness required some sharper, more specific details. I used the reliable Arches paper for the next one, and I did prefer the sharper edges. I liked, too, the juxtaposition of the straight, left side of the rectangle with the more gestural, calligraphic, right side, allowing the surrounding negative space to move into the rectangle. The violet color held together the red and blue.

I wanted to buck the run-of-the-mill executive portrait. This one certainly had energy and immediacy. Rather confidently I brought it over the same day to Gonda Design. When I saw the look on Tom's face I knew this was not going to be an easy sell. Tom sent it over to Karen Abarbanel and Mardi

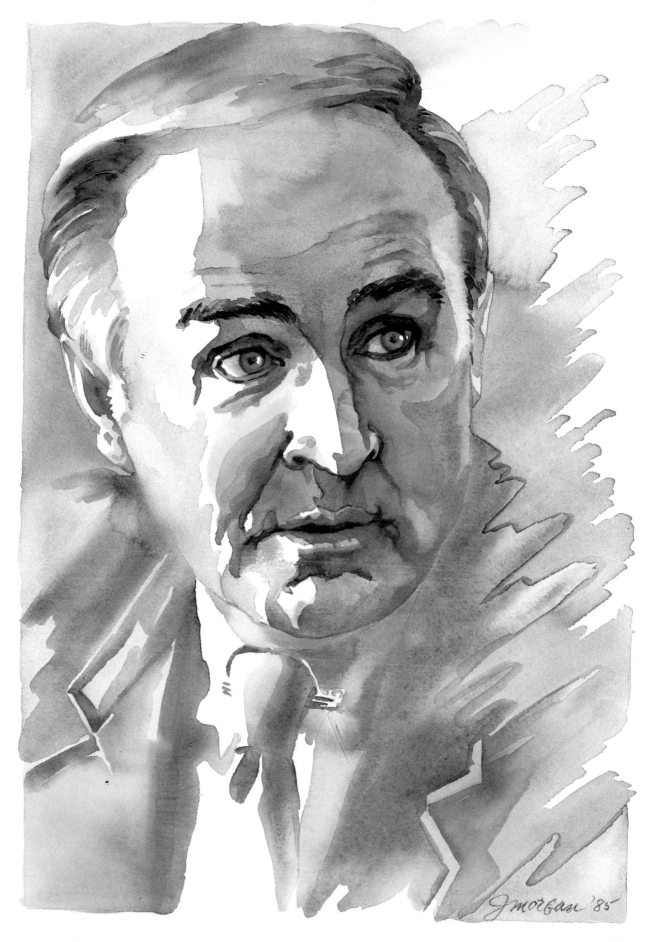

The fragmented multiple portrait of Nick Rosal, above, served as a departure point for the final portrait because it suggests motion—a dynamic, active person. (Watercolor on Arches paper.)

The final portrait of John F. Welch, Jr., Chairman and CEO, General Electric Company, right, as it appeared in Outlook, *a publication of Booz-Allen and Hamilton, Inc. The best design solution happily consisted of the winning smile, the thoughtful person, and the decisive leader. (Watercolor on Arches paper. Art Director: Tomas Gonda, Gonda Design, Inc.)*

O'Shaughnessy, editors of *Outlook*. The next day I received a call to arrange a meeting, accompanied by the statement that this portrait was not Welch. Though unaccepted, this painting became the source of other portrait commissions.

Diplomatically, Karen and Mardi stated truthfully enough that we should have had a meeting prior to painting and that Welch is a dynamic, physically active decision-maker who likes the color yellow. Of course, their expertise is words not images. Still I was becoming nervous that I was being pushed into doing a yellow, beige, and brown rendering and actually said something to that effect. Then they showed me two published photographs of Welch. They were almost identical to each other and Welch had a really winning smile. I understood at once why they would have to reject my interpretation without question. There was something in these photos not apparent in those from the shooting during the interview. It was the man's public image, an attractive one at that.

More relaxed, following Tom's suggestion, I showed the editors the fragmented multiple portrait of Nick Rosal as a suggested approach. They responded enthusiastically because of the sense of motion it conveyed. Well, I failed to sell my painting, but I had a grasp of a solution that might perhaps be more challenging, though in a different way.

To decide which heads worked best together, I did black-and-white drawings of five of them, indicating the darks. Then I made several copies of each to cut up and paste together in a collage. The best design solution happily consisted of a combination of the brilliant smile, the thoughtful expression, and the decisive leader. Using a light box, I traced the collage onto the watercolor paper. Then the real pleasure began.

It is not within me to succumb to a yellow-and-burnt umber rendering, but I did soften the blues and bring them closer to the warms by using more violet. The painting has a less immediate energy, but it is also painted much larger than the first version; therefore the energy is less visible. Booz-Allen decided to buy the original of the painting and give it to Welch as a gift, which, I am told, he happily took home.

Since then I've seen Welch on television explaining GE's position relative to NBC's autonomy, and I have to admit that the accepted solution is better than my first effort. It is much more a reflection of the man I saw on television. For future likeness commissions I'll seriously consider this aspect of a public image.

Annual Report: Scott Paper Company

1985–86
Corporate Graphics Inc.
Art Director: Jim Hatch with Bennett Robinson

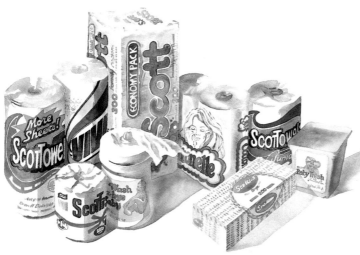

The decisions made on the photocopy, top, of the first tight pencil (sketch), representing the domestic division for Scott's Corporate Annual Report, carried through to all the other pencils and paintings.

I was pleased by the simplification of the first painting, above, but disappointed by the lack of mystery. The concern with correct package and logo did intimidate me, and happily the client's response was that we should take advantage of illustration techniques by taking more liberties with color and shadow. (Watercolor on Arches paper.)

In recent years, I have become more and more fascinated by everyday objects; the more mundane, the more eager I am to portray them as objects of beauty. For illustration purposes, a painting can imbue objects with mystery, energy, and drama. In this regard a photograph is more limited. A painting is a much more entertaining way of viewing an object or product. We are made to see it through new eyes. For example, a painting forces us to see well-known, indeed overexposed, consumer products again with greater interest, especially if all the elements are not represented concretely. Then, as viewers, our eyes complete what is left out and we participate in making the picture. It is my fervent hope that more advertisers see the benefit of this approach.

A large part of my fondness for objects as subjects is because I can paint them from life, without a photograph as intermediary. I can play with a light source until I am satisfied with the shadows created, and everything stays put. Nothing is wrong with taking photographs and painting from them except my feeling of being trapped. Although a photograph does make three-dimensional objects into two-dimensional forms, facilitating drawing and painting them, I am not able to move my eyes around the object, locate the best point of view, and incorporate that into the painting. I feel as though all choices must be made during the photographic process. People present a different problem. When a person can hold a position for a length of time, the attitude becomes stiff, pained, and unconvincing for me. Then I resort to photography—to several photos from various angles.

When Corporate Graphics called me to do the Scott annual report from the Scott products themselves, I was thrilled, even though my studio became a warehouse. Each of five divisions needed visual material to represent their major products, and Corporate Graphics was visionary enough to recommend paintings rather than the traditional photography.

Aside from the advantages I've already pointed out, illustration has several more virtues for the designer, as opposed to photography. The shipped products need not arrive in perfect condition. Liberties can be taken with color. Packaging is designed to function and to attract notice in markets from among a cacophony of competitive products. By contrast, the isolated printed page requires a cohesive whole. And the illustrator can maintain product identity through selection of a logo and important elements and can eliminate or simplify confusing shapes and nonessen-

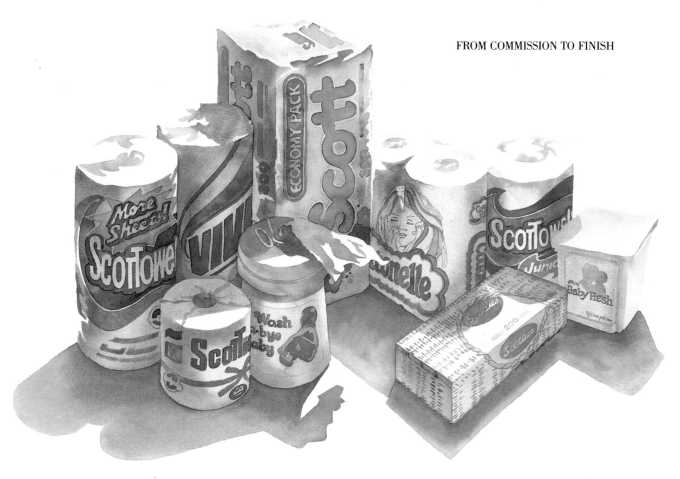

We dealt with the balance of the divisions before Scott agreed to having the domestic product painting redone, above, to fit in better with the other, somewhat more shadowy, paintings.

The painting representing their International Division, below, is probably my favorite because there are fewer products and the packages have a cleaner look.

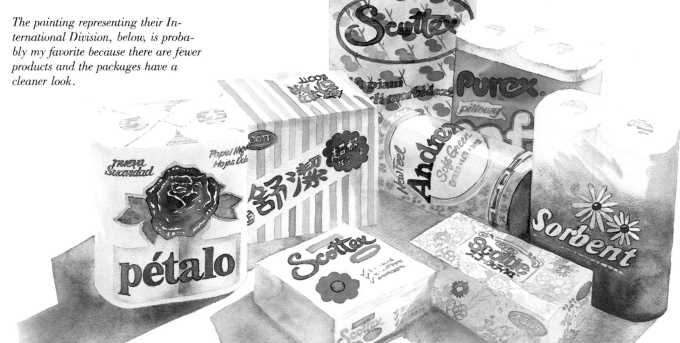

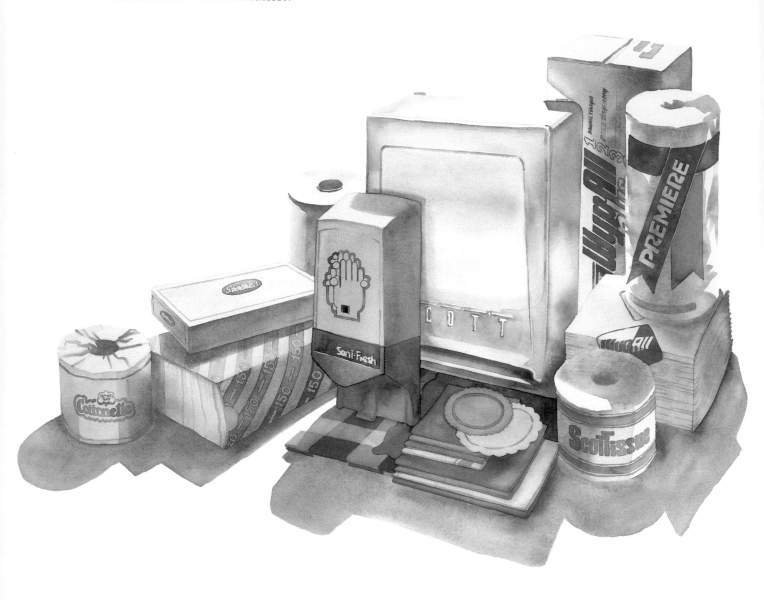

The painting for the Industrial Division went through the most stages, primarily because their products are so numerous. Finally, products of lesser importance were eliminated.

I took a 35mm slide of the Industrial Division products, right, only for comparison—photo versus watercolor painting.

tial package information. The selectiveness of the human eye is a great asset; photography records flaws and essentials equally.

A meeting was held with Jim Hatch, the art director; Martine Chepigin, vice-president of production; and Norman Begun, Scott's director of corporate communications, at my studio soon after all the products arrived. Going over each group of products, we decided as a first step which could be eliminated, which were necessary to show, and which should have the most prominence. We also discussed which portions of the packaging could be eliminated without loss of product identification. This point was relevant to all consumer products because they contain more typography and decoration. The next step, we decided, was for me to lay out the packages to suit the comp and to do a tight pencil of each group to submit for approval before painting; this procedure is usual and better for all parties.

The first comp in a series is the most crucial because it establishes the point of view for all. It therefore undergoes the most scrutiny and requires more thought and decision. The most crowded double-page spread was chosen for the first because there was the additional requirement of products reading as two separate groups, one for the Domestic Division, the other for the Industrial Division. The layout had to be designed so that products thin out or stop before the magazine gutter. The first tight pencil also included precise drawing of typography.

Approval of the first drawing took a long time because decisions made on this one would carry through to the others. Days passed while everyone in New York and Philadelphia reviewed the photocopies of the pencil. In the meantime, I continued doing other tight pencils.

Approval was granted, except that it was pointed out that I had drawn the logo of an earlier Viva paper towel package and not the most current. That was changed and painting began. I must admit I was somewhat intimidated by all the attention to correct package and logo. I suspect the literalness of my first

painting reflects this concern; I was disappointed with the lack of mystery, but pleased with the simplification. I expressed my reactions to Jim Hatch, who also couldn't know how much liberty we could take with the renditions and still serve the client's purpose. Then Norman Begun happily, but carefully, said that we should take more advantage of illustration by taking more liberties with color and shadow.

The second painting, for the International Division of Consumer Products, had more mystery and was preferred to the first. We continued to deal with the rest of the divisions before Scott agreed to having the domestic products redone to weigh in with the others.

Annual reports are complex projects involving a board of directors, division heads, and production people. Typically, there are last-minute changes in art and text. This project was no exception. One painting was redone because one product had to be replaced by another. Another had an addition of three-dimensional products to make it look more like the other paintings. The Natural Resources Division felt that the blue shadows falling on the wood and chips was unrepresentative of the products, and a couple of patches had to be made on another piece. On the whole, I did not mind the redos as much as I had expected I might. For some the second time the handling was freer, more transparent and confident than the first, and the client's remuneration was always fair.

Looking at the job overall, I miss the magic present in the Champion Papers job, where the emphasis of the communication was that they also made packages—rather than precisely which packages. Possibly my courage failed and I became too literal in an atmosphere of deadline pressure and crucial product identification. The next time, I will create adequate time to present two versions of the first painting: one more literal and the other closer to the abstracted handling of the Champion Papers job. Notwithstanding my objections, these paintings are a far more appealing representation of products than any photograph could possibly be.

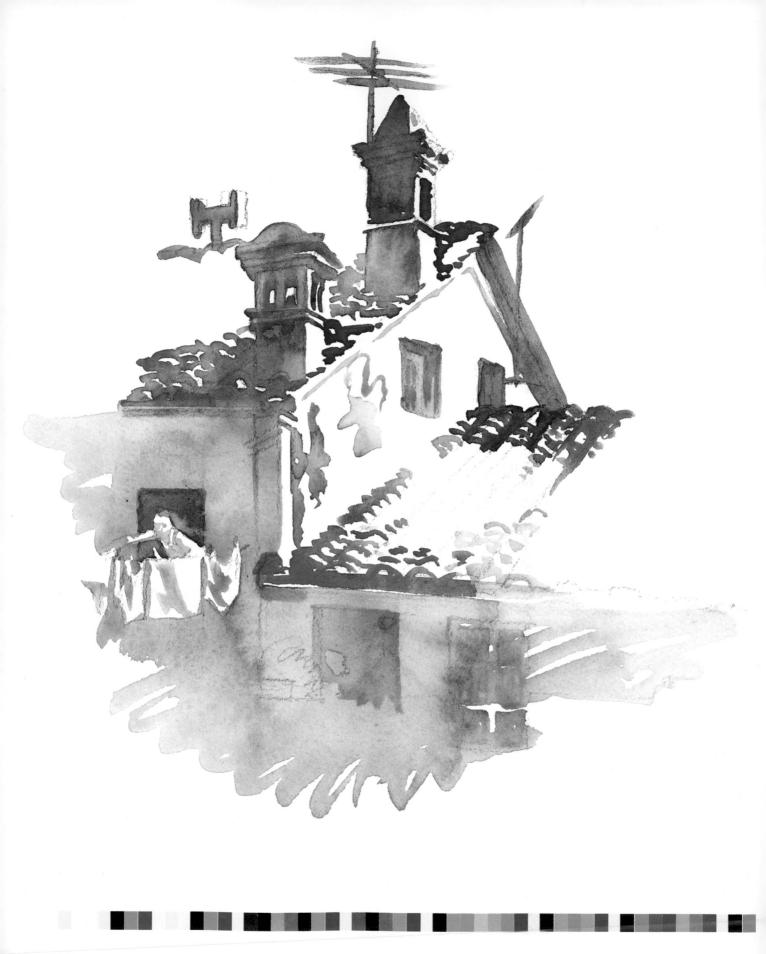

10

Camera-Ready Art for Reproduction

Presentation of finished art has two important, distinct goals. One is the necessity of impressing the client with your professionalism and your respect for the artwork and its solution of the client's problem. Clients should feel that their money is well spent and should want to consider you for future commissions. The other goal is that you wish to do everything in your power to protect the original artwork from damage. It is handled by client committees, production people, separators, and printers. Clean, protected art is how you wish to have your work returned to you. Such work is also a prerequisite for the highest-quality reproduction. A minimum understanding of the reproduction process is helpful in making decisions about watercolor painting and presentation.

Color Separation

All an illustrator has to know about reproducing a watercolor in color is that 99 percent of all full-color reproductions are achieved by printing only four colors—magenta, cyan (blue), yellow, and black. The artwork must be color separated for these colors. Through the use of filters the original artwork or photograph is scanned by computer or photographed to pick up each color, one at a time. From the resulting four films, four plates are made up of dots of different density from which the image is printed. The dots plus the transparency of the printing inks create all colors. The scanner facilitates the process by altering the color balance instantly, saving time and labor. In most instances the dot pattern is created at the same time, lowering separation costs.

A scanner or camera does not, however, see selec-

Almost all full-color art is reproduced with only the four colors shown on the printer's band. This vignette, of Lucca, *was done during our Italian watercolor workshop.*

tively. Whatever is there, including paper texture or the use of opaque white in painting, will be apparent in the reproduction, unless the reduction in size is dramatic. Consequently, retouching with opaque white, or Chinese white, is not recommended; it never looks the same as the watercolor paper. Were you to mix the exact hue of the warm white paper, the aging of the paint and paper would change the relationship within days. Scraping the pigment off the paper with a blade, however, is not apparent in reproduction. Any fuzz can be sanded and erased. This may go a long way to explain my purist approach to transparent watercolor. The reproduction, not the original, is what is published and remembered.

The scanner works best with artwork on paper, rather than board, because paper can be wrapped around a cylinder to be color separated. The advantage of this method is that the fewer steps or stages between the original painting and final reproduction, the truer to the original the result should be. Many people have had related experiences with photography when making a print from a transparency. Much information in the original transparency is lost, softened, and distorted in the print because a negative must be made from the transparency before a photographic print is made. The result is two steps away from the transparency, with something lost at each step. The use of a scanner should, therefore, result in superior reproduction. The maximum size paper that fits the scanner, however, is 20 inches by 24 inches (50.8 cm by 60.9 cm) and the image must be at least one inch (2.5 cm) smaller all around.

Original art on board can be color separated by shooting a 4-by-5 or 8-by-10 transparency and scanning the transparency, using the original art only as a guide. The other, more dangerous, method is carefully peeling away the top layer of paper from the board so that it can be rolled around the cylinder. It can so easily tear that I would not want to be responsible for this operation.

Working to Size

Standard practice for most illustrators is to paint final art, with the exceptions of large posters and billboards, approximately 150 percent up, or one and a half times the reproduction size. Size decisions are based on personal comfort; a larger original can be handled more freely and gesturally. When reduced, the appearance becomes tighter, slicker, more commercial. Several of these terms have

negative connotations in relation to art, but the market still has more need for concrete realistic art than any other type. Additionally, art buyers, art directors, and designers more readily feel they have received their money's worth when they hold larger-sized artwork.

Working up-scale makes more sense when the goal is a tight, realistic appearance such as a product illustration or some genres of book jackets. Detail is easier to insert. However, if your goal is a loose, painterly, gestural illustration and you are more comfortable working in a smaller scale or in the same size, you are not alone.

Line work is more fragile in this regard. A large piece of line art reduced dramatically for tiny newspaper space can cause the lines to fill in. Conversely, line art done to small newspaper size does not blow up well for use on a large poster. Consequently, two separate pieces of original art may be required or one done to a scale that is between the two reproduction sizes.

Presentation

After the painting is complete, presentation is a job in itself. You may need to spend another forty-five minutes to prepare the art for delivery to the client.

Untape the watercolor from the working board. If the paper was taped all around during the painting process, it should be perfectly flat.

Place the painting on top of a mat board that is larger on all sides. I prefer mat boards that are white on one side and black or gray on the other, and I buy them in volume. The white side is for the inside, under the watercolor, and the black for the outside. Using masking tape, attach the complete top edge of the watercolor to the complete top edge of the mat board. Then cut a piece of acetate or tracing paper, also larger than the art, and tape it over the previous tape along the complete upper edge protecting the art. Do not trim anything yet.

The art is protected bottom and top and can be viewed without exposing it to fingerprints, but it is still too vulnerable for travel. Now take a sheet of opaque paper to cover the transparent sheet. Inexpensive large sheets, either cover stock or oaktag, are available in art supply stores. This sheet, larger than the art and slightly deeper than the mat board, is taped to the top of the back of the mat board and flipped over to the front to cover the entire board.

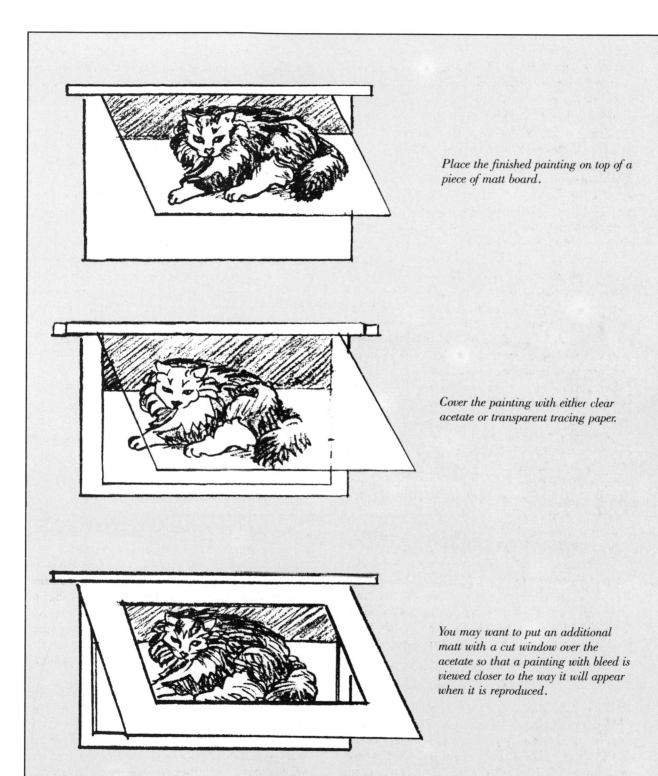

Place the finished painting on top of a piece of matt board.

Cover the painting with either clear acetate or transparent tracing paper.

You may want to put an additional matt with a cut window over the acetate so that a painting with bleed is viewed closer to the way it will appear when it is reproduced.

Cover the acetate with a piece of heavy, colored opaque paper. Attach your business card to one corner. Trim all the layers together.

Put the covered painting into a clean manila envelope. Carefully address the envelope and attach another business card to the upper left-hand corner or use a self-stick label with your name and address imprinted.

At this point, all layers are ready to trim in one step. Using a steel straightedge and a sharp, single-edge razor blade or mat knife, trim all layers flush at once, including the board on three sides. The secret to this step is having several sharp blades available. If you are preparing a bleed job, one in which the illustration will extend to the edge of the printed page, as in a book jacket or record album cover, you will have to paint or complete an additional border around the art of a minimum of ⅝ inch (1.6 cm) over reproduction size. The excess is trimmed after printing. Sometimes designers will request much more bleed in order to have more flexibility with a typographic solution within the art.

If you enjoy working in larger sizes, add the bleed dimension to the reproduction size before scaling up the work. Put masking tape around the outside dimension to get a clean painting edge. Then it is wise to indicate crop marks outside the art area in pencil.

When the bleed painting is complete, you may want to add an additional mat to your presentation so that your art will be seen in a way that is closer to the way it will finally appear. From larger, heavy black paper or mat board cut a window to reproduction proportion, using your crop marks as a guide. Place it over the transparent acetate or tracing paper under the cover flap and tape it with black tape along the complete upper edge. Then crop or trim the outside of all layers at the same time, using several sharp blades.

If your watercolor is too wavy because of its large size or lighter-weight paper, there is a way to flatten it. Place the painting face down on a large, clean, white surface or mat board and sponge the back, making sure the entire surface is damp. Then, place over it another white, clean, flat board and layer your heaviest books evenly over the entire surface of the board. When dry, your watercolor will be flat.

After your work is trimmed and flat, it's professional and attractive to attach a business card or sticker to the lower right corner of the cover flap. This card should have your name, address, and telephone number along with a visual symbol for instant recognition of the contents.

No, you're not finished yet. Put the precious package into a clean manila envelope. After you have a sense of the general scale of your work, it's wise to purchase these envelopes in volume along with gummed brown tape for packing.

Address the envelope and attach another business card to the upper left corner, again for recognition and speedy delivery of the contents to the anxiously waiting client.

Presentation is work and it takes time, but it's a professional necessity. Many clients are not visually oriented. Their area of expertise lies elsewhere. Especially for these less visual clients, the more professional and complete the packaging, the greater the likelihood of your artwork's being given a warm reception and respectful consideration.

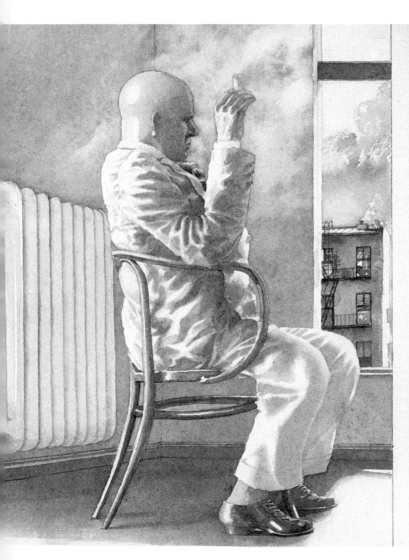
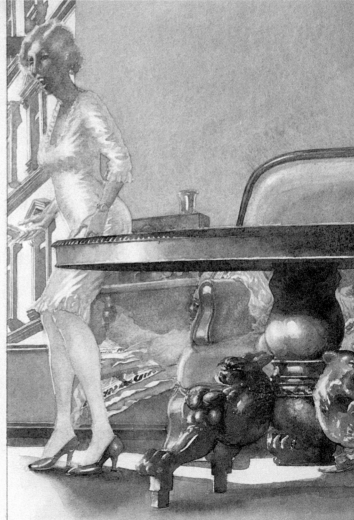

11

Marketing Your Work and Yourself

Beautiful artwork accumulated in drawers brings neither commissions nor recognition. Selecting and preparing your portfolio is the first step to these goals, followed by an understanding of interaction with clients. You present yourself as well as your art.

Portfolio Preparation

The first step in preparing a portfolio is to lay out all work being considered for it and evaluate it. Study the pieces as a group or groups. Usually several pieces share a similar personality, mood, and point of view, and, therefore, a potential market. Place related works adjacent to one another. Not infrequently the result is three distinct groups of work, plus a couple of pieces unique to themselves.

Next, consider which of the groups is most related to your current interests, which type you are presently pursuing. Consider, too, which group is the largest and which group you prefer. An objective professional may be helpful in making this choice, for the ultimate goal is to present a portfolio with a single pervasive personality.

Designers and art directors prefer viewing portfolios with a consistent point of view and type of imagery. It shows commitment and, it is hoped, a personal visual language, stating that the illustrator is not simply an imitator of other styles. Moreover, art directors see many portfolios each week. Presentation of more than one look confuses the viewer and makes the work and the artist less unique and memorable for future commissions. Yet another important reason for consistency is that it increases the art director's confidence in the illustrator, knowing that what is commissioned will be delivered. Rare are the instances when

This watercolor is one of 172 done by Hans Hillman, the German illustrator, for Fly Paper, *a Dashiell Hammett story told through full-page visuals with a minimum of text. (Published by Zweitausendeins, Frankfort, A.M., 1982)*

an art director can gamble. Risks are costly in time and money, and the art director's job is on the line.

Including a variety of styles could be advantageous to someone seeking a staff job. Such a job might include layout, paste-up work, along with marker comping to visual solutions. The ability to imitate and execute a variety of illustrative styles in a variety of media could be desirable here. If you wish to freelance and pursue several modes of art, you should consider putting together a portfolio of twelve to fifteen pieces for each of the styles. Many illustrators maintain two or three distinct portfolios. If marketing your work is a pressing priority, however, select one point of view at a time. Make it into a portfolio, putting away the balance of your work for the moment. At another time, if one direction is growing static, or if there appears to be an insufficient market for that direction, retrieve and pursue another facet of your work, creating a separate portfolio for presentation to possibly an entirely different clientele.

Consistency of presentation also adds to the confidence and professionalism projected. Inclusion of original art is not recommended because of probable damage and possible loss. Reproductions weigh less and provide consistency of size and surface that are more nearly that of a printed piece. Consistency of size, usually a reduction, has a much more professional appearance. Reproductions also facilitate your having more than one portfolio, which you will eventually find to be a necessity. As many as five different organizations have requested my portfolio in a single day. Many need to hold onto the portfolio for at least twenty-four hours to show to other people who are involved in the decision-making process. One portfolio is too limiting.

Size of reproductions is based on three factors—the average size of the original art, the complexity of detail within each piece, and the size of the portfolio case that is portable for the individual. Standard reproduction sizes are 8 inches by 10 inches (20.3 cm by 25.4 cm) and 11 inches by 14 inches (27.9 cm by 35.6 cm). If the artist works very small, 5 inches by 7 inches (12.7 cm by 17.8 cm) is a possibility.

There are several methods of reproduction available. The only way to know which method is best for a specific type of artwork is to try several methods with one favorite piece of art that is fairly representative of the body of the work. The following are some of the less expensive means of reproduction.

C prints, obtained at photographic laboratories, are photographic prints with an internegative. Therefore, additional positives for additional portfolios are less expensive. C prints tend to increase the contrast and the blueness of the original art and to reduce the intensity of warm tones. For many styles and media the greater contrast and smaller size of the C print improve the presentation.

Ciba chromes and color stats, obtained frequently at a photostater, are more color saturated than C prints and are warmer in color and more faithful to the original artwork. There is no internegative from which to make additional prints. Ciba chromes are made from transparencies only. Since results and prices vary from excellent to mediocre, depending upon the producer and the machine model, you may wish to try two or three different suppliers.

Chroma copies are made by a separate process and, if locally available, are used primarily by architectural illustrators and renderers. Chroma copies have no internegative, but they tend to make color appear warmer than it is in the original art. Chroma copies can be made from transparencies, but results are superior when they are made from the original art.

Chromes, such as the 35mm slide and larger transparencies, are the most faithful to watercolor originals. But even large transparencies have to be held up to a light source to be viewed, so print methods should also be tried. If art is too subtle, however, and if prints lose detail or distort the original too much, 8-by-10 chromes can be placed with their protective sheets into commercially available, firm, black mats for presentation. The mats have precut windows that range from 4 inches by 6 inches (10.1 cm by 15.2 cm) to 7½ inches by 9½ inches (19.1 cm by 24.1 cm) with an outer measurement of 11 inches by 14 inches (27.9 cm by 35.6 cm). Masking tape or magic tape makes it a one-minute maneuver to secure the chrome to the mat.

Also available are 11½-inch by 14½-inch (29.2-cm by 36.8-cm) acetate sleeves made to protect the matted chrome. One side is of clear plastic, and the other, for the back, is cloudy to diffuse and distribute the light evenly. The result is a lightweight, clean, professional, and consistent portfolio. The disadvantage of this type of portfolio is that some people prefer to see prints and reproduced art. Of greater concern is the need to keep a record of how many chromes are sent to each potential client. It is easier to lose these

pieces than the pages in a loose-leaf portfolio. Small 35mm slides should not be considered unless they are carried with a slide projector and the art director or designer has the time and a place for such a viewing.

Color Xeroxes, not available in all photoduplicating shops, are less expensive than other print methods. Color Xeroxes can be made from 35mm slides and often appear like silk screen. The results, however, may be inconsistent and tend to distort the original more than any other print method. Some illustrators prefer color Xerox results to their original art. For them it is the solution to the commission and is delivered as their original camera-ready art.

For black-and-white line or stipple art, direct-positive photostats are excellent and are more nearly what occurs in the actual, commercial, reproduction process. Line becomes blacker and any pale smudges or grays disappear for a cleaner, more graphic appearance.

To present halftone work, which watercolor is, in black and white, you should use a good-quality continuous-tone photostat or a Velox. The continuous-tone stat is a black-and-white photograph. The Velox is closer to reproduction because it breaks the tone down into dots. These can be made from a single-color painting or a full-color painting in which the values are well conceived. It is advisable to have a couple of black-and-white pieces in your portfolio to demonstrate black-and-white reproducibility. Since the quality of a photostat or a Velox depends on the equipment used, try either or both methods, or different producers, on a particular painting.

It is necessary to try several methods of reproduction with a favorite representative original piece of artwork since the operating technicians themselves cannot predict the result. Often an artist is so attached to the appearance of the original art that any form of reproduction is a disappointment. This reaction diminishes with experience, however, and as the artist's commissioned work is commercially reproduced. The reproduction always varies from the original; it is often worse, sometimes better, but never the same.

When preparing your first portfolio, present a few types of prints of the same piece to an objective professional to get his or her opinion. After you decide on a single method, reproduce the balance of your work in the same way, in the same size. For expediency, bring along a satisfactory, already-printed piece

and its original to the lab for comparison of results. If the new print is inadequate, request that it be redone, using the previous result as a point of reference and a means of giving precise instructions.

Always include printed works in your portfolio. A portfolio must forever be in a state of flux. Often pieces are changed when a potential client calls, trying to solve a particular problem. The more works that relate to the client's problem, the greater the likelihood of your landing the job. Certainly your portfolio should be continuously updated by the best of your reproduced commissions. Clients feel more secure seeing reproduced works; after all, they are documented proof that you've solved a problem.

When a successful work is reproduced well, there are several ways to include them in your portfolio. Lamination of the printed piece is popular. It is surrounded by your choice of a black, white, or clear border and sealed within plastic, front and back, making it stiff and permanent. By making the borders larger or smaller you can match the size of the other artwork in your portfolio. The only damage that can occur is some scratching of the plastic surface. Laminations can also be placed, without any loose leaf, in an attache case.

If you've decided your portfolio is prints in a loose-leaf acetate book, the reproductions can be treated identically. If you decided that 8-by-10 chromes are your form of presentation, you can have the printed page made into a chrome and matted.

Some illustrators show both chromes and laminates because the reproductions of some commissions are disappointing because of reduction, poor typography, or poor printing. In such cases, treat the presentation as you have the rest of your portfolio. To communicate that these works are the results of commissions, type the title, client, and use on a small piece of paper and slip it into your portfolio sheet or glue it to the mat of the chrome. If the reproduction is good and well designed but too small to be impressive, try inserting it next to your print on the same page, or attach it to the mat of the chrome.

Send all photography work out to a professional with expertise in shooting flat or reflective art, unless you are a professional photographer. The costs per shot are less than your time and the waste of rolls of film. While your work is at the lab, have them shoot three 35mm slides. These are useful for out-of-town clients and for submission to exhibitions. Profes-

sional photography means that you will have not only the perfect exposure but parallax correction, or perfectly squared edges, and no hot spots, or uneven lighting.

To reinforce a sense of consistency, develop an order of presentation. Group together the works most alike in subject matter and mood, especially any two pieces facing each other and viewed simultaneously. Place together figurative work, scenes or landscapes, and portraits and close-ups and similar compositional structures. Begin with strength and end with strength. The first impression should draw the viewer to continue looking; the last impression should be exceptionally positive and memorable.

There is a saying, "You will not have a second chance to make a first impression." The second time you telephone for an appointment the art director may not be interested. Rest assured that clients will be there in three months or even a year. Take the time now to develop an artistic point of view and manual skills. In the long run, the more personal art is the more memorable and longer-lived. Though your work needs constantly to evolve, the more realized the presentation and the more pleasurable the process, the greater the chances for long-term success.

Take the time to make a thoughtful portfolio, one that will be impressive without your presence, providing an easy, pleasant discovery of your work. If the communication of a visual piece requires explanation, a simple typed, not designed, statement can be inserted. Leave the typographic design to the client. Remove the weakest piece because it is by that that you are judged. A good designer wonders why it is included, thinking that the artist believes it, too, represents quality and that he or she is capable of delivering that level of work in answer to a commission. You are ready when the portfolio is ready to make that first impression.

Relationship Between Illustrator and Client

Along with the portfolio, you present yourself. Yes, the art speaks for itself, but the presence of the artist speaks to the unspoken questions. Is this person easy to work with, reliable, responsible, understanding, and flexible? Does this beginning illustrator understand the needs, pressures, and responsibilities I have as art director or editor?

A valuable illustration class experience is playing the art director's role. With a given class assignment, half the class, as art directors, conceive and present layouts of their solutions to individuals of the other half of the class, as illustrators, in one-to-one situations. The emphasis is on listening and asking relevant questions. The subsequent assignment can reverse the roles so that each person experiences to some degree the problems of the art director. Class critique involves a team at a time, discussing first the art directors' layout and then the illustrators' result. Is the solution a valid communication? Is the result as the art director envisioned it? Does the illustration expand upon and improve the conceived solution? Or, is there a failure of communication between the art director and the illustrator?

Since the art director does not stand alone, it is important not to lose sight of the overview, of how each person is interdependent. The interdependence begins with the publisher, who has created a prodigious market for the publication, be it a newspaper or a magazine. To maintain this market the publication must uphold, in contents and visual material, its established point of view.

The editor, whose responsibility it is to feed and enlarge the audience, commissions journalists and novelists to write articles and fiction in line with the publication's established point of view. Since the art director is answerable to the editor, his or her responsibility is to maintain, and if possible increase, the publication's audience visually. He or she commissions photographers and illustrators whose work fits into the established visual image of the publication. The cover or front page is especially crucial, because a sudden change in appearance could lose audience recognition and, therefore, sales. While the art director is cautious, making certain a visual does not express an attitude that is undesirable by audience standards, he or she may also have a desire for pioneering excellence. Within the publication's framework each participant—publisher, editor, art director, and any writer or artist—attempts to make an outstanding contribution to the state of the art. Thus each walks the fine line between maintenance of the established success and the experimental breakthrough.

Sharing the same responsibilities as the rest of the team, the illustrator is not simply illustrating a story. While striving for excellence and the exceptional, the illustrator's job is to solve the communication problem

visually, in line with the publication's established image and point of view. In the long run, it is the illustrator who is sensitive to the team and the publication's needs who receives commissions on a regular basis. The opposite can also be true, however. There are the unique and exceptionally talented illustrators, who, though overly self-concerned, find their work useful and in demand.

An illustrator's professional responsibility should always dictate the prompt meeting of deadlines and the acknowledgment that the jobs of the rest of the team are on the line, as well as the illustrator's own future. News travels swiftly within an industry; even an exceptional, sought-after image-maker can find himself or herself without a commission because of unreliable delivery habits.

With or Without an Agent

If a beginning illustrator's visual language is similar to what is currently in demand, an agent or representative may be receptive to taking his or her work. The representative, referred to as the rep, possibly has more requests for a particular type of illustration than his or her stable of illustrators can handle. For a beginner, the probable arrangement would be that the rep would receive a percentage of every incoming commission whether it was obtained directly through the rep or through direct contact with the client. The rep promotes the illustrator's work through the industry, thereby justifying a share of the return. An experienced illustrator with an established clientele frequently negotiates with the rep that these clients are exempt from the percentage and are serviced only by the illustrator.

Often the beginning illustrator brings a fresh, untested imagery to the field and must create or prove there is a market for the work. Additionally, the experiences of selling, direct contact with the client, visual problem solving, and negotiating fees are invaluable for the illustrator and eventually to a potential rep. Reps are more receptive to illustrators who are experienced in the reality of the marketplace. Frequently, reps perceive themselves less as active commission-seekers and more as fee-negotiators and client-servicers. They perceive their contribution to illustrators as being a vehicle of freeing the in-demand illustrator to produce a greater volume of work by attending to such business matters as promotion, negotiation, servicing clients, and billing. Though it

seems like a catch-22, the time to seek a rep is probably when you have too many commissions to attend to these other aspects of the profession.

Interviews with a rep are mutual and concern not only art and markets but especially the expectations of each party. The art must fit into that of the rep's general clientele, but it should not be in conflict, by its similarity, with that of another of the rep's illustrators. The quality of that stable of illustrators is equally important to the enquiring illustrator. The nature of the commissions the illustrator seeks should be of interest to the rep, within the area of the rep's current clientele; possibly such commissions would be an expansion of the market, resulting in adequate remuneration for both parties.

The frequency and quality of promotion and the percentage of cost for which each is responsible is another relevant matter for discussion. There is also the question of who decides to accept a commission, the rep or the illustrator. And does the illustrator discuss the job with the client directly or accept the rep's communication of the commission's requirements, limitations, and freedoms? Not least is the relationship between rep and illustrator. Similar to a marriage, not unlike a business partnership, the two people must communicate frequently and need to like and respect each other. They must have the visceral feeling that honesty and communication exist between them, since conflicts do arise and the relationship can be costly and complex to sever.

There are as many successful illustrators without reps as there are with reps. Many illustrators prefer more personal contact with clients and control of negotiations about job acceptance and promotion. While some are capable of doing a better job for themselves than any rep can, others prefer to use in other ways the 25 percent to 30 percent of income that would go to a rep. Some illustrators hire assistants to help in research, servicing, and billing. Others put that money into advertising. Still others feel freer without a rep to pursue what are for them more satisfying, although perhaps less remunerative, commissions.

Generally, reps are not particularly advantageous for editorial work. Relationships with editorial art directors tend to be more personal, and fees tend to be less negotiable. For advertising work, while not a necessity, reps are prevalent and are expected by agency art directors. As advertising tends to have

higher, more flexible budgets, reps can utilize their negotiating skills for greater remuneration. For the illustrator most interested in advertising commissions, it makes good financial sense to seek a rep.

Those with primary interests in other areas may prefer using the Graphic Artists Guild's *Pricing and Ethical Guidelines*. Frequently updated, this publication facilitates pricing and negotiation for almost any market and use. Consider your geographic location and access to the major communication centers as well as your strengths and shortcomings with clients. If you are in a large communication center and have the will and capacity to handle clients, you might nevertheless find it advantageous to have reps in other cities and countries.

The Markets

Traditional markets include magazines, newspapers, paperback covers, children's books, greeting cards, record album covers, fashion illustration, and advertising. Some of these provide viable means of earning a livelihood and others do not. Some work in these areas is done primarily for exposure that can lead to more lucrative commissions. Initially, however, everyone seeks experience, printed portfolio pieces, and exposure.

The many special-interest magazines are excellent vehicles for initial exposure. Spots, or small illustrations, are needed to introduce articles. Fresh new styles are sought by creative art directors, who are not taking too large a gamble with smaller, internal illustrations. There is also ample opportunity to do work for color reproduction. Observe, buy, borrow, or study in the library every magazine possible; look to see whether the editorial and visual image of a publication leans in the direction of your own work. When you locate a sympathetic publication, look for the art director's name on the masthead and telephone to find out the publication's portfolio-viewing policy, whether it is interviews by appointment or, perhaps, a drop-off arrangement.

Newspapers, too, provide a good way to get your foot in the door. Remuneration is low, but circulation is high and exposure can lead to other commissions. Artwork tends to reproduce better on newsprint than photographs do. For the individual whose work is strong in values and in black and white, newspapers are good vehicles. Here, too, consider the style and image of the various sections of the newspaper. Focus

on the possible sections to which your art can apply, and telephone each of those art directors.

The primary disadvantage of newspaper work, the short deadlines, is initially intimidating. If you can arrive at a concept quickly and establish a reliable relationship with an art director and an editorial team, regular commissions can be the reward. Since the need for strong black-and-white reproducible art is vast, requests from other markets are likely, including newspaper advertisers.

Depending very much on the illustrator's work, covers for paperback books can be a rewarding and lucrative source of commissions. Each genre, however, calls for a specific type of imagery and mood. Think about paperback gothic novels, romances, spy thrillers, mysteries, or science fiction. The audience for a genre expects to recognize it by the cover treatment. If your work fits any of the popular genres, pursue the publishers.

What could be more satisfying than illustrating a book from cover to cover? If children's books are your chosen focus, try writing them as well. In fact, write and illustrate a few books and present them in dummy form to children's book publishers; they are more interested in seeing both together. Be warned, however, this is not an easy market to enter, nor is it large or remunerative. Unless a book becomes a very big seller, satisfaction lies more in the product than in the money it provides. While very few illustrators are fortunate enough to earn a livelihood doing children's books, perseverance, the creation of a lasting character, and a little luck could make you one of those few.

Another pleasurable vehicle is the design of gift wrapping and greeting cards, but these are not very lucrative areas. But satisfaction counts, too; so if your work is particularly well suited to this market, do a group of greeting cards for the known classifications, such as birthdays, get-well cards, and congratulations, and submit them to large greeting card companies. If any are accepted, who knows where it can lead? If you also have some entrepreneurial skills, consider financing, producing, and distributing your own and perhaps other people's original designs.

Record album covers actually include many categories of subjects and utilize a variety of imagery. The 12-inch (30.5-cm) square format is excellent. If you are an illustrator with imagery strong in mood and color, who is involved with music, you should pursue the album market. As with magazines, consider

which label uses art that most nearly resembles your work and tailor a portion of the portfolio to the square format. Don't be disappointed if you can't get a commission for an album cover of your favorite recording artist; the most famous musicians often have control over the image on their albums and many prefer photography.

Fashion illustration is quite separate from general illustration. There are two basic types. One, with a larger market for pattern books and fashion buying offices, requires merchandising, which necessitates indicating such details as zippers, pleats, darts, and buttons, with accuracy. If this is your capability and interest, the quantity of work available more than compensates for the relatively low remuneration per figure. The other, more glamorous, area is the free gestural drawings like those of Antonio, whose prime function is to express general proportions, cut, and mood with flair. These drawings are seen in sophisticated fashion publications and are sometimes commissioned by the manufacturers. Unfortunately, there is not a large market for them. One lucrative and remunerative aspect of fashion is accessories, very much in demand for advertising. They include bags, gloves, shoes, and jewelry. Another aspect of fashion illustration, sometimes more related to general illustration, is referred to as beauty. It includes hair, makeup, perfume, and skin care. This has a larger regular market, in all women's magazines and advertising, and the commissions are far more challenging and variable.

Many of these markets overlap and many commissions originate at advertising agencies. These tend to be among the most lucrative. Illustrations done for advertisements need not appear very different from those used editorially. Editorial illustrations for travel or wines, for example, may differ only in the preciseness of the label and typography. Should your interest and work lend themselves to a strong, readable way of illustrating products, however, both the market and the remuneration are large and attractive. Most agencies look for work that is upbeat in mood; however, agencies that specialize in pharmaceutical accounts also use expressively moody and painterly works. Since agencies tend to be less experimental and can afford to take fewer gambles, it is wisest to approach them after you've had editorial exposure.

Other, nontraditional, markets, though possibly less visible to the general public, are potentially lucrative and enjoy considerable prestige. They include television, textbooks, direct mail material, and institutional publications.

For less painterly, more graphic illustration, consider animation design for television commercials. Magical things can be created with movement, things impossible to realize in a single painting. These commercials are produced both in-house at advertising agencies and at animation production companies. The same two sources also require storyboard illustration for both live action and animation commercials. While the commercials lack the satisfaction of being reproduced and seen publicly, they are a regular and lucrative source of work, possibly an additional source of income. Television stations are also large users of graphics and illustration. They are to be approached directly. They hire illustrators and designers and train them to do computer-generated art.

Publishers of textbooks and reference books are another market, especially for black-and-white line drawings. Illustrators frequently say that a number of spot drawings require less time and are more profitable than a single large work, although they are perhaps less ambitious and ultimately less satisfying.

Promotion and graphic design studios are constantly producing direct mail brochures, catalogues, and point-of-sale and display advertising requiring art in both color and black and white. Their needs are similar to those of advertising agencies, though budgets may be smaller corresponding to the size of the viewing audience.

Institutional publications are put out by large companies for distribution to their employees, investors, and clients. The communication is not a direct sales pitch and is usually more subtle than advertising and newsstand requirements. The publications include annual reports to stockholders, corporate capability publications, corporate magazines, and literature for high-level recruitment. Beautifully printed on superior-quality papers with more understated design, these are among the most valued commissions, frequently resulting in awards. Work for these publications is often commissioned by independent corporate designers, best located through annuals publishing the best work in an industry. The *Society of Illustrators Annual* publishes the best illustration for this category under "institutional" and also lists the art director and clients.

One of the most precise ways to locate the markets

141

best suited to your work is to study the illustration and design annuals that purport to publish the best work produced each year. In these books, locate works related to your own; they also list the designer or art director as well as the client. From there go to the telephone directory or to the publication and either telephone for an appointment or drop-off day or send out a mailer to that person, followed up by a telephone call. In any situation, it is advisable to invest in a printed card with an example of your work to leave with the art director for filing and referral purposes.

Pursuit of Private Work

There are illustrators who say that their art grows and evolves adequately through commissions. Most, however, eventually find that doing only jobs becomes repetitive and draining, that the reason for this career choice, the pleasure of it, has somehow diminished in direct proportion to the time allotted for personal work.

Experimentation is necessary for nourishment and artistic evolution. Commissions ask that results be similar to previous work, limiting experimentation. Private work is free of any but self-imposed criteria. Some illustrators perceive private work as a means of producing new portfolio pieces. Others perceive it as a feeding process bringing visual development applicable to commission solutions. Still others pursue private directions that are not particular illustrative but that frequently result in some commissions.

In any event, original art done for commission has value apart from reproduction use. As ownership of the original is usually retained by the illustrator, these along with private work have a gallery market and exhibition value. Pursuit of private work makes it possible to take chances where failure does not mean loss of a client. Success can mean tremendous personal satisfaction and greater, more enduring professional accomplishment.

Pursue favorite subjects and themes. Experiment with forms and media. Express personal idiosyncrasies. Some illustrators are like journalists in their inclination toward commentary and satire. Saturation with communicating other people's messages can motivate your own personal expression. Pursue any of these directions, in series, as gallery artists do. Not only do series propel and inspire, but a percentage will be successful. In addition, series are a means of exploring a direction thoroughly. Regardless of the direction you choose, the greater your investment in your work, the richer will be the reward.

Watercolor illustration for the cover of Fresh 15-Minute Meals *by Emalee Chapman, published by E. P. Dutton, New York. (Art Director: Nancy Etheridge.)*

Index